IMAGES
of America

CHRISTIANSBURG

IMAGES
of America

CHRISTIANSBURG

M. Anna Fariello and Kate Rubick

ARCADIA
PUBLISHING

Published by Arcadia Publishing
Charleston, South Carolina

Library of Congress Catalog Card Number: 2004115241

For all general information contact Arcadia Publishing at:
Telephone 843-853-2070
Fax 843-853-0044
E-mail sales@arcadiapublishing.com
For customer service and orders:
Toll-Free 1-888-313-2665

Visit us on the Internet at www.arcadiapublishing.com

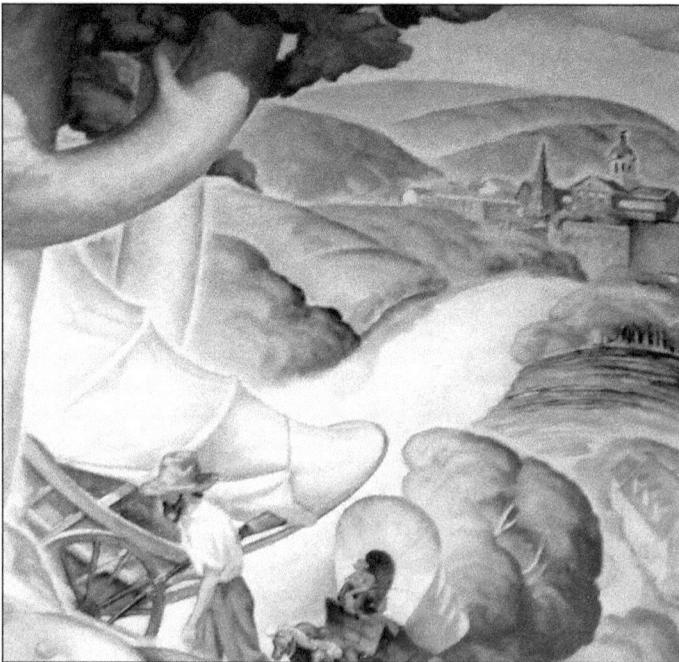

This 1938 mural by Paul Detroot depicts Christiansburg and events of its early history. Still located in the historic 1936 post office, the restored painting includes a rendering of the 1909 Montgomery County courthouse at far right. During the Great Depression, the Federal Arts Project employed artists who created an unparalleled legacy of public artworks. Detroot's mural is one of many that grace contemporary post offices and federal buildings throughout the country. (Photograph by Anna Fariello, courtesy of the author.)

CONTENTS

ACKNOWLEDGMENTS

For many of us, pictures make history real. Seeing an actual person or place adds life to historical facts, meaning that history comes alive and resonates with the present. The past is a starting point to understanding where we are today and where we intend to be tomorrow. When I curate an exhibition, I start out looking for resources that contribute to a particular story. When I am finished, however, I realize that I have—at the same time—identified the organizations and people who remain most important to that story today. Through assembling the photographs for Images of America: *Christiansburg*, Kate Rubick and I met many local citizens and citizen groups that cared enough to preserve significant historical material. In seeing this book come into print, we'd like to express our gratitude to those who contributed to its content by their generosity.

We extend our thanks to Robert B. Basham, who worked with us first from Alabama and then from Wise, Virginia, to provide images from his family's collection; Rhonda Broom, who facilitated our work with the Norfolk Southern collection; Shearon Campbell at the Montgomery Museum for helping to locate important sources; Elaine Dowe Carter for making available the rich collection of the Christiansburg Institute; Kent Chrisman for providing materials from the History Museum and Historical Society of Western Virginia; Clara Lee Dobbins and Katie May for lending us a treasured family portrait; Brian Horne for sharing his family's collection of historic photographs; John Kline for providing important historical annotations along with photographic material; Ariel Lambert at the Department of Historic Resources for helping us search the wealth of their collections for relevant images; Jennifer McDaid at the Library of Virginia for facilitating what could have been a complicated process of selection and duplication; Gene Morrell of the *News Messenger* for answering numerous questions and pointing us in new directions; Donna Roberts, who was always generous and accommodating in sharing her late husband's photographic collection; Joey Showalter, who provided important family history; Aaron Spelbring of Radford University's Special Collections, who, although new at the helm when we began this project, did everything possible to accommodate our requests; James Harman, art director of Radford University's Creative Services, who solved our digital and technological problems (as usual); Jane Wills at Virginia Tech's Digital Library for providing initial advice, help along the way, and image duplication on short notice; and Shelda Wills, former Montgomery County Public School teacher, who assembled and cared for a marvelous collection of high school yearbooks. Finally, we wish to thank those closest to home and extend our gratitude to Ted Auch and William Rogers for their patience in driving us around to see yet another old building. Images of America: *Christiansburg* not only demonstrates the rich history of a community but also identifies the people and organizations that care to preserve it.

INTRODUCTION

Anyone approaching Christiansburg while driving on Interstate 81 is familiar with the steep uphill grade that leaves a convoy of tractor-trailer trucks moving slowly in the right-hand lane. Situated along the edge of a plateau that rises to 2,000 feet from the Valley of Virginia, Christiansburg lies between the Allegheny and Blue Ridge Mountains. Within the New River watershed, the town straddles the Eastern Continental Divide, where waters part for points east toward the Atlantic Ocean and points west towards the Ohio River and into the Gulf of Mexico. Its landscape is marked by rolling hills and distant mountains and defined by the majestic and meandering New River. For centuries, the only way across the New was by boat, poled along by a ferryman.

The lands of Montgomery County once swept from the Blue Ridge westward toward the Ohio River. Although the present county is not nearly so large a territory, its early pristine heritage is preserved in the 20,000 acres of national forest located along its northern boundary. Before its settlement by European immigrants, this land was wild, populated by big game animals and old growth forests. Rich alluvial soil and tempered valley climates distinguished the territory as a fertile hunting ground for Native Americans. Present-day Christiansburg encompasses 14 square miles of this original territory.

In the closing years of the 1700s, Christiansburg town fathers obtained a charter to establish an officially recognized town on the site of a small settlement called Hans Meadows. The town's first official building was a 20-square-foot log cabin, but when the growing settlement was chosen to serve as the Montgomery County seat, a new brick courthouse was constructed. In 1833, a stately courthouse was erected adjacent to the newly dedicated public square, anchoring Christiansburg's governmental and commercial activity to its present site.

The town prospered at the crossroads of important early transportation arteries. During the period from 1800 to 1850, supply grew to meet demand and a number of general stores sprang up to serve travelers stopping to restock and refuel. Two restful mountain resorts—Yellow Sulphur and White Sulphur Springs—were built on the outskirts of Christiansburg. During summers, when the threat of illness heightened, affluent city dwellers escaped to the mountains to take in fresh air and bathe in the purifying mineral springs. When the Civil War put a halt to the vacations of the resort-going crowd, the buildings were put to wartime use, one as a field hospital.

Christiansburg was already situated near the crossroads of two major byways—the Wilderness Trail and the Great Wagon Road—when the railroad arrived in the mid-19th century to transport agricultural commodities and coal from source to supplier. Even today, Norfolk Southern trains transverse the county along tracks that crisscross the area. The town's rail heritage began in 1854 when the Virginia Tennessee Company laid the first tracks through the

valley. The thriving Montgomery County seat was adamant that a train would not run directly through its cultivated community center, so the rail depot was built just over the hill and out of sight. In the wake of its construction, a populous community developed around the rail stop. Known as Christiansburg Station, the area once called Bangs was now called Cambria. As a result of immediate rail access, Cambria became a thriving industrial center with factories and freight warehouses lining the tracks. Bangs was formally renamed Cambria in 1892 and incorporated in 1906 as Montgomery County's third largest town.

The latter half of the 19th century was distinguished by progress in the area's educational institutions. In 1849, the Montgomery Academy was established as a Presbyterian school for boys. In its wake came a sister school for girls, established during the 1850s. In the 1860s, a Freedmen's Bureau school was founded to meet the needs of the area's African-American population; the Christiansburg Institute would evolve from a private to a public institution over the course of its 100 years. The future of Christiansburg was forever altered a decade later when, in 1872, Virginia Agricultural and Mechanical College opened its doors in the northern section of the county. Soon after the start of the 20th century, a teachers' college for young women was established nearby. In the 1930s, Montgomery County built the new Christiansburg High School to serve area students' needs for several generations.

The cornerstone of Montgomery County's third courthouse was laid in 1909, thus inaugurating the 20th-century image of the town with its hallmark eagle soaring high above the landscape. Assembled on the town square on that hot day in July, citizens listened to speeches, a brass band, and groups of singers from local churches. Only a few decades later, the elaborate porch and columns of the new courthouse were removed to accommodate construction of Lee Highway, an early interstate system of roads leading out from the nation's capitol to points south. Completed through Christiansburg in November 1926, the highway was cause for a celebration. The increase in automobile travel through Christiansburg along this major thoroughfare prompted the construction of individually owned motels, restaurants, and filling stations.

In the first years of the 20th century, Christiansburg's commercial downtown continued to develop and expand. The townsfolk were served by a newspaper, several hotels, general stores, a livestock market, and a number of banking institutions. By the first decade of the new century, a developing communications system accommodated nearly 300 telephone lines strung throughout the town, and multiple power lines were hung along the main streets to supply the town's electricity. Although the commercial center of Christiansburg was devastated by major fires that changed the townscape, the town recovered, adding important services in the way of a community hospital and civic infrastructure.

In spite of a tremendous growth in its population, industry, and tourism, the area surrounding Christiansburg remains linked to its agricultural roots. Working the land included a variety of activities, from coalmining in Merrimac to harvesting crops from nearby farms. Events of the agricultural season brought communities together to share work and celebrate the harvest. In the fall, after the corn was shucked and the squash gathered, farmers turned their attention to apple trees. Apple butter making called for families to gather, peel, and quarter bushels of fruit that were stewed and seasoned in vast copper kettles over open fires. The all-day stirring was often accompanied by music, storytelling, or newsy chatter, marking early forms of the region's hallmark agricultural customs. As events of the growing season brought communities together to share work and celebrate the annual harvest, today's Christiansburg continues to celebrate its heritage and hope for a vibrant future.

One

LAY OF THE LAND

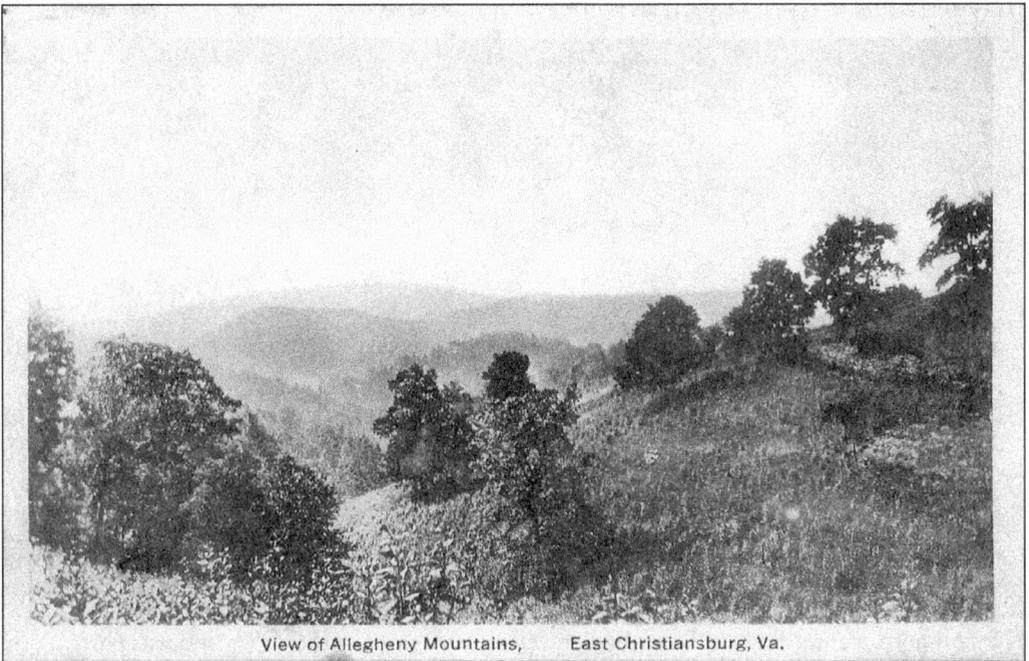

View of Allegheny Mountains, East Christiansburg, Va.

The town of Christiansburg is situated at an elevation of 2,089 feet along the edge of a plateau that rises between the Allegheny and Blue Ridge Mountains. The two ranges are part of a continental divide separating waters that flow west to the Gulf of Mexico and east toward the Atlantic Ocean. The entire Christiansburg area is located within the New River Watershed. In places, contemporary vistas still recall the early landscape that cradled the village. (Robert B. Basham Collection.)

German-born painter Edward Beyer first traveled to Virginia in the 1850s and was particularly drawn to the western portion of the state. His drawings during this period depict antebellum villages and countryside in an idyllic, but authentic, way. Beyer is noted for a graceful incorporation of technological developments into his signature romantic style. His view of

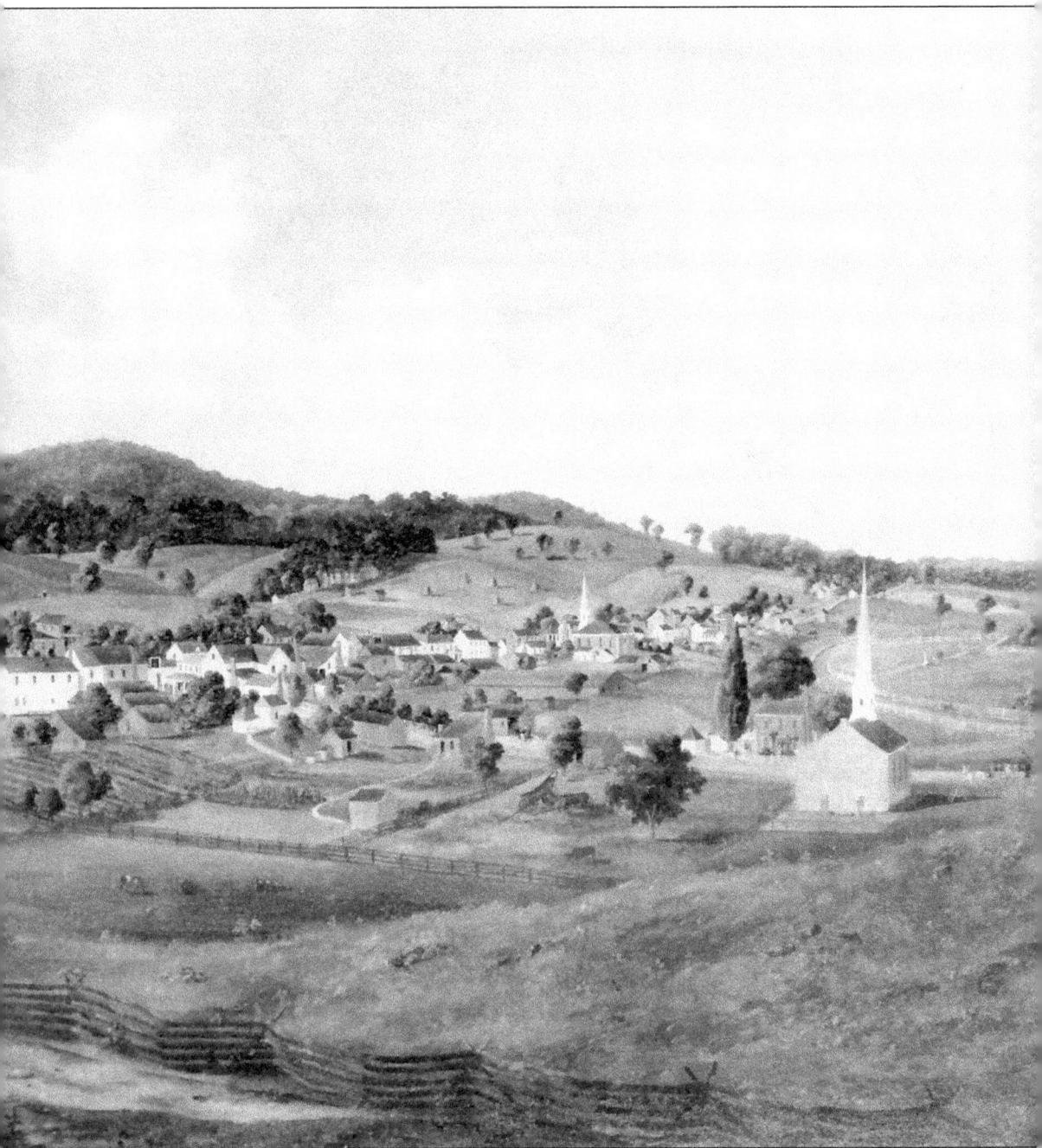

Christiansburg is oil-on-canvas and dates to 1855. Montgomery County's 1833 courthouse is visible in the landscape's center, as are the steeples of the cozy town's first churches. (Virginia Historical Society, Richmond, Virginia.)

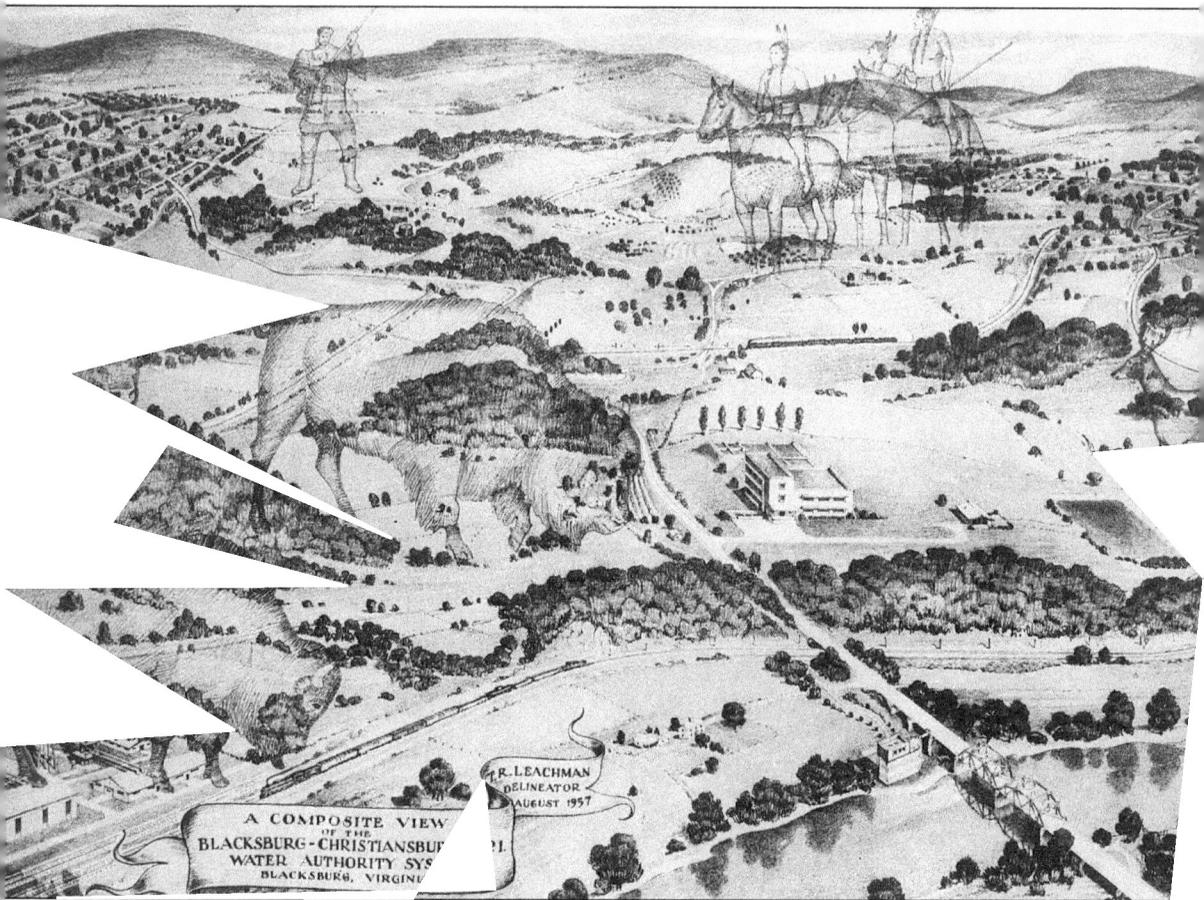

A COMPOSITE VIEW
OF THE
BLACKSBURG - CHRISTIANSBURG PL.
WATER AUTHORITY SYS
BLACKSBURG, VIRGINIA

R. LEACHMAN
DELINEATOR
AUGUST 1957

This Water Authority sketch, completed in 1957, offers a colorful glimpse into Montgomery County's early history. The fertile valley, populated by big game and old growth forests, was considered a significant hunting ground by local Native American tribes. Curiously, the map integrates a vision of this early period with more modern developments, such as the railroad, highway, and bridge spanning the New River. The town of Christiansburg is depicted beneath the shadow of the bison at lower left. (Bruce Harper Historic Photograph Collection, Digital Library and Archives, Virginia Polytechnic Institute and State University.)

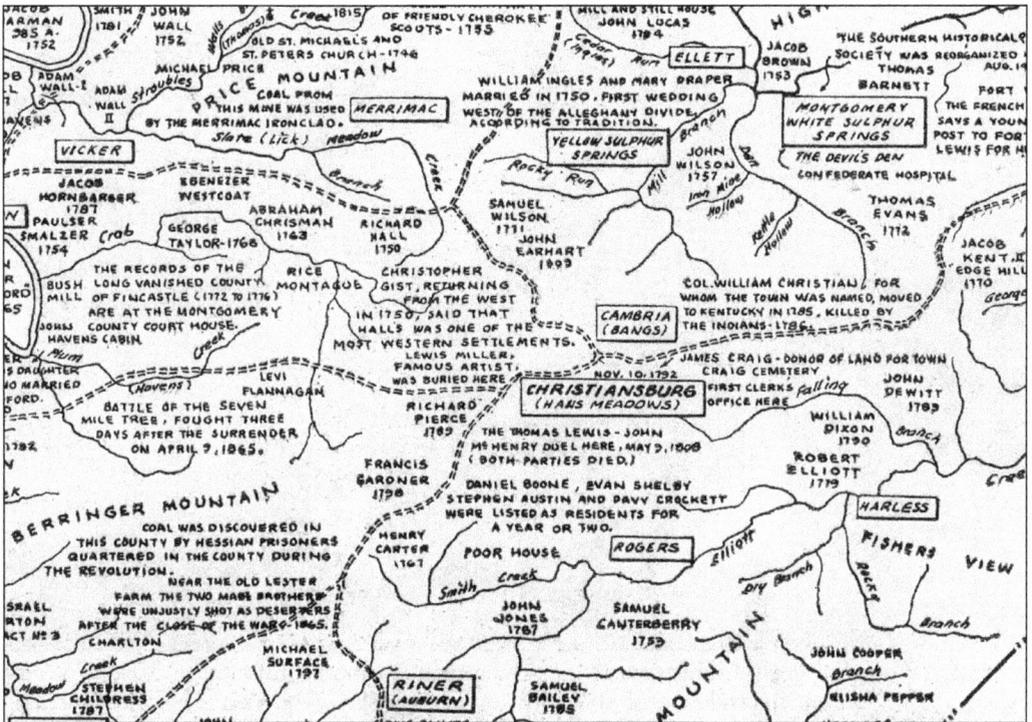

This annotated map of Montgomery County documents the relationship between locations significant to Christiansburg's history. The map's center lists the town's original name, Hans Meadows, which was the name of landholder James Craig's estate. Craig later donated the land that became Christiansburg. North of Christiansburg are Cambria, Merrimac, and Vicker, important early industrial communities. To the northeast were two mountain resorts, Yellow Sulphur Springs and Montgomery White Sulphur Springs. All of these communities were nestled among several small upland ranges shown on the map, including Price, Berringer, Brush, and Hightop Mountains. (Southwest Virginia Images Collection, Digital Library and Archives, Virginia Polytechnic Institute and State University.)

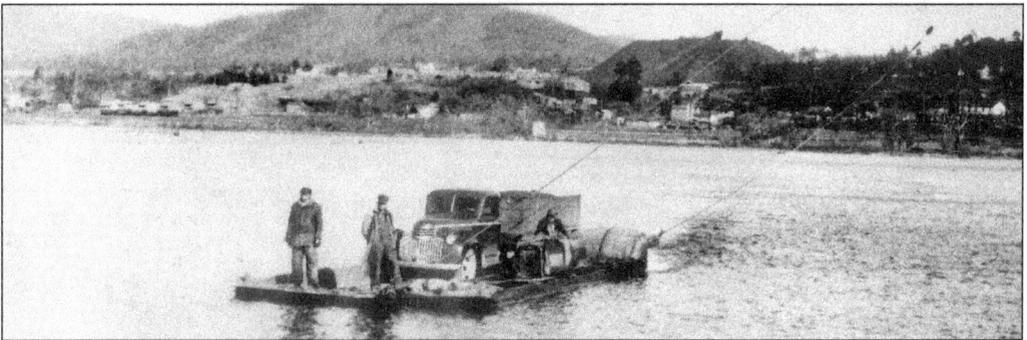

Perhaps the most dominant feature of the region near Christiansburg is the New River, which flows northward from the Eastern Continental Divide. Near the turn of the century, residents and travelers crossed the New River by privately run, hand-poled ferryboats. Mechanized cable systems were later installed, and travelers were able to board the ferry with their automobiles. This 1939 photograph depicts county motorists crossing the New River near McCoy. (Southwest Virginia Images Collection, Digital Library and Archives, Virginia Polytechnic Institute and State University.)

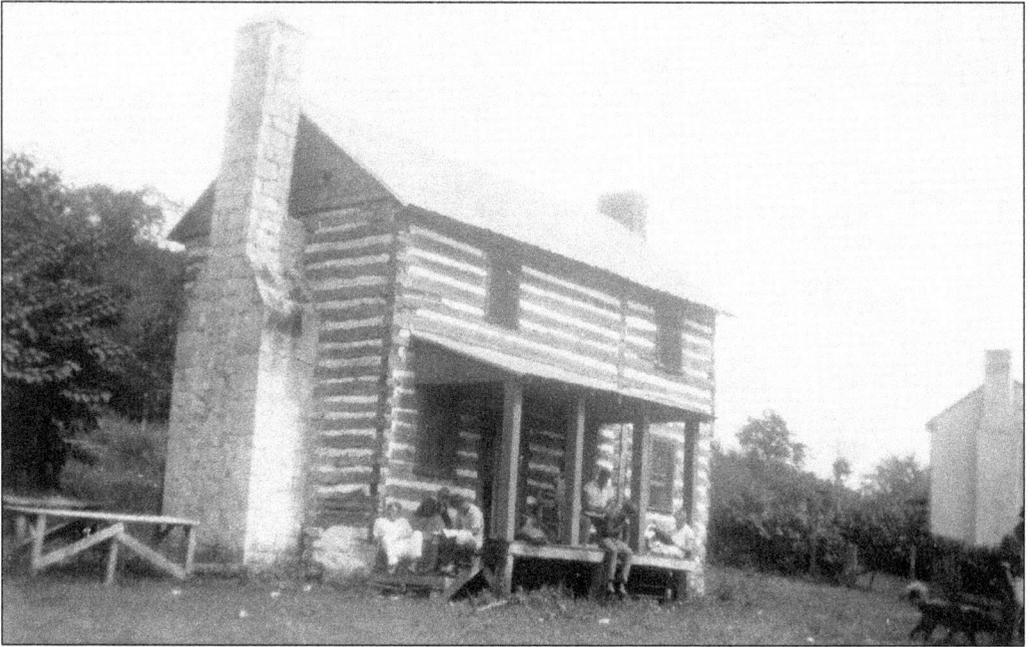

Part of a Works Progress Administration–era historical inventory, this image depicts Willow Spring Farm, a typical residence of the 18th and early 19th centuries. This two-story log building was constructed in 1798 by Edward Rutledge, whose family lived here for several generations. The home, located a few miles north of downtown Christiansburg on Route 114, was built with shop-made nails and hand-hewn logs. The cabin measured 29 by 15 feet and was heated by a massive fireplace. The porch was not original and was added much later. The farm was named for a large willow tree that stood near a cold mountain spring running along the edge of the property. (Photograph by Pearl C. Vest; WPA Virginia Historical Inventory, The Library of Virginia.)

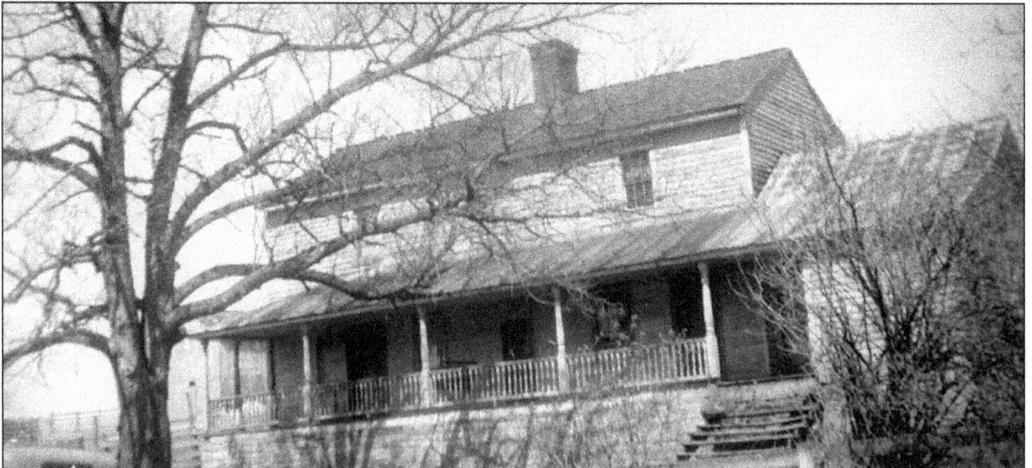

Before Archibald Murray purchased this rambling farmhouse, it was owned by the Hancocks of nearby Fotheringay Plantation. The frame building was typical of many constructed in the early 19th century with a long, wide porch, two chimneys, and stone foundation. The home was located a few miles east of Christiansburg along the Old Allegheny Turnpike (Route 11). (Photograph by Pearl C. Vest; WPA Virginia Historical Inventory, The Library of Virginia.)

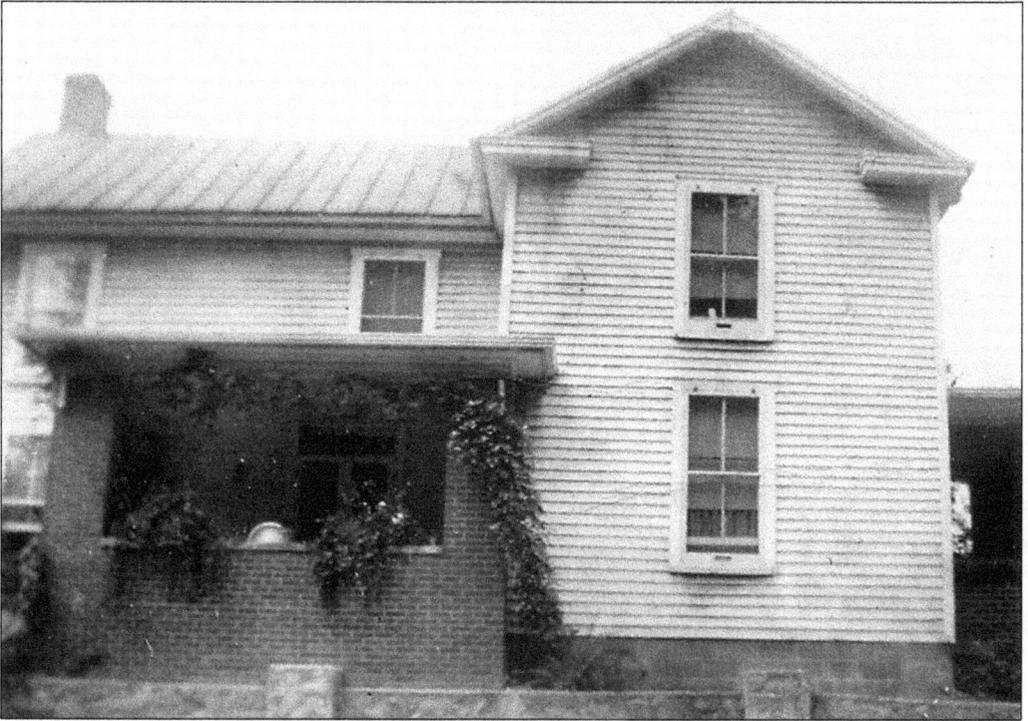

This East Main Street residence was constructed over a two-room log cabin built by local saddler Alex Cooper in the late 18th century. The house was enlarged significantly when purchased by the Moore family in the first half of the 20th century and still stands today. Nearby were a liniment barn, the Colhoun house, and the Montague house. Today, along East Main Street, the names of Christiansburg's earliest families are preserved on neighborhood street signs. (Robert B. Basham Collection.)

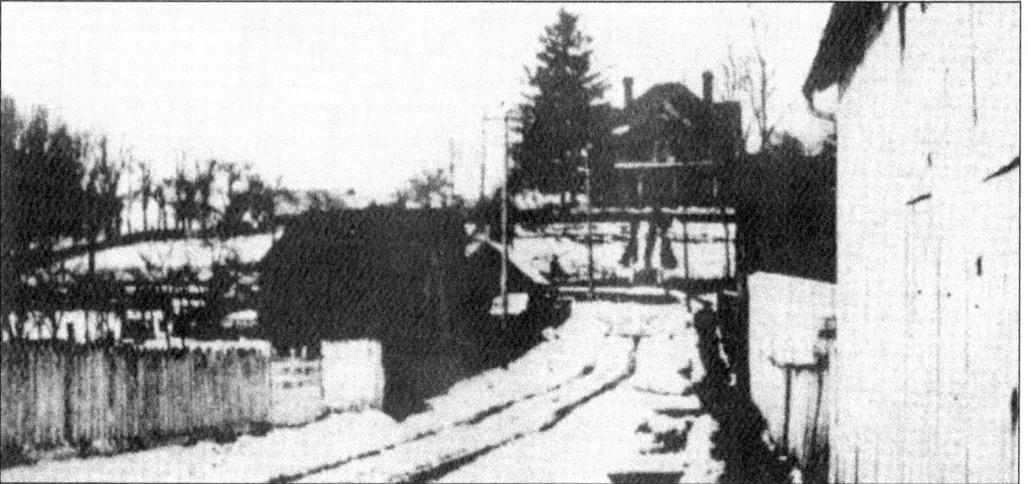

This wintry photograph depicts a view of Dunkley Street seen from its intersection with West Main, a few blocks down from the courthouse square. The large residence at the end of Dunkley was the Spindle House. Once a summer hotel, the existing structure on the hill (though not the original) was constructed with a similar floor plan and built on the same foundation. (Horne Family Collection.)

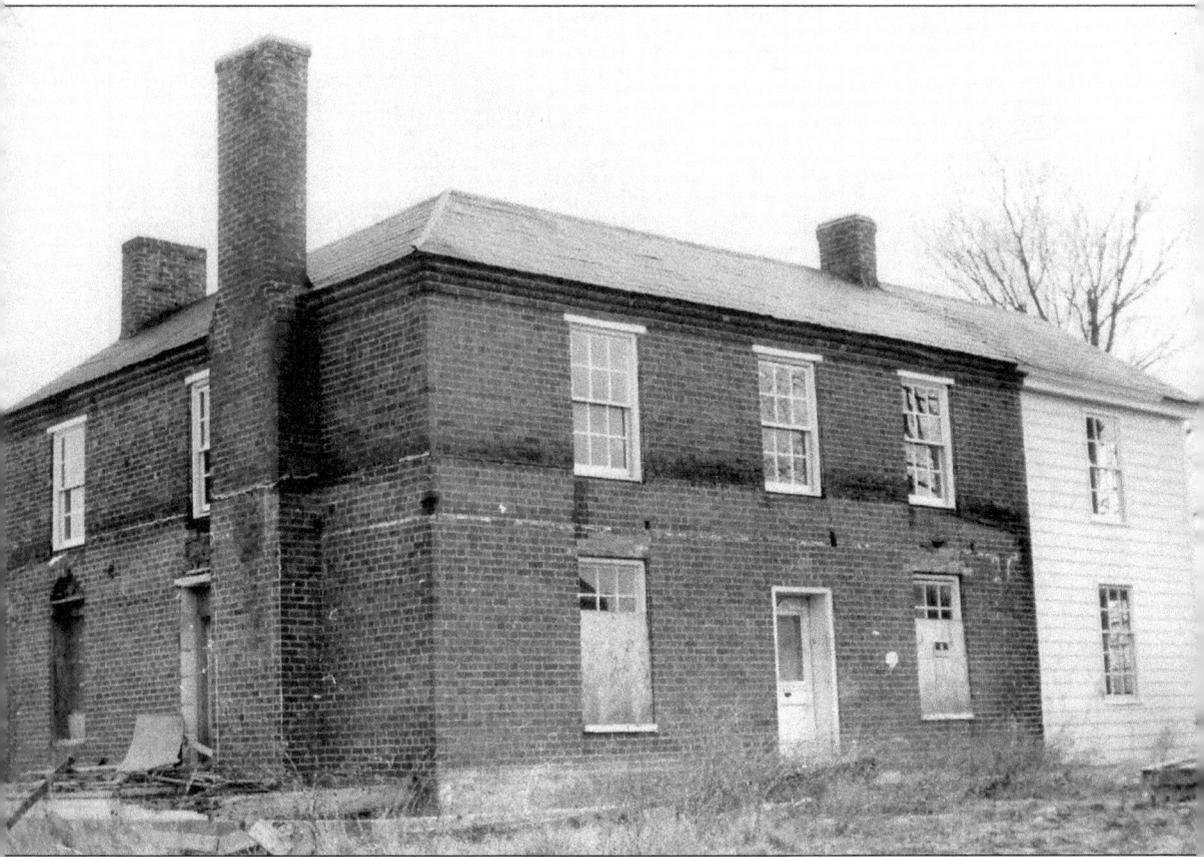

The brick portion of this historic structure dates to the mid-19th century. Constructed in the Georgian style, with hewn beams and brick hand fired on the property, the building served as a home for the Presbyterian clergy until 1858. The residence stands on a portion of the original tract of Hans Meadows. The manse was purchased in 1873 by local physician William Pepper, whose family lived in the home for nearly a century. Today, the Pepper House has been restored and a frame addition added to accommodate the Montgomery Museum and Lewis Miller Regional Arts Center. (Photograph by B.B. Bailey; *Montgomery News Messenger* Photographic Archive.)

This two-story farmhouse was originally part of a small plantation located on a south-facing slope along Crab Creek. In 1900, the farm was purchased by the Christiansburg Institute, an African-American school that was originally established in Cambria. Although the institute constructed many buildings to serve the school, this one—known as the Mansion House—was original to the farm. It was used as a classroom building from 1900 until 1927, when a more modern brick edifice was constructed to serve the needs of the growing school. (Christiansburg Institute Museum and Archive.)

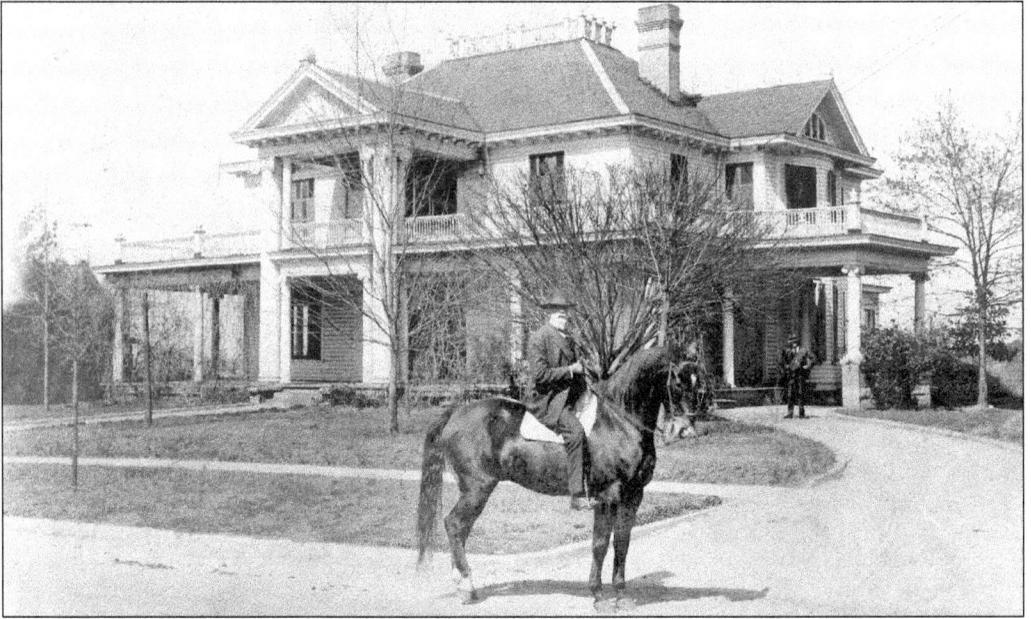

The white frame residence with wraparound porches, dramatic entrance, and upper-floor balconies is representative of the construction that occurred as the town grew into its position as county seat. In today's downtown, sections of some streets are still lined with substantial, turn-of-the-century homes, evidence of an affluent demographic that marked the town's early development. The gentleman on horseback is James Hoge Tyler, Democratic governor of Virginia from 1898 until 1902. (*Montgomery News Messenger* Photographic Archive.)

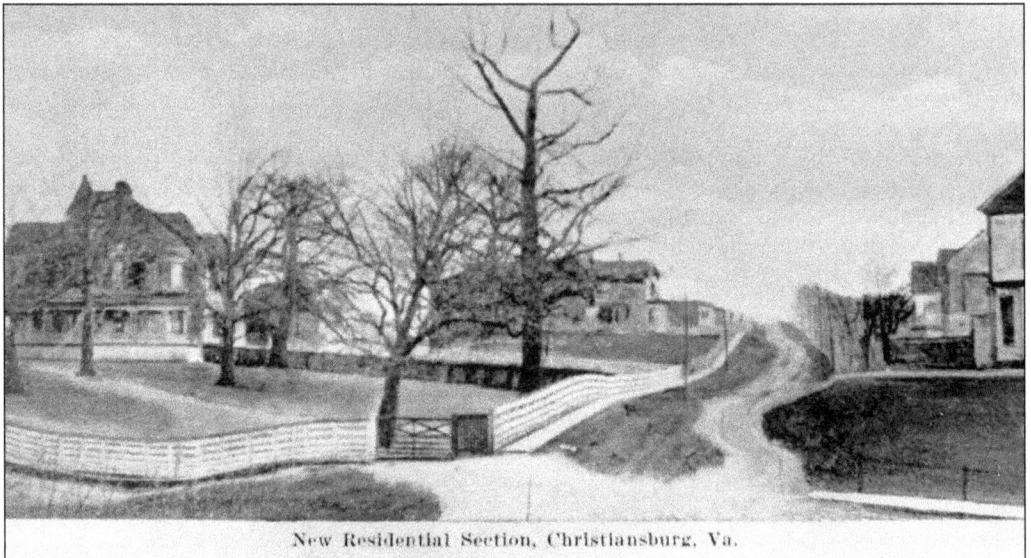

New Residential Section, Christiansburg, Va.

This image depicts a turn-of-the-century affluent residential area in Christiansburg proper, a view taken from East Main looking up Park Street. The Victorian home on the left, known today as the Oaks, dates to 1889, when it was constructed for Julia Baird by her soon-to-be husband. East Main Street runs in the foreground of the elegant residence and Park runs into the distance. Today, sections of both streets are designated historic districts for their many examples of Queen Anne and Colonial Revival architecture. (Mr. and Mrs. Richard Roberts Collection.)

18

Two

Establishing a
County Seat

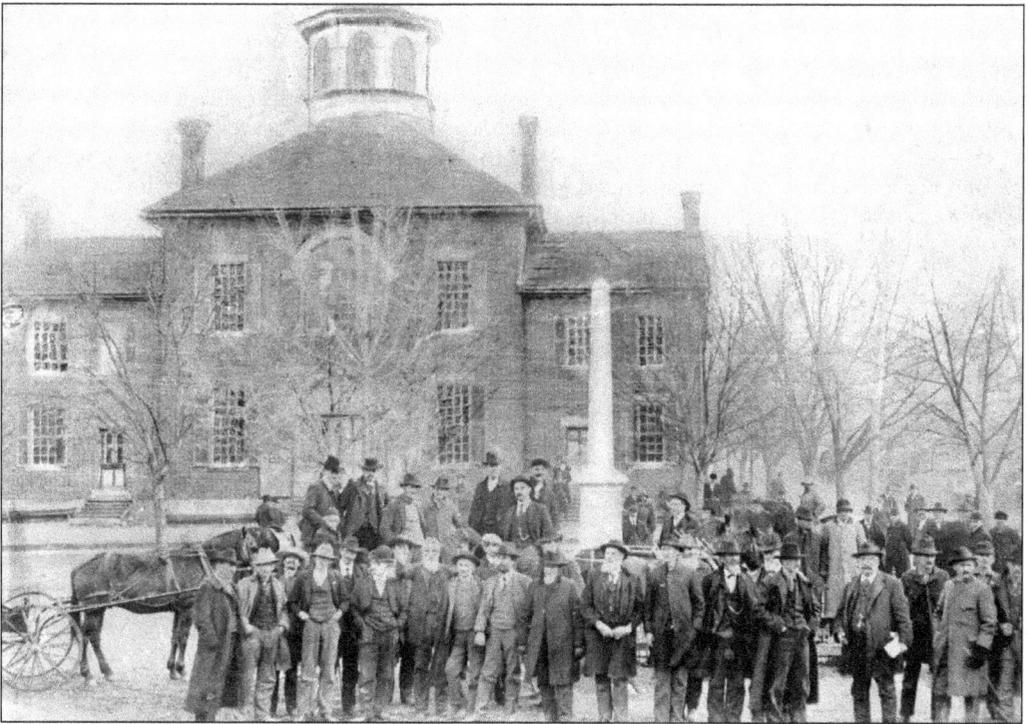

In 1792, a group of appointed justices convened at Hans Meadows. There, after re-naming their community for Col. William Christian, they were granted an official charter to establish the town of Christiansburg. Shortly thereafter, a 20-foot-square log cabin was built to accommodate local judiciary needs. When the growing town of Christiansburg was chosen to serve as the Montgomery County seat, a new brick courthouse was constructed. Finished in the 1790s, the building was two-storied with bay windows that flanked an elaborate six-panel door. A town square developed around a second brick courthouse (shown here), designed in the traditional Virginia vernacular. In this photograph, members of the Masonic Lodge gather in front of a monument to the Lost Cause. (Special Collections, McConnell Library, Radford University.)

Designed by James Toncray, the 1833 courthouse was constructed adjacent to the newly dedicated public square. Toncray was considered the most prolific architect of antebellum government buildings in southwest Virginia. His Montgomery County courthouse was distinguished by a hipped roof and cupola with lightning rod. The vertical shaft of the Civil War monument is visible at center left. A second monument, constructed adjacent to this one, marks the site of the 1808 Lewis-McHenry duel in which both parties died. The tragic duel inspired passage of the Barbour Bill, outlawing gun fighting in the Commonwealth. Today, both monuments remain but are separated by an expanded Main Street, which runs between them. (D.D. Lester Family Collection, Montgomery Museum and Lewis Miller Regional Art Center.)

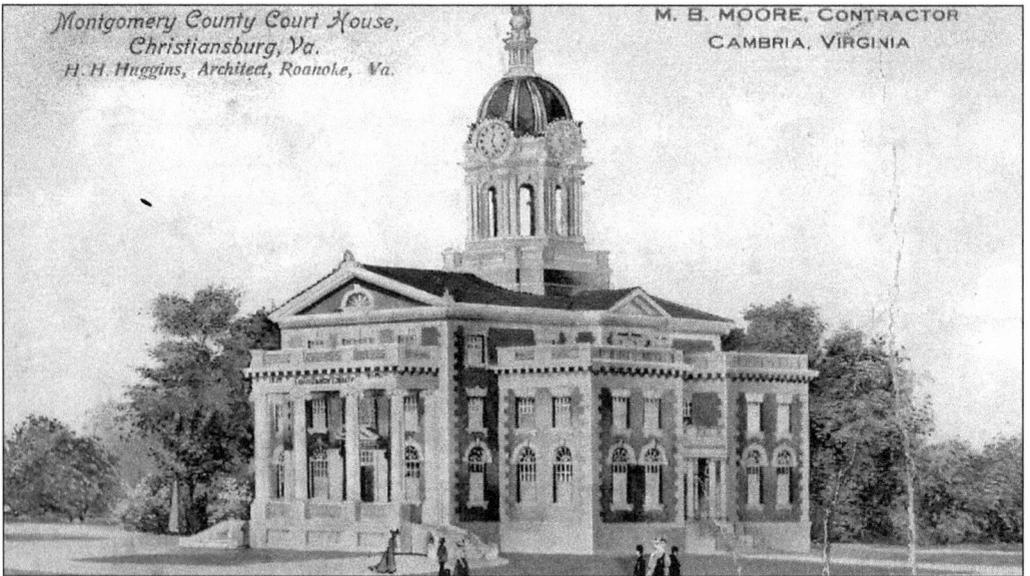

To meet the needs of a growing population, a larger and more elaborate courthouse, designed by Roanoke architect H.H. Huggins, was built in 1909. This postcard was produced to commemorate the completion of the Greek Revival courthouse. An elegant drawing done by a traveling artist, the card depicts a bucolic scene with distinguished ladies and gents walking about the landscaped grounds. The postcard's text pays homage to the architect and to local contractor M.B. Moore. (Robert B. Basham Collection.)

Marshall Brazine Moore was a young and successful contractor responsible for many residential and commercial structures in the Christiansburg and Cambria communities. His fine reputation led to his commission by Huggins to translate the architect's ornate vision—with columned portico and tall clock tower—into reality. Here, Moore appears in a formal portrait dating to the early 20th century. (Robert B. Basham Collection.)

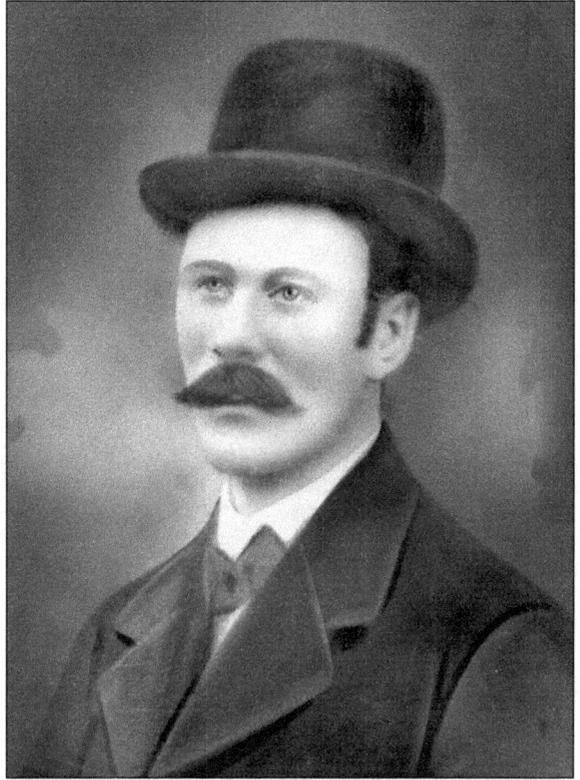

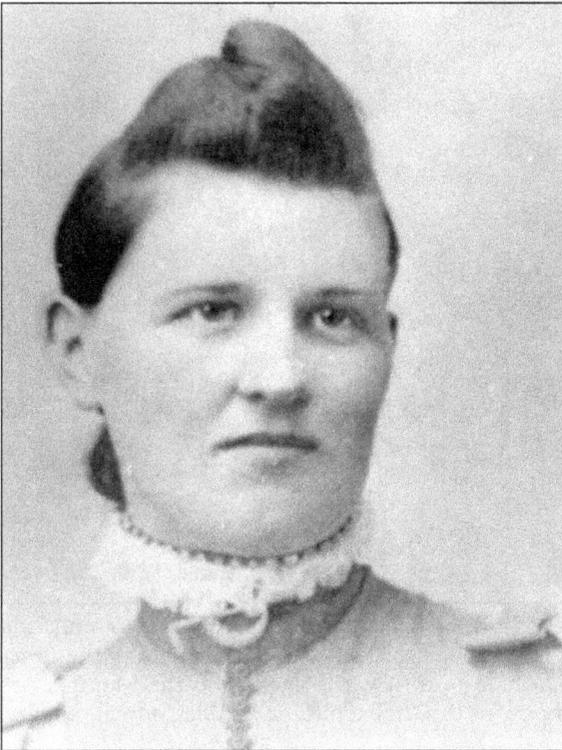

This photograph of Floyd native Lelia Vivian Altizer was taken after her 1895 marriage to contractor Moore. They had six children. After her husband passed away, she moved with her daughter Hazel to a house at 202 East Main Street. The residence would stay in their family for three generations and still stands today. Lelia Moore was an avid gardener, and her flowerbeds were always admired by local residents. (Robert B. Basham Collection.)

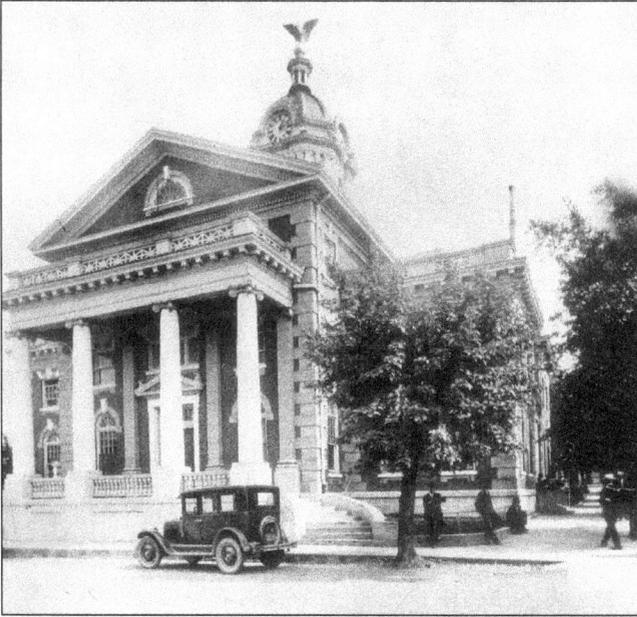

The cornerstone of the county's third courthouse was laid in July 1909. Citizens picnicked after hearing addresses by local orators, politicians, and officers of the court. A brass band played to accompany groups of singers from local churches. In this image, professional men talk while leaning on the handrails at the foot of the steps at right. (Southwest Virginia Images Collection, Digital Library and Archives, Virginia Polytechnic Institute and State University.)

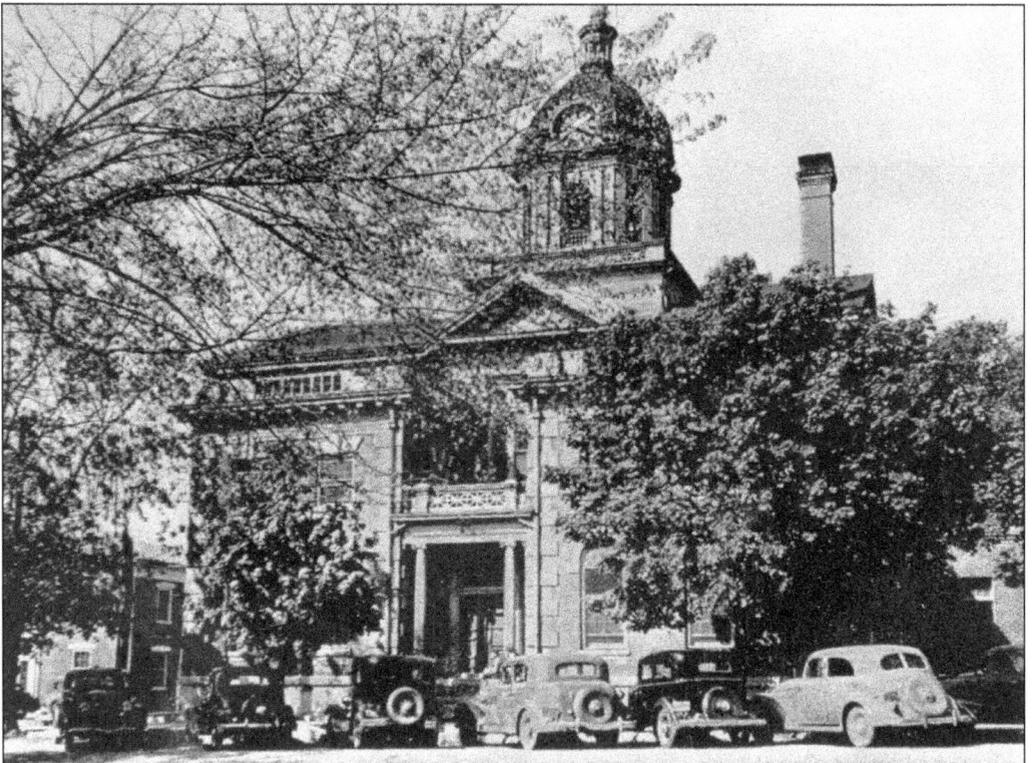

The new courthouse was a stately symbol of progress with a clock tower topped with a rendering of an eagle in flight. A local jeweler was commissioned to "keep the time," minding the inner workings of the fancy clock. For better than half a century, the eagle atop the Montgomery County Courthouse soared above the cityscape. (Special Collections, McConnell Library, Radford University.)

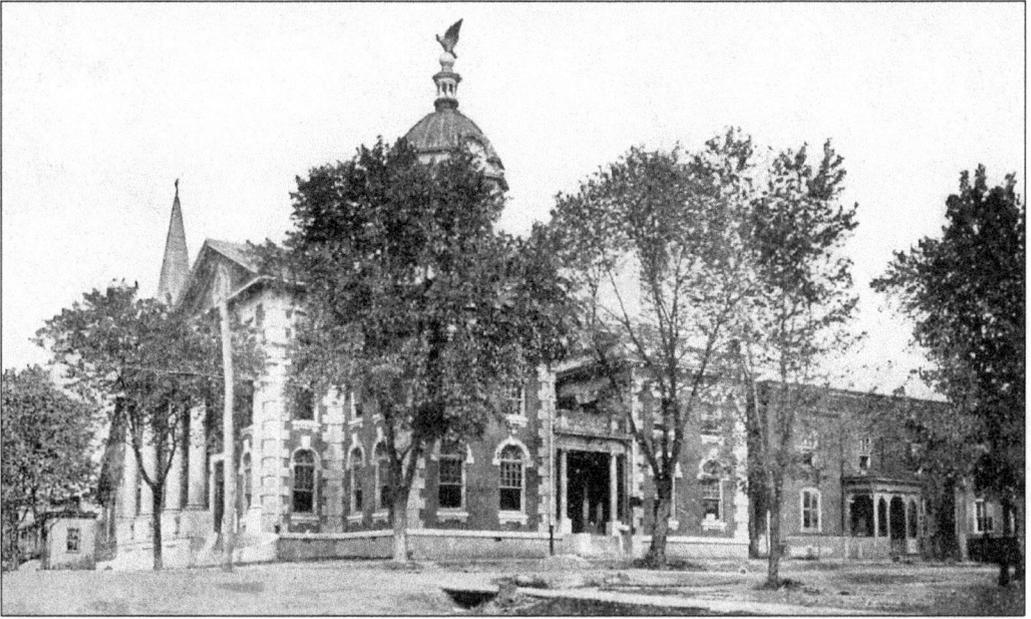

The columned façade of the county courthouse faced Main Street and was bounded along its side by Franklin Street. In the early 1920s, the front face of the judicial building was altered significantly. The elaborate porch and columns were removed to accommodate construction of the Lee Highway, the first completed interstate road in America. To the left of the courthouse, the steeple of the downtown's original Methodist church is visible. (Robert B. Basham Collection.)

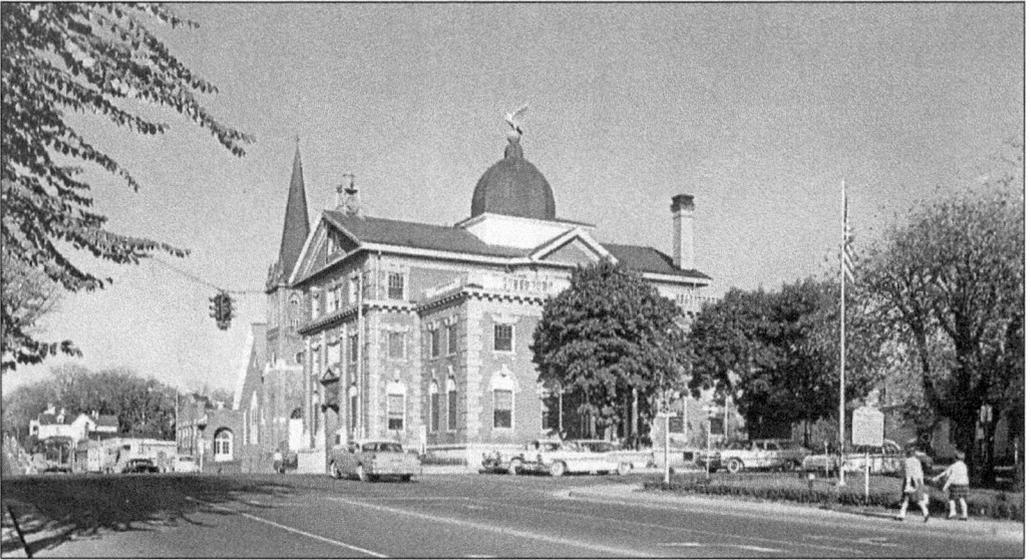

After the Lee Highway was completed, Main Street developed quickly. This image reveals a full line of commercial buildings stretching away from the town center toward the passenger train station in Cambria. The typically American scene includes two school girls with lunch pails walking alongside the neatly manicured green, flag waving in the breeze, while cars with mid-20th-century fins line up at the intersection below the town's first suspended stoplight. (Robert B. Basham Collection.)

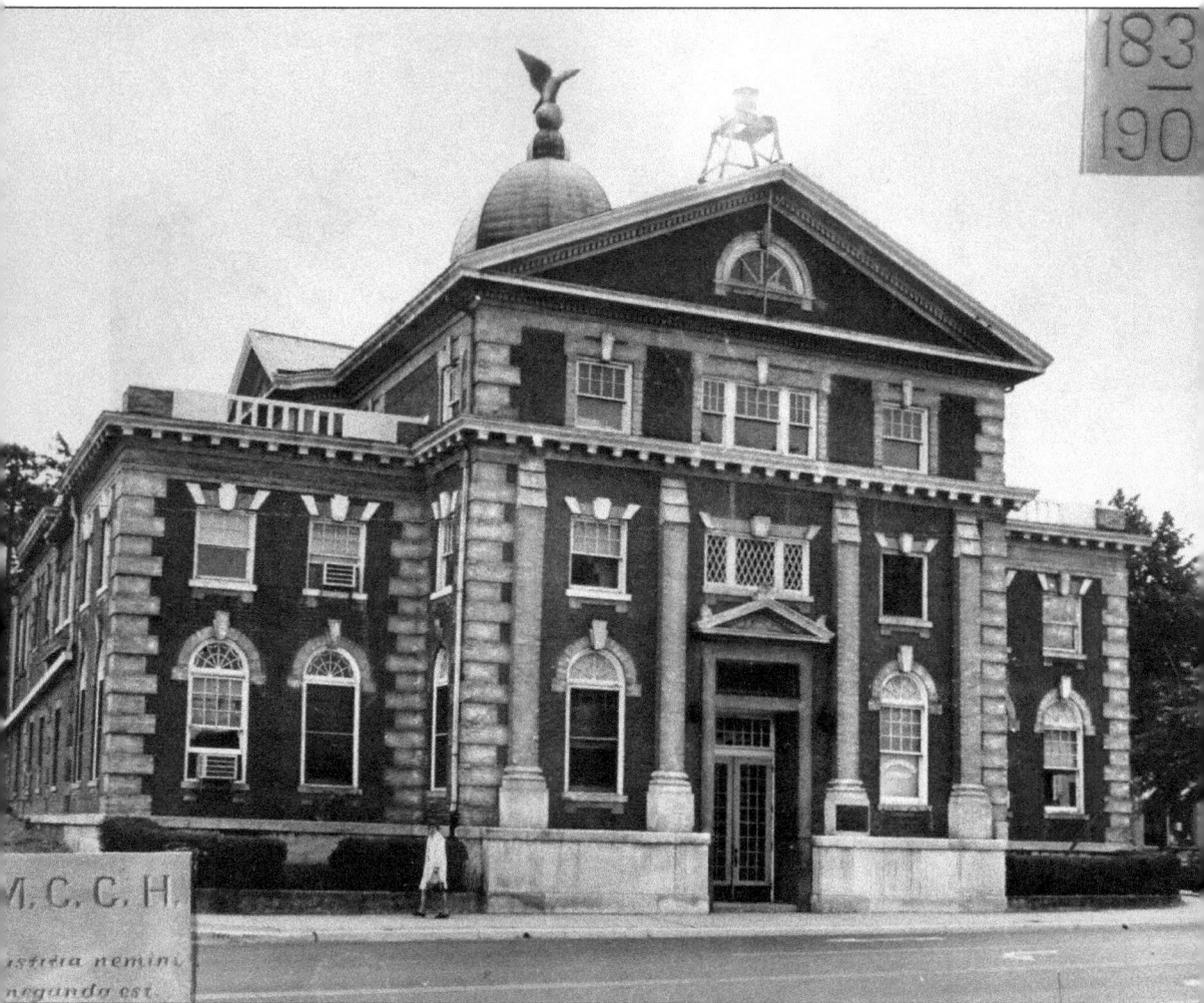

This picture, taken by well-known local photographer Earl Palmer in 1975, commemorates the history of Montgomery County's 1909 courthouse. A testament to days long past, Palmer's photograph included the construction date of this building and its predecessor (upper right) and the Latin inscription of the cornerstone (lower left). (Photograph by Earl Palmer; Special Collections, McConnell Library, Radford University.)

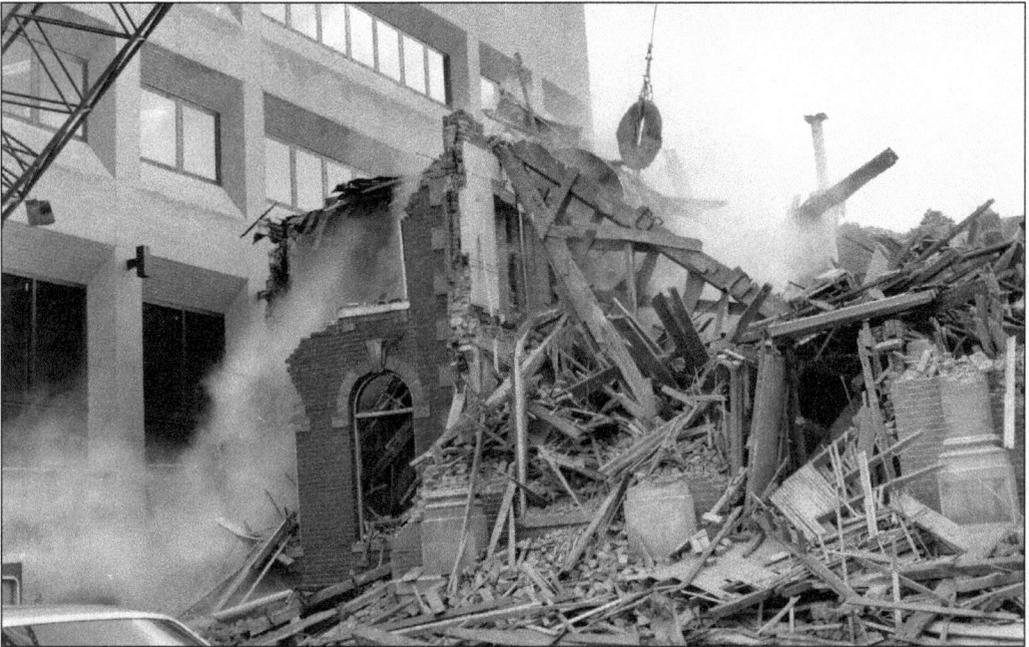

On November 30, 1979, after serving the county for 70 years, the Montgomery County Courthouse was leveled to the ground. A wrecking ball flew through the brick walls and sheltered columns of the 1909 building, making room for an updated facility. (Photograph by Earl Palmer; Special Collections, McConnell Library, Radford University.)

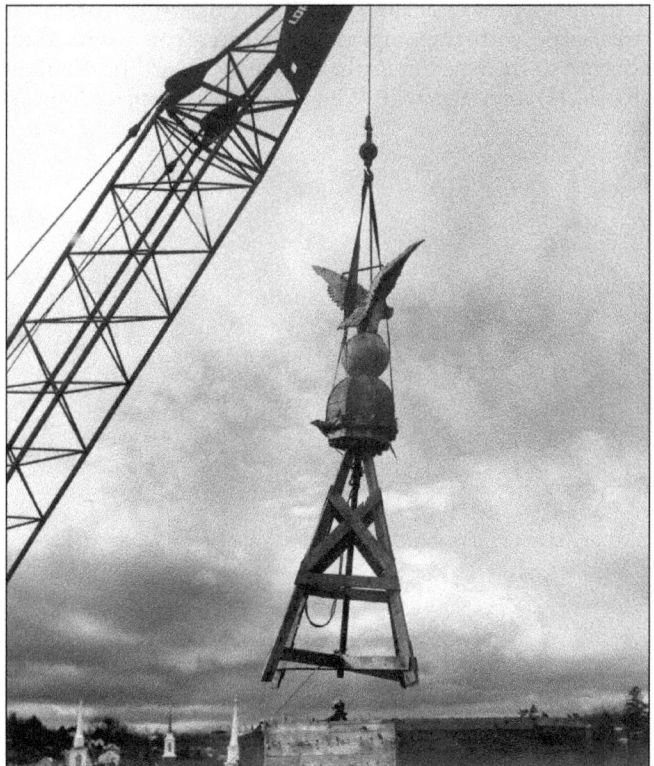

The clock tower sculpture and old cast-iron bell were saved. The bell stands in the foyer of the contemporary courthouse; the famous eagle that capped the 1909 cupola was set atop a stone base in the courtyard. Here a crane moves the winged eagle to safety. Visible at the lower edge of the photograph are the white spires of several Christiansburg churches—Main Street Baptist, St. Paul Methodist, and the Christiansburg Presbyterian Church—that line West Main Street. (Photograph by Earl Palmer; Special Collections, McConnell Library, Radford University.)

This 1980s view of Main Street in downtown Christiansburg reflects the synthesis of an older streetscape with trappings of modernity. The town's traditional white steeples stand out in contrast to the newly constructed massive courthouse building. In the foreground, Radford Road (Route 11) intersects with West Main. (*Montgomery News Messenger* Photographic Archive.)

Three

MAKING OF A TOWN

The 20th century brought electric lights and clapboard sidewalks to Christiansburg. In this view of West Main Street looking toward the public square, a man stands in the middle of an unpaved and rutted road while a buggy travels toward him. Above his head hangs an early street lamp. To the right, the clock tower of the 1909 courthouse and the steeple of the old Methodist church are distinguishable elements of the town's skyline. The building at the far right dates to 1905 and was constructed for the First National Bank and the law offices of W.H. Colhoun. (Mr. and Mrs. Richard Roberts Collection.)

Once the home of a prominent local attorney, the Colhoun house is no longer standing. It was constructed in the late 19th century on East Main Street next to the Moore family home (see page 15). The empty lot is still distinguishable. This area of downtown Christiansburg remains largely residential and well populated. (Robert B. Basham Collection.)

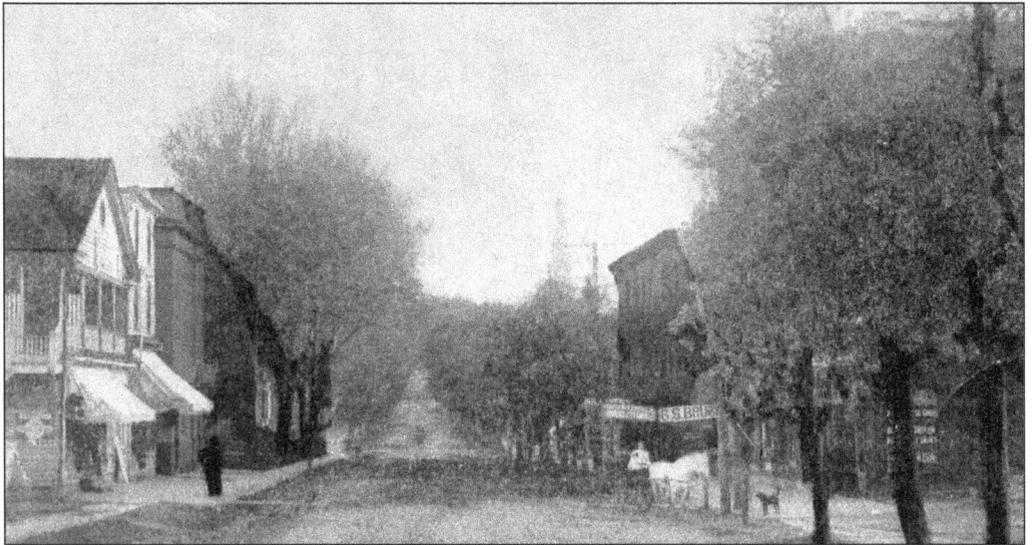

The period from 1800 to 1850 was particularly lively for the growing burg. One of the first commercial ventures in town was the Christiansburg Tavern, which offered dinner, dancing, drinks, and rooms for rent to folks passing through. The town prospered as supply grew to meet demand. On the left are several distinguished commercial buildings and a market with clean white awnings. A number of shops like these sprang up as travelers stopped to restock and refuel. (History Museum of Western Virginia's Clare White Library Collection.)

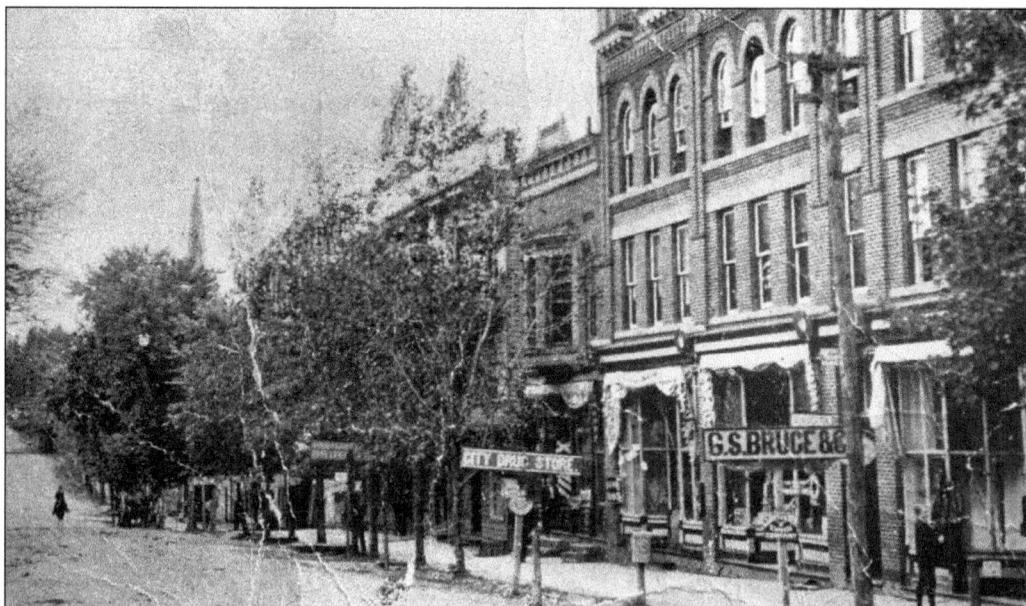

On the right side of Main Street, looking west, were the City Drug Store and the three-story brick Shelton-Waters building, home to the G.S. Bruce store. Above the third-floor arched windows was a rooftop overlook. The elaborate commercial building burned to the ground in 1942 in one of several fires that devastated the town's commercial district. (Special Collections, McConnell Library, Radford University.)

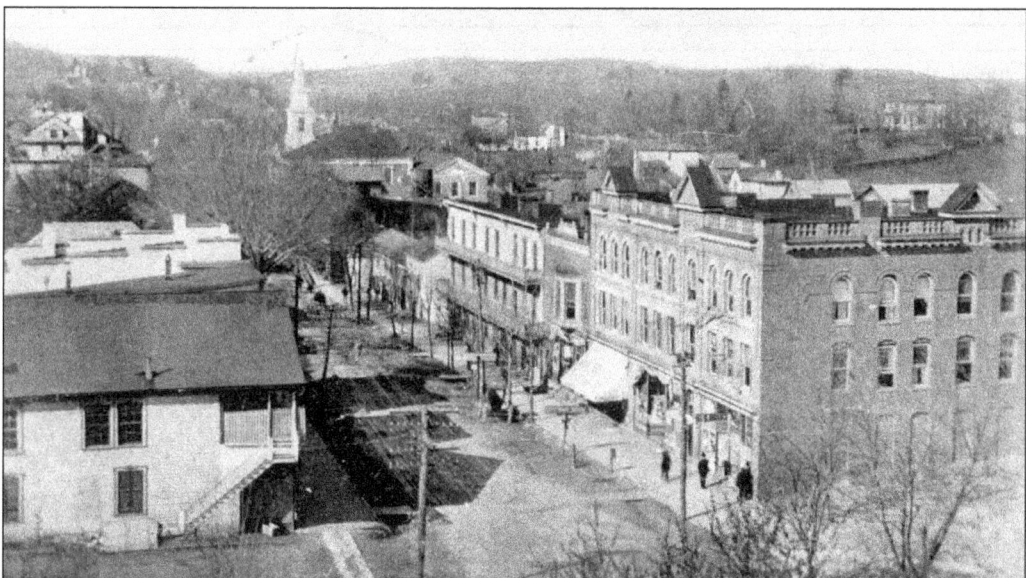

This 1930s photograph, taken from the clock tower of the 1909 courthouse, shows West Main Street flanked by brick mercantile buildings. The diminutive Thomson-Hagan Drug Company was situated between the grandiose G.S. Bruce store on the corner and an unidentified building with open-air second- and third-floor porches. The building to the left of the drugstore burned in 1954, and the corner building burned ten years earlier. Fortunately, the little Thomson-Hagan building survived both blazes and still stands today. (History Museum of Western Virginia's Clare White Library Collection.)

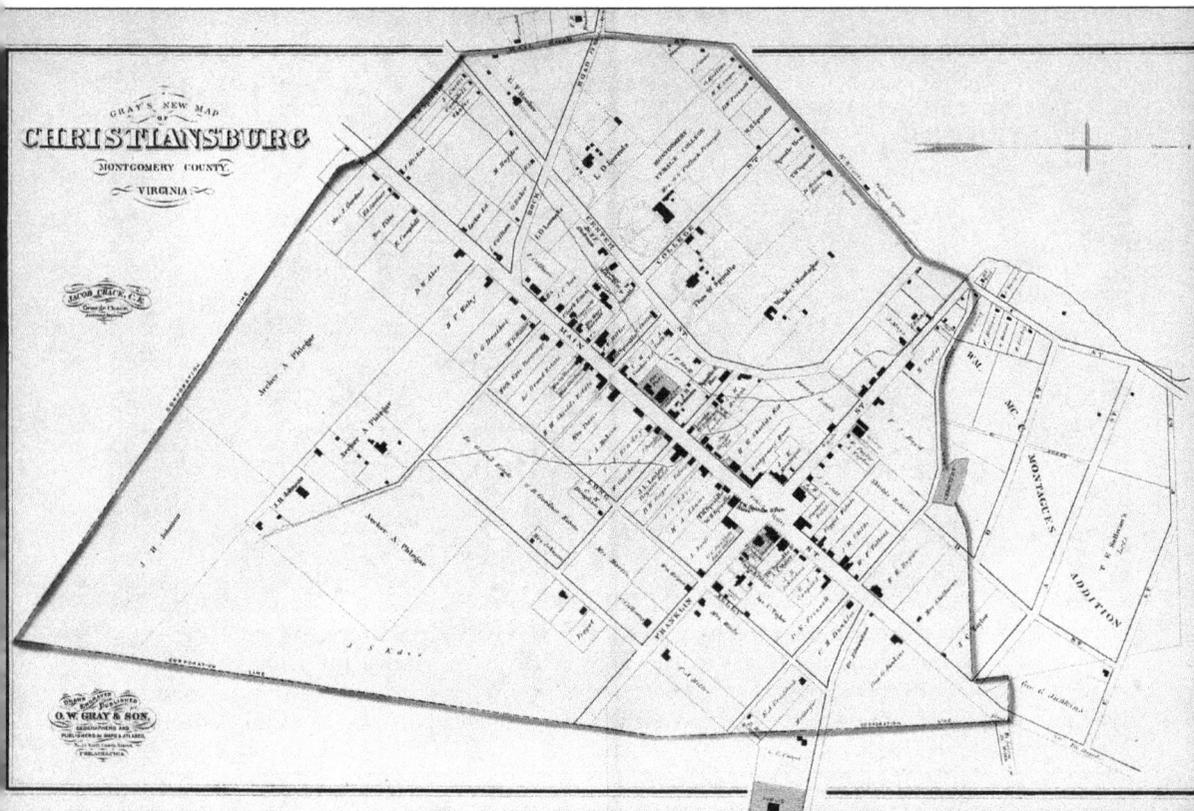

One of the first formally commissioned maps of the town, *Gray's New Map of Christiansburg* was drawn in the first decade of the 20th century. The site of the Female Academy (at upper right) still bears the name of the school's original principal, Mrs. O.S. Pollock, who conceded that position in 1909. The map identifies early residential and commercial players, names such as Spindle, Montague, Phlegar, and Junkin. (Southwest Virginia Images Collection, Digital Library and Archives, Virginia Polytechnic Institute and State University.)

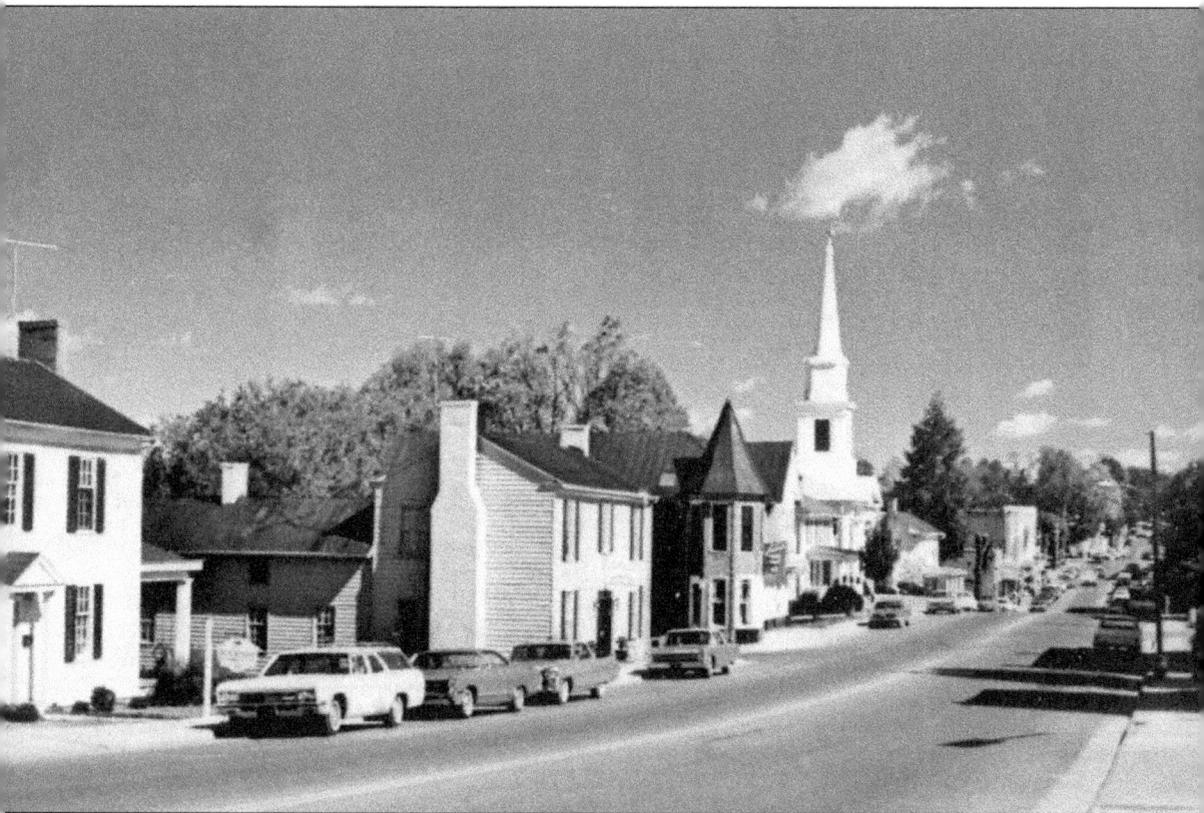

This view of Christiansburg, looking eastward along West Main Street at its intersection with Dunkley, highlights several historic structures. The Colonial-style building to the far left dates to the early 19th century. Its first owner was prominent local businessman Charles A. Miller, who purchased the house in 1855. Near the old house was once an early town jail, used in the 1800s. The residence still stands today. (Robert B. Basham Collection.)

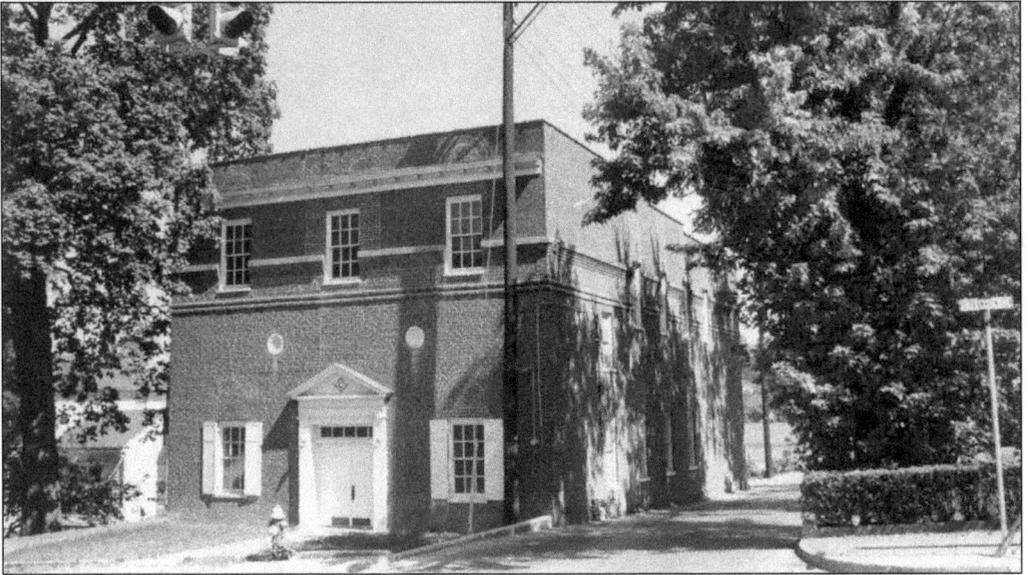

Originally the site of a Presbyterian church, the two-story brick lodge was constructed in 1897 in the typical Masonic style. For a brief period, the first floor was used to stage theatrical events while the Masons utilized the upper level. Eventually their organization grew to require the entire space. A series of subtle arches can be seen in the brick pattern above the windows. The building, located at the corner of South Franklin and First Streets, was razed in the 1970s to accommodate the Department of Transportation. (Virginia Department of Historic Resources.)

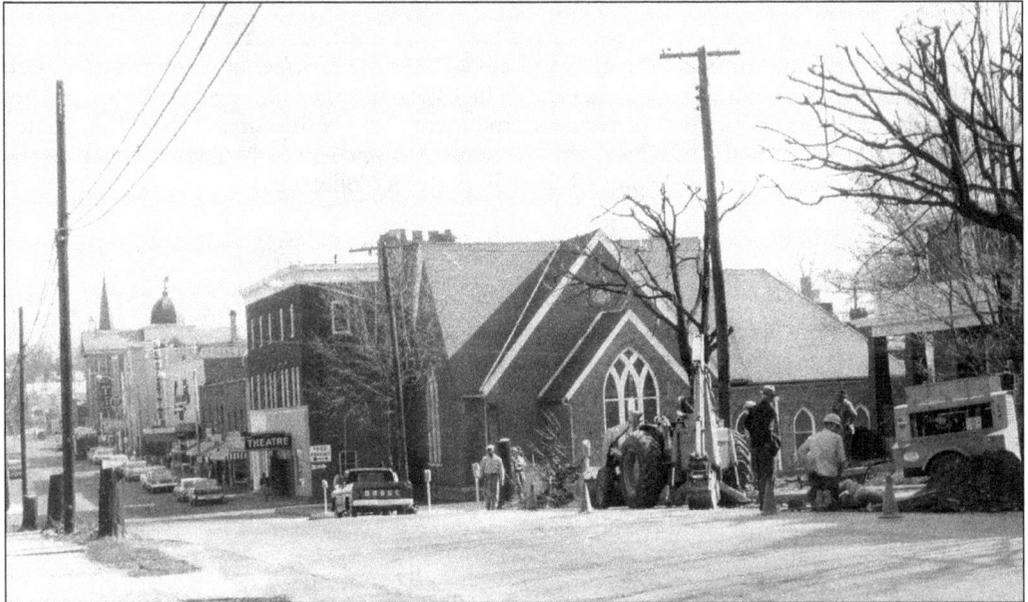

This shot of West Main Street shows the Palace Theater marquee behind the Gothic façade of the Main Street Baptist Church. The courthouse dome in the background is visible at left. The marquee overhung a set of art deco–patterned glass doors. Current movie bills were posted in ornate display cases that flanked the entrance and could be seen from the curb. At the height of its popularity, the theater could entertain 600 guests. (*Montgomery News Messenger* Photographic Archive.)

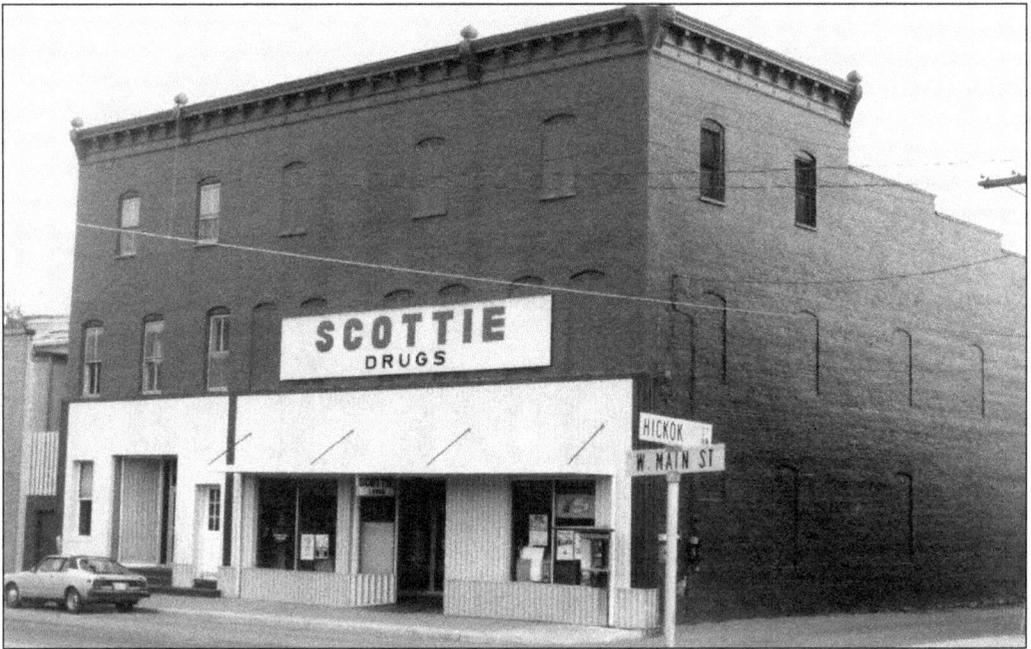

Built in the early years of the 20th century, the Scottie Drugs building was previously home to the Christiansburg Post Office, an automotive company, and Johnson & Janney, a local feed store. Jewel's Photography Studio also occupied space in the building, but its best-known occupant was the Palace Theater, the site of many special events and engagements. An interesting architectural feature was the ornate molding along the roofline. The structure was torn down in the 1980s to make way for a larger medical complex. (Virginia Department of Historic Resources.)

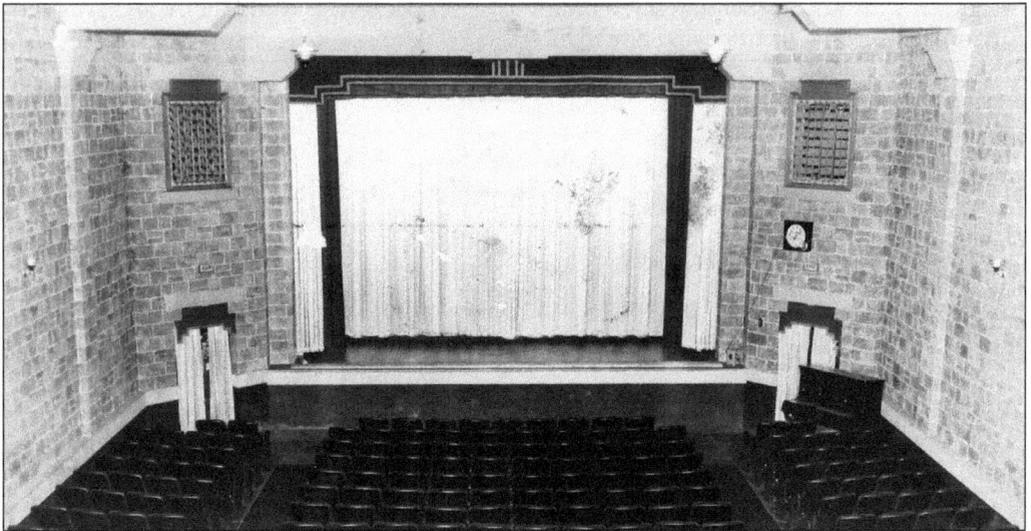

Located at the corner of West Main and Hickok Streets, just a block or two from courthouse square, the entertainment hall was used for theatrical and musical performances. An upright piano is visible to the right of the stage. The Palace Theater succeeded Christiansburg's first movie house, the Wilmont, and installed a cinema screen to accommodate double-feature Westerns and newsreels, punctuated by a cartoon or two. In the 1940s, the cost of a show was a quarter with popcorn included. (*Montgomery News Messenger* Photographic Archive.)

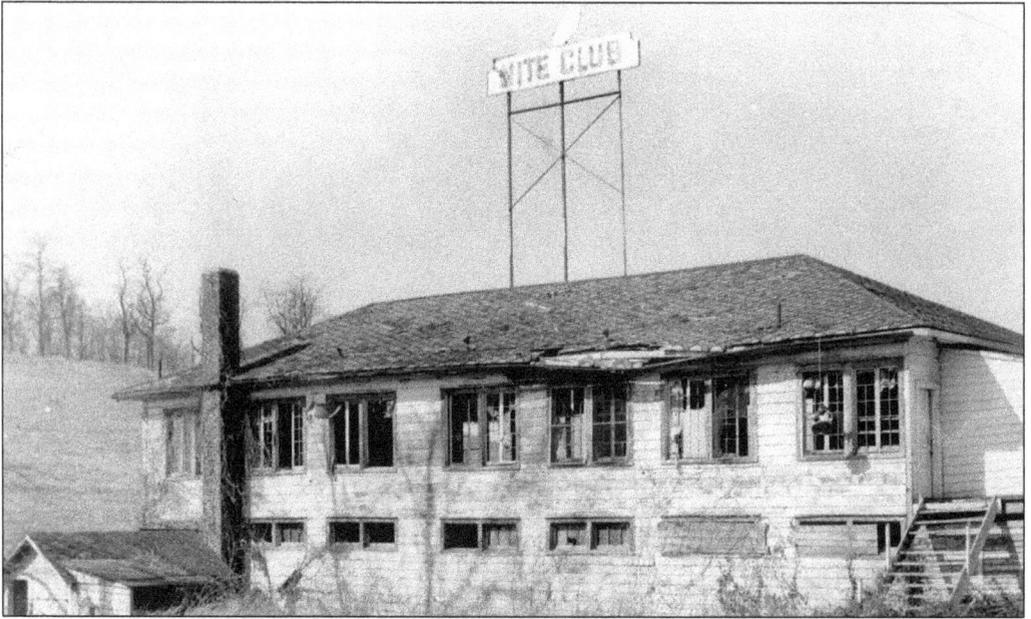

The Silver Lake Nite Club was built by the Economy Lumber Company in the 1920s. The long, rambling structure, located off Radford Road at Silver Lake Road, was a popular site for special events and receptions. Cadets from nearby Virginia Polytechnic Institute would hop a train or pile into an early motorcar to attend dances and rallies at the club. In its heyday, when the grounds were still maintained, local children spent summer afternoons splashing in a naturally fed swimming pool on the opposite side of the building. The club closed in the late 1940s and was destroyed sometime thereafter, leaving only the remains of its swimming pool, today overgrown with weeds. (Southwest Virginia Images Collection, Digital Library and Archives, Virginia Polytechnic Institute and State University.)

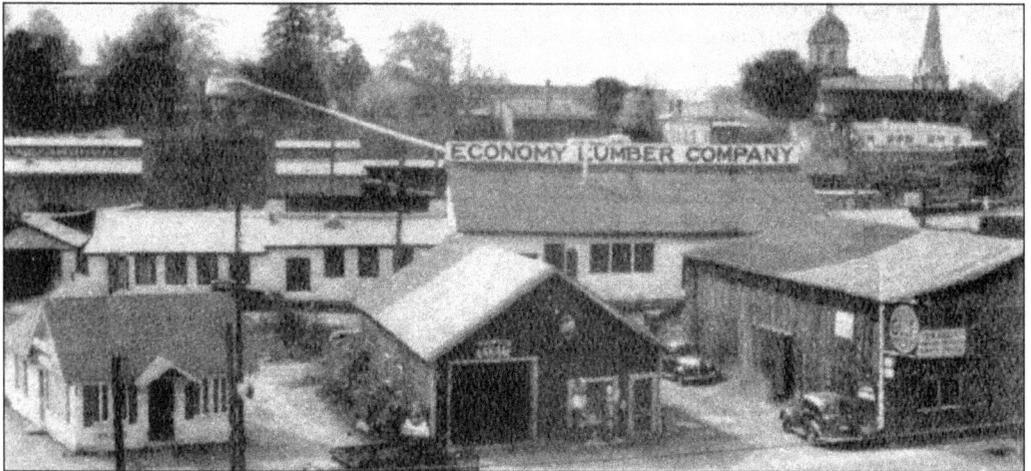

This view of the Economy Lumber Company is taken from Roanoke Street and dates to the early 20th century. The long mill building, workshops, and offices were an impressive spread for southwest Virginia. The company built many of the commercial structures in town and conducted a steady shipping business out of the Cambria depot. Economy Lumber also operated a retail shop at 129 East Main Street. The courthouse dome and Methodist church steeple at upper right are signatures of the Christiansburg skyline. (Horne Family Collection.)

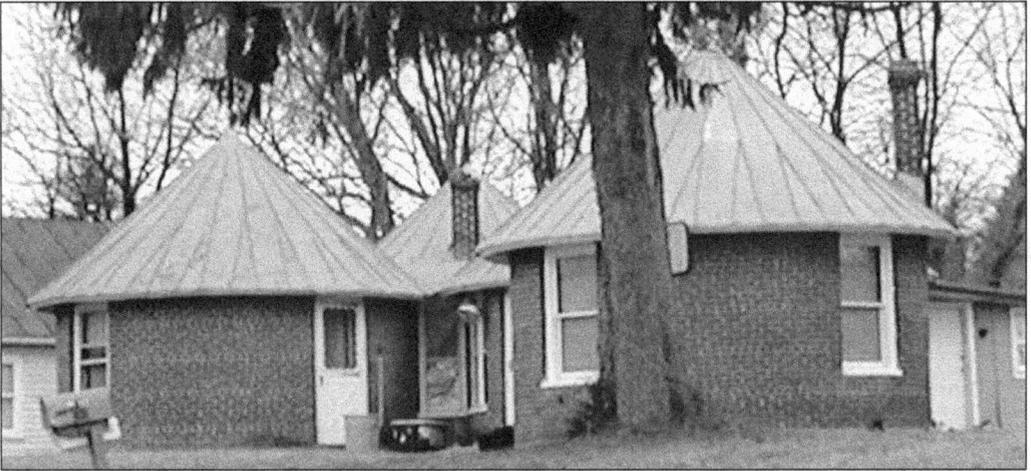

One of the most distinctive residential structures in Christiansburg, the Huts were designed in 1919 by Ethel Rice. Rice and her husband, William, were schooled, met, and settled in Virginia until William's interests took them to Rhodesia (present-day Zimbabwe), where William worked for the British American Tobacco Company. William died overseas, and Ethel returned to Virginia, settling in Christiansburg. She commissioned this architectural design reminiscent of the Zimbabwe countryside. Three adjoining structures are capped with conical roofs, lending to high, vaulted ceilings inside. A separate hut was built for guests in accordance with African tradition. (Photograph by Anna Fariello; courtesy of the author.)

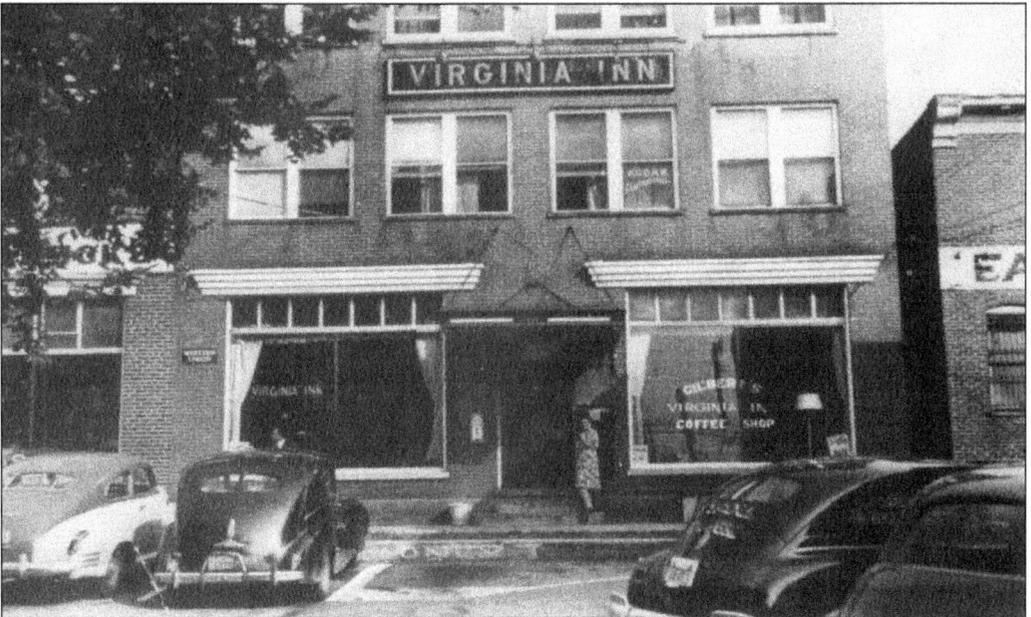

The original brick building on this site across from the courthouse was constructed to house the post office. Later, the building became the Central Park Hotel, an unsuccessful venture that met its fate in flames. Three businessmen constructed another building on the foundation and opened the Barnes-Surface Motor Company. In the mid-1920s, the shop became the town's first Ford dealership and expanded with a new addition to the right. The new wing, shown here, housed a restaurant and hotel. As the Virginia Inn, it operated successfully until the mid-1960s. In that location today is a retail shop called Virginia Inn Antiques. (Horne Family Collection.)

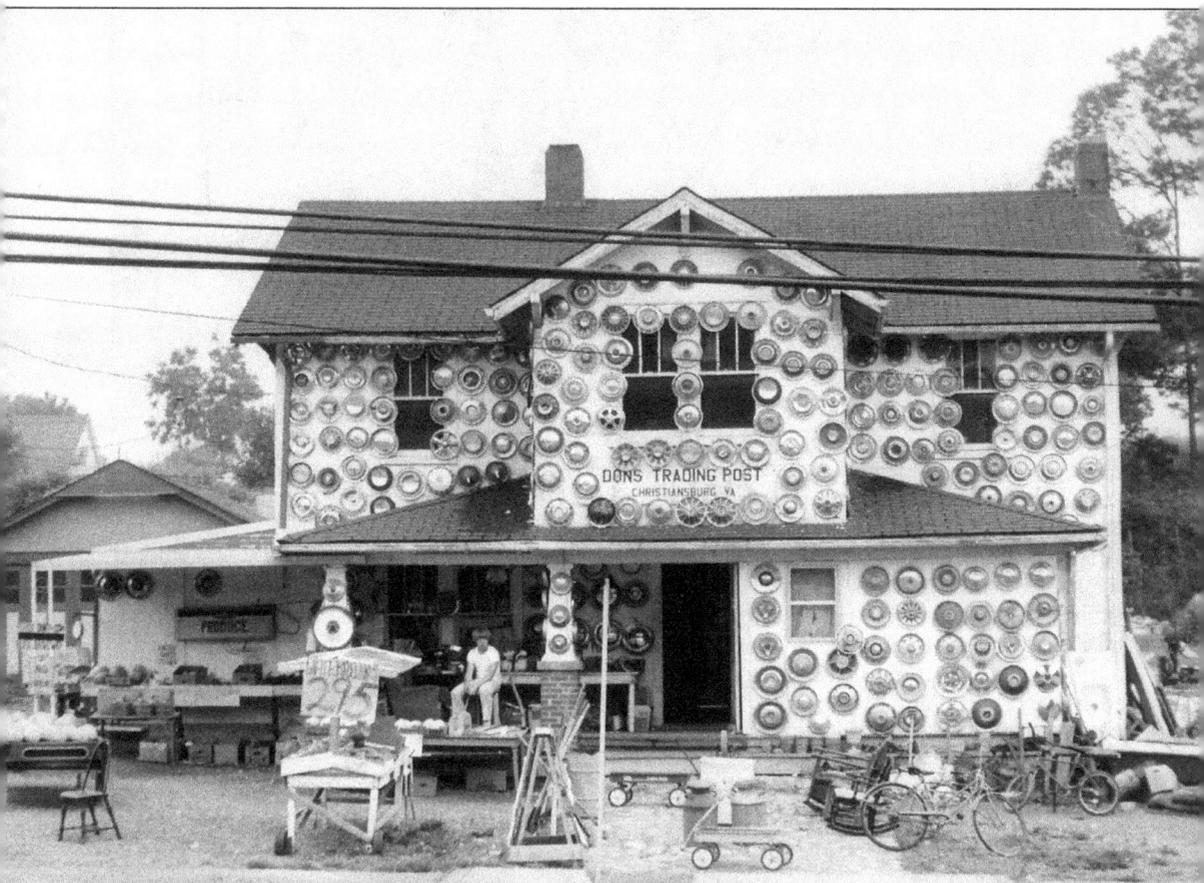

Don's Trading Post was a unique Christiansburg establishment. In the shade of the porch, a young man watches the street, minding the produce stand and items for sale or trade. Watermelon and cantaloupe overflow their bins and baskets. Hubcaps cover every inch of the home's façade. Radio Flyer wagons and old milk cans line the front walk. (*Montgomery News Messenger* Photographic Archive.)

Four

HEALING SPRINGS

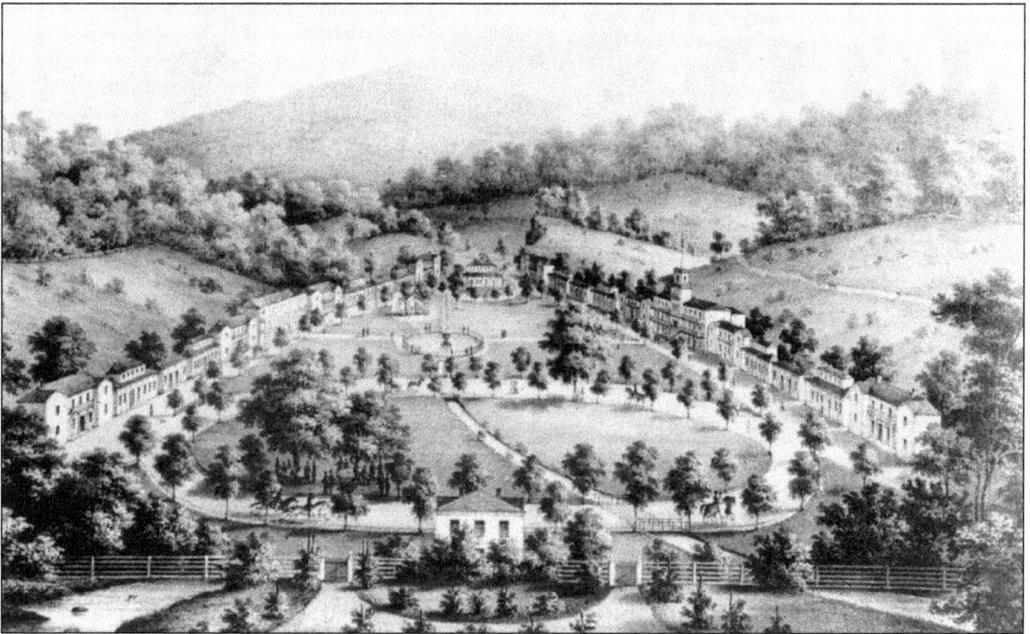

In the early 19th century, Virginia's mountainous west was home to several mineral spring resorts. In summer, the threat of illness prompted prosperous city dwellers to escape to the mountains to take in fresh, clean air and bathe in the purifying mineral springs. Fresh air and clean water were thought to prevent two of the period's most deadly diseases, tuberculosis and yellow fever. Entire families from tidewater and Carolina plantations stayed several weeks or an entire summer. During his Virginia tour, German painter Edward Beyer travelled to the many springs located in southwest Virginia. This sketch preceded the actual construction of the Montgomery White Sulphur Springs. Beyer's 1853 vision of the resort included 20 structures surrounding an ornately landscaped park, complete with fountain, reflecting pool, and racetrack. Although the completed resort was not actually so elaborate, Beyer's portrait conveys the genteel atmosphere associated with many of the springs. (Dorothy H. Bodell Collection, Digital Library and Archives, Virginia Polytechnic Institute and State University.)

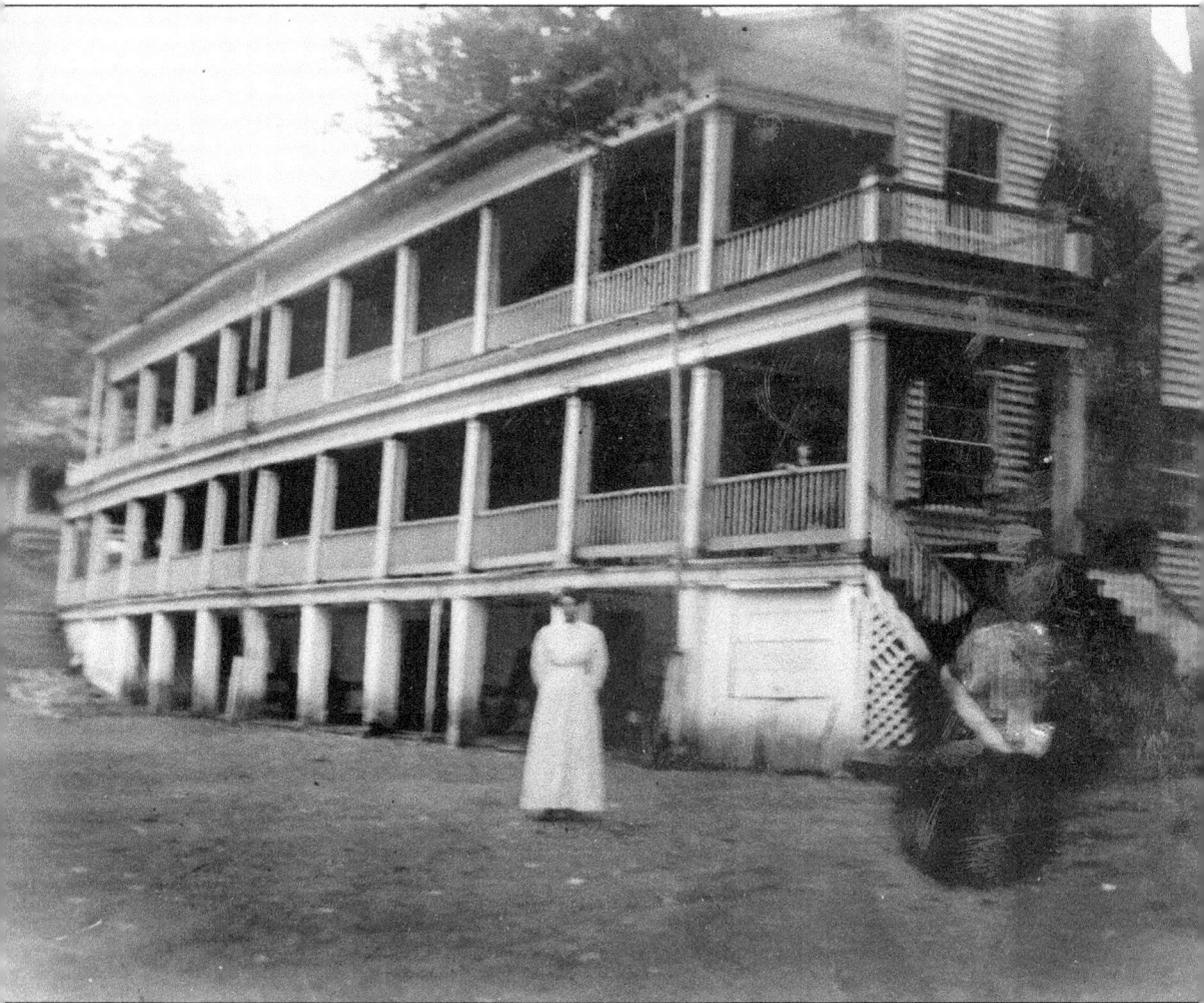

Two restful mountain resorts located on the outskirts of Christiansburg were Yellow Sulphur and White Sulphur Springs. Sulphur water, with its characteristic hard-boiled-egg smell, functioned medicinally in an age before antibiotics. The beginnings of Yellow Sulphur (shown here) date to the early 1800s when Charles Taylor rented a portion of a massive tract of land in a valley a few miles north of Christiansburg proper. On land rimmed with mineral springs, Taylor built a handful of rudimentary log cabins and invited ailing guests to come, stay, and be revitalized. He constructed this large two-story hotel building in 1810. (Southwest Virginia Images Collection; Digital Library and Archives, Virginia Polytechnic Institute and State University.)

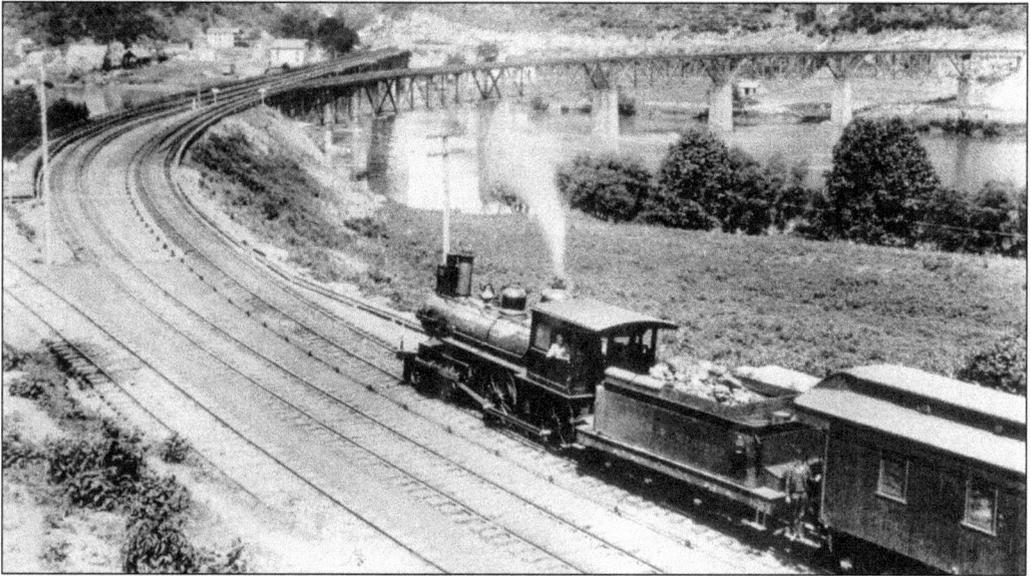

As new rail lines were constructed and rail travel became increasingly popular, interest in the springs boomed. In the 19th century, the Virginia Tennessee rail line was extended through the region, crossing over the New River on this bridge constructed in 1888. The town of New River (at left) grew and then disappeared after the bridge was demolished in 1905. (Southwest Virginia Images Collection, Digital Library and Archives, Virginia Polytechnic Institute and State University.)

Arriving at the resort, guests registered and recorded the time of their arrival. This page, from a late summer afternoon, shows that visitors from Philadelphia and Richmond came to the resort as well as local guests from Montgomery County. Advertisements surrounding the page propose to sell a variety of goods, from pianos to "drugs, chemicals, etc." As the railroad continued to develop, during the high season, wealthy guests traveled a kind of spa circuit, visiting several resorts for short periods of time. (Southwest Virginia Images Collection, Digital Library and Archives, Virginia Polytechnic Institute and State University.)

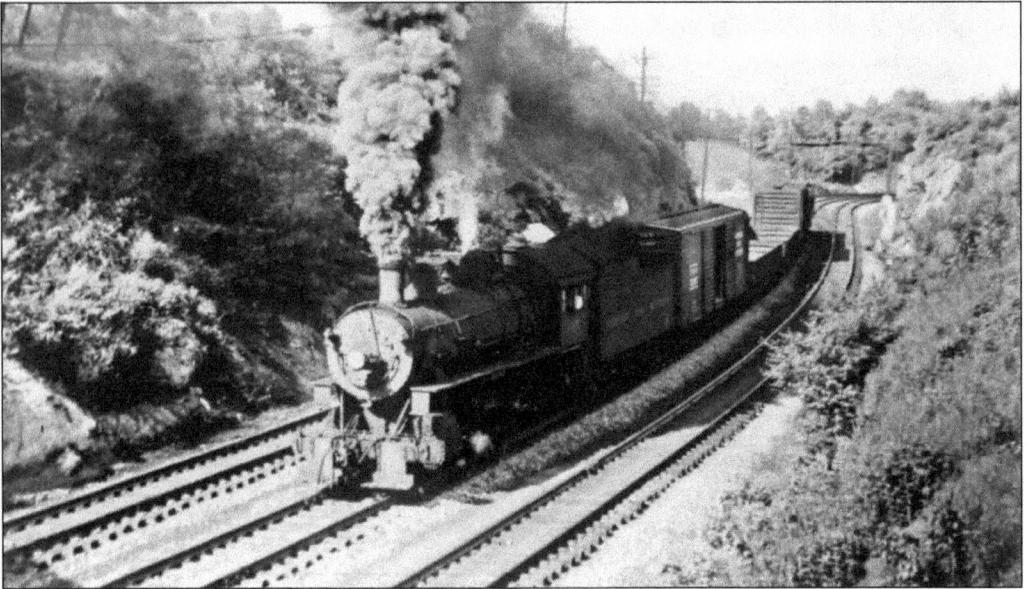

Most of the advertisements that appear along the boarder of the Yellow Sulphur Springs guest register were placed by businesses in Lynchburg. Steam trains rolled in from Lynchburg, linking Christiansburg to the state capital at Richmond and the industrial center at Petersburg. The rail system had a sweeping and positive impact on the economy across the state. (Charles Aliff Railroad Collection, Digital Library and Archives, Virginia Polytechnic Institute and State University.)

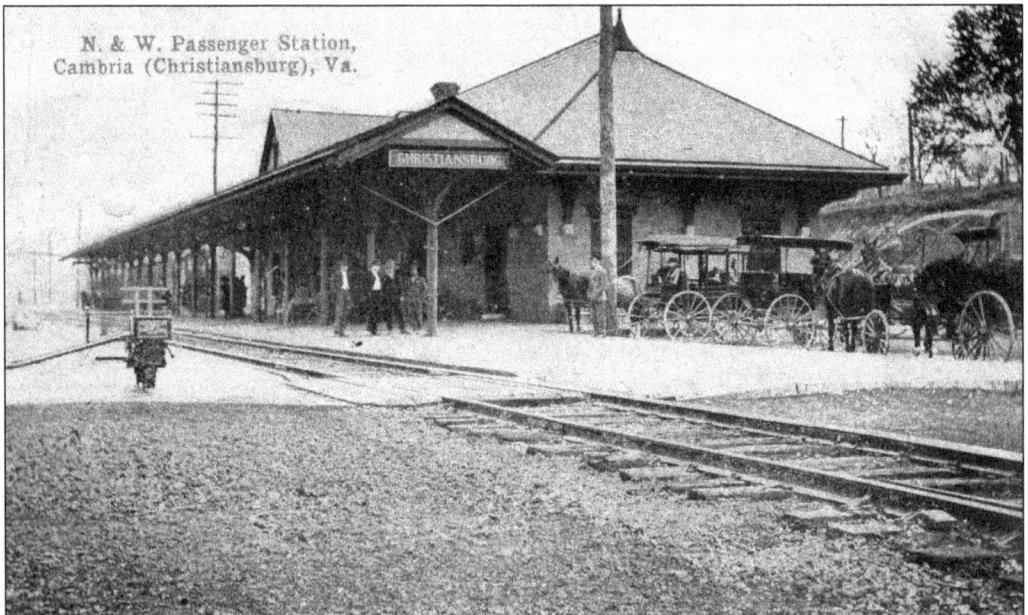

Many visitors arriving at the Christiansburg Depot from points east and west were bound for one of the local resorts. At the depot, travelers boarded a wagon to carry them and their belongings, bumping and jolting along the newly constructed turnpike, to their mountainside destinations. This portrait of the station shows carriages (at right) lined up to meet passengers arriving on the next train. (History Museum of Western Virginia's Clare White Library Collection.)

The Civil War halted the summer vacationing of the resort-going crowd. Many mountain spas sat empty long enough to fall into serious disrepair. White Sulphur Springs, however, was used steadily throughout the duration of the war, its buildings put to wartime uses. The resort was converted to a headquarters and hospital for Confederate troops. The Sisters of Mercy traveled by rail to supply nursing staff to the 400 soldiers recovering at the medical center. The elegant quarters, attractive grounds, and mountain air were a sharp contrast to the harrowing events of the battlefield. (Dorothy H. Bodell Collection, Digital Library and Archives, Virginia Polytechnic Institute and State University.)

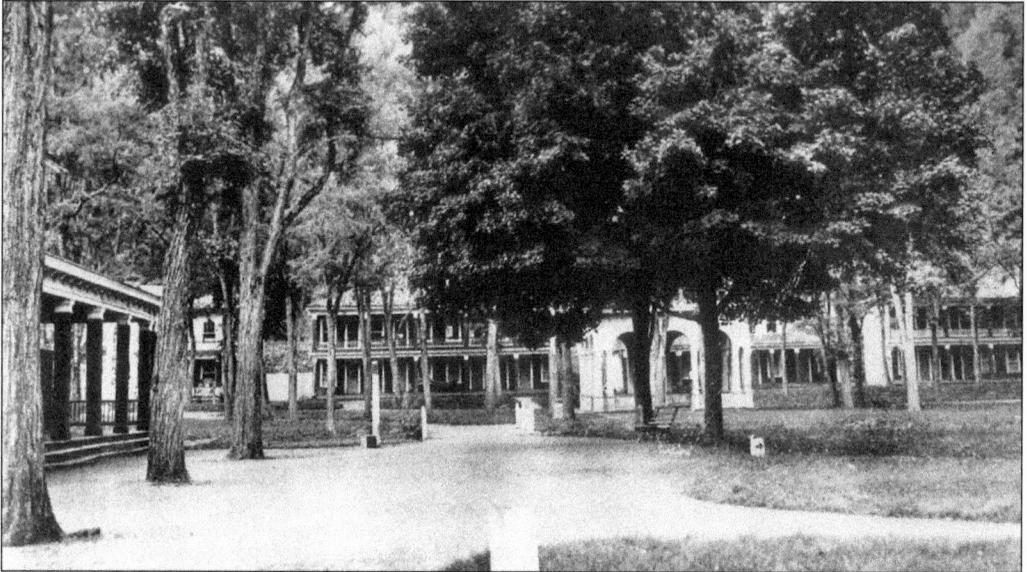

At the close of the war, the resort was left decayed and in debt. Two young entrepreneurs purchased the property, renovated it, and added more modern conveniences. A new hotel building, more than 100 feet across, was constructed to include a dining room of the same length, three parlors, a gala hall, and 16 guest rooms. The grounds accommodated individual cottages of varying sizes. All residential appointments were furnished with outdoor porches so that guests could enjoy the purifying mountain air at their leisure. (Harry Temple Collection, Digital Library and Archives, Virginia Polytechnic Institute and State University.)

41

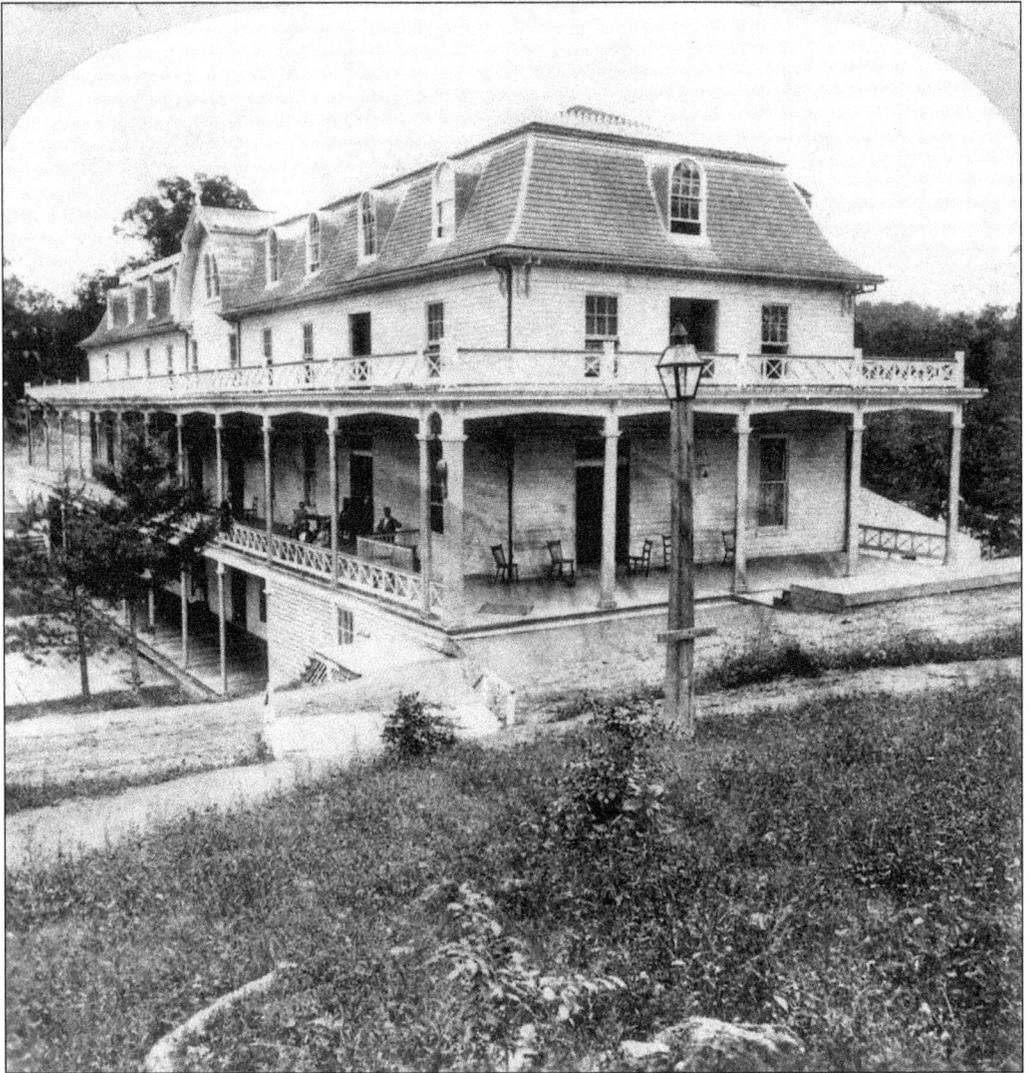

The grounds of Yellow Sulphur were quiet during the War between the States. When the conflict ended, the economy gradually rebounded and travelers began to come again for rest and recreation. The original frame hotel building was torn down and reconstructed in 1871 with 40 guest residences, dining and gaming spaces, and a formal ballroom. (Harry Temple Collection, Digital Library and Archives, Virginia Polytechnic Institute and State University.)

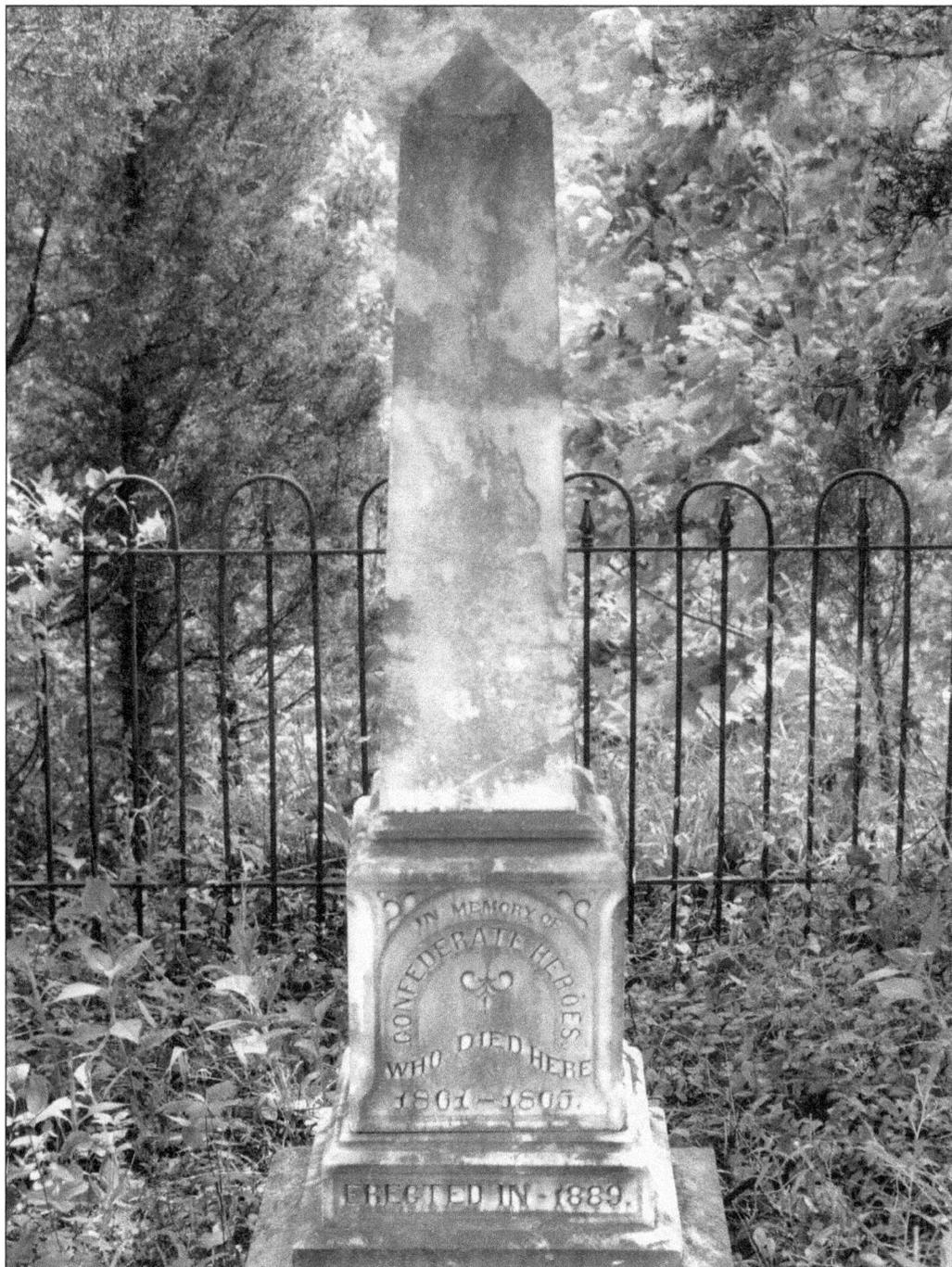

This Civil War memorial was erected on the grounds of White Sulphur Springs in 1889, on a tiny plat of land enclosed by a wrought-iron fence. The monument's inscription reads, "In Memory of Confederate Heroes Who Died Here—1861–1865." A smaller marker was installed by the local Daughters of the Confederacy during the 1940s. Although nothing is left of the old resort, the markers are located at the foot of Christiansburg Mountain on Den Hill Road. (Photograph by Earl Palmer; Special Collections, McConnell Library, Radford University.)

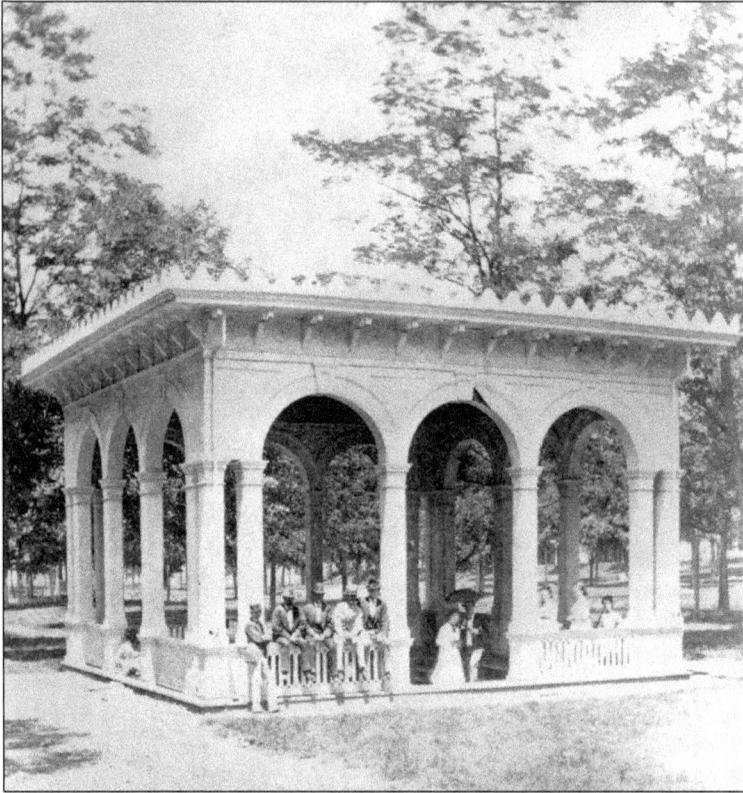

By the 1880s, the resorts were again in full swing, complemented by the region's booming economy and railroad development. The spas received guests from the South's major cities and from locations as far west as Salt Lake City, Utah. The hotels, cottages, and grounds were an idyllic vision. Guests strolled about the walking paths, took leisurely carriage rides, and spent long afternoons in the shade of this elegant gazebo. (Dorothy H. Bodell Collection, Digital Library and Archives, Virginia Polytechnic Institute and State University.)

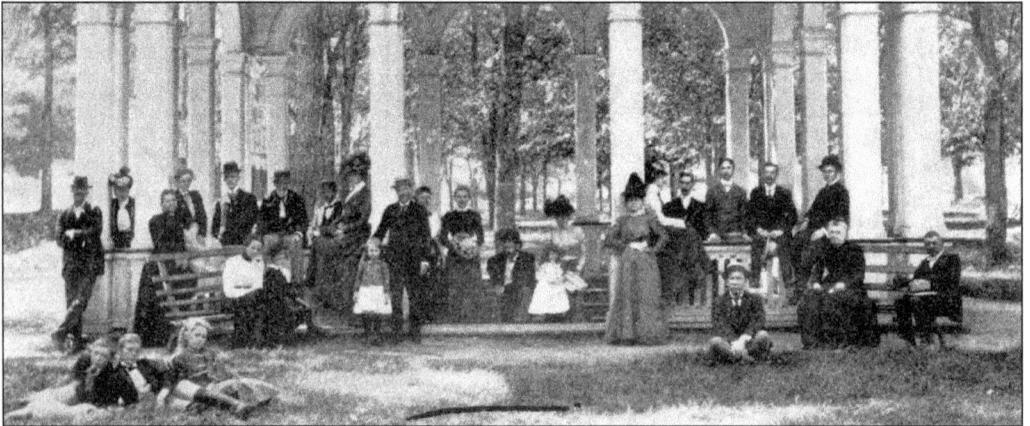

White Sulphur Springs was favored by Civil War veterans as a reunion site in the years following the war. Famed Southern general Jubal Early owned a cottage at nearby Yellow Sulphur and hosted social events there as well. Early is credited with having established the Southern Historical Society in 1873. White Sulphur Springs hosted the critical 1872 meeting of the Board of Supervisors that organized Virginia Agricultural and Mechanical College, now Virginia Tech. (Dorothy H. Bodell Collection, Digital Library and Archives, Virginia Polytechnic Institute and State University.)

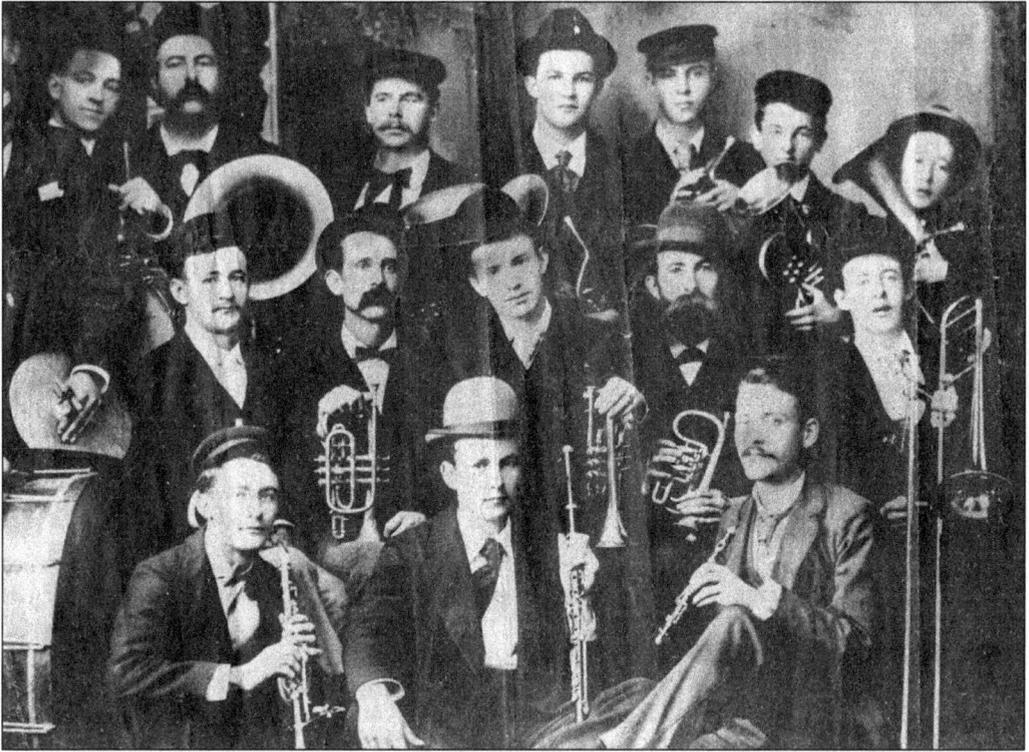

As the century wore on, the resorts became as famous for their entertainment and recreational programs as for the healing treatments of their mineral waters. Both resorts had large banquet halls and ballrooms. Brass bands, like this one from Christiansburg, traveled to resorts for high-profile engagements. Pictured here, from left to right, in 1890 were (front row) B. Walters, G. Haley, and R. Charlton; (middle row) O. Garner, R. Martin, T. Ragan, M. Dunkley, and F. Dunkley; (back row) C. Bingham, J. Galloway, J. Dunkley, C. Humphries, B. Page, L. Jewel, L. Walters, and D. Dunkley. (Southwest Virginia Images Collection, Digital Library and Archives, Virginia Polytechnic Institute and State University.)

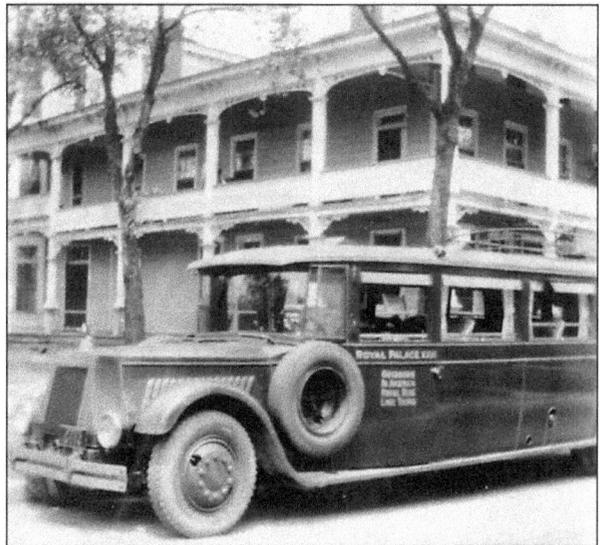

This photograph depicts an extended automobile, a precursor to today's stretch limousine. The car, with its multiple seats, was an early form of mass transit for the region. The Royal Palace Transport and Touring Company advertised "Outdoors in America," painted on the driver's door. The service carried a full load of passengers to and from the resort springs. For a bit extra, city folks could take a country tour. (Robert B. Basham Collection.)

In 1866, Capt. Ridgway Holt purchased the declining property at Yellow Sulphur Springs and constructed a new, dramatic hotel with 60 rooms under an ornately decorated roofline. For almost 50 years, the resort flourished. While the automobile made it easier for guests to reach the springs, it allowed families to travel farther afield. As cures were developed for the illnesses that mandated mountain rest, Yellow Sulphur Springs closed for good in 1923. It was used again for a brief period during the Great Depression as a camp for the Civilian Conservation Corps. While there, the corps restored many of the buildings. Part of the original hotel building still stands on private property. (Southwest Virginia Images Collection, Digital Library and Archives, Virginia Polytechnic Institute and State University.)

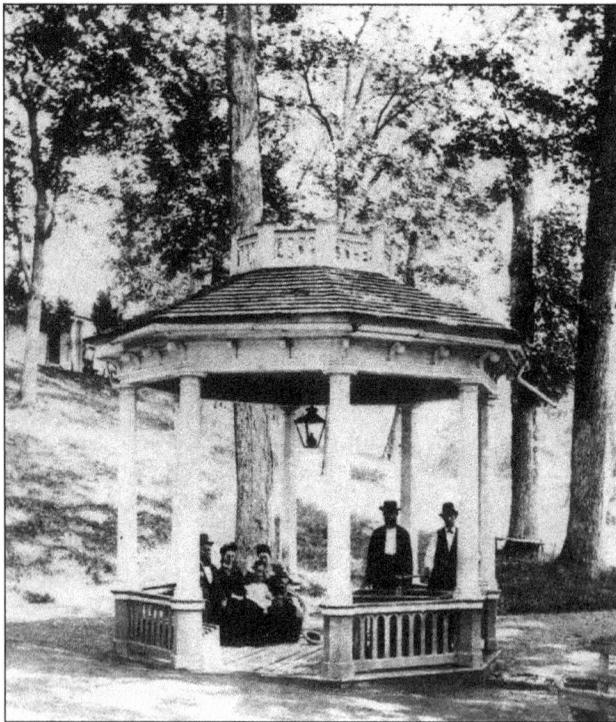

This gazebo at Yellow Sulphur Springs was built during the post–Civil War reconstruction of the resort. Reflecting the elegance of the Victorian tradition, guests gathered under the gazebo, comfortable in the shade and surrounded by old trees and filtered sunshine. The mountain spas' glory lasted briefly, curtailed by social progress and natural disaster. Yellow Sulphur was damaged by fire and White Sulphur was destroyed by a flash flood in 1902. Many of the mineral spas in the region followed a similar path, rising with the course of the railroad, lulling with the war, rising again with the peace, and at last, fading away. (Harry Templeton Collection, Digital Library and Archives, Virginia Polytechnic Institute and State University.)

Five

COMING OF
THE RAILROAD

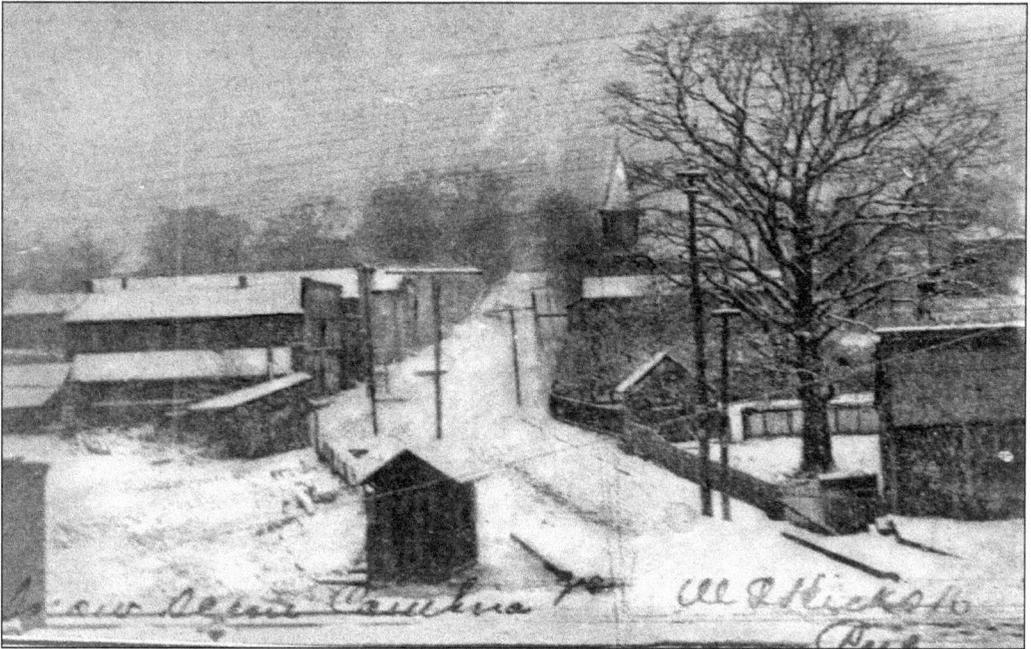

Christiansburg was already situated near the crossroads of two major byways—the Wilderness Trail and the Great Wagon Road—when the railroad arrived in the mid-19th century to transport agricultural commodities and coal from source to supplier. In 1854, the Virginia Tennessee Company laid tracks through the valley. The thriving Montgomery County seat was adamant that a train would not run directly through its cultivated community center and suggested a compromise. It was agreed that the rail depot would be constructed just over the hill and out of sight. In the wake of construction, a populous community developed around the rail stop. Known as Christiansburg Station, the area was also called Bangs. This 1916 painted snow scene is dated and signed by W.L. Hicks. (Earl Palmer Collection, Digital Library and Archives, Virginia Polytechnic Institute and State University.)

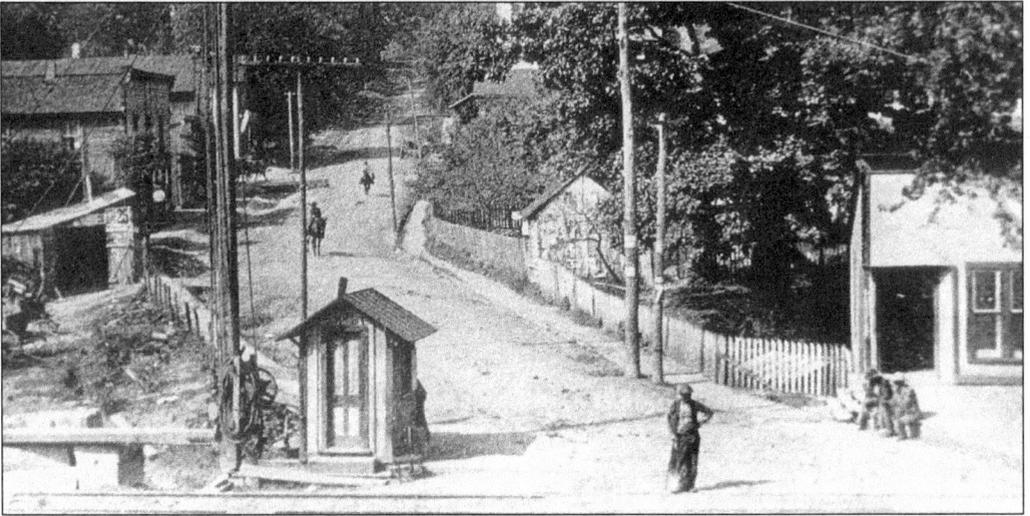

Bangs was formally renamed Cambria in 1892 and incorporated in 1906 as Montgomery County's third largest town. The origin of the name "Bangs" has been attributed to the rowdy rail workers, a Welsh nickname, and to the geological period responsible for the local land formation. In spite of its speculative beginnings, the area grew to become a well-known commercial crossroads. The small building at left was labeled as the watchman's house on an early map of the town. An 1890s telegraph station was located some distance down the tracks, east of the depot. This photograph depicts Cambria as it appeared in 1904. (Southwest Virginia Images Collection, Digital Library and Archives, Virginia Polytechnic Institute and State University.)

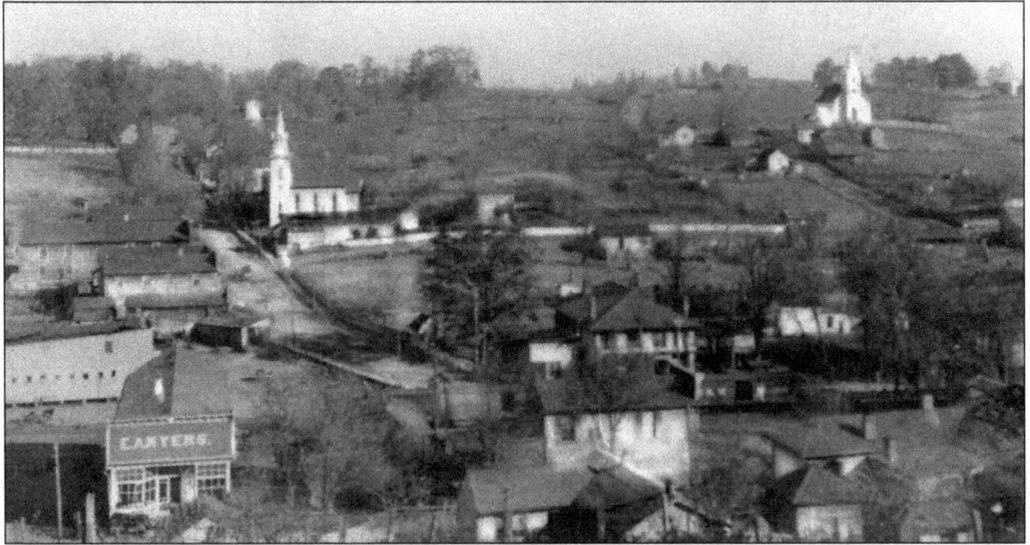

This view of Cambria was taken from High Street around 1910. Note the E.A. Myers storefront and the bright steeple of the Cambria Baptist Church, just a mile up the street from the depot. The white frame church was built in 1885, destroyed by fire in 1927, and replaced the next year by a more durable brick building erected at the same location. The small white church to the right may be the Cambria Methodist Episcopal, which appears on a map of the town made in 1926. Not only has the townscape changed significantly, but the landscape has filled in with so much foliage that the view afforded by this photograph is inaccessible today. (Mr. and Mrs. Richard Roberts Collection.)

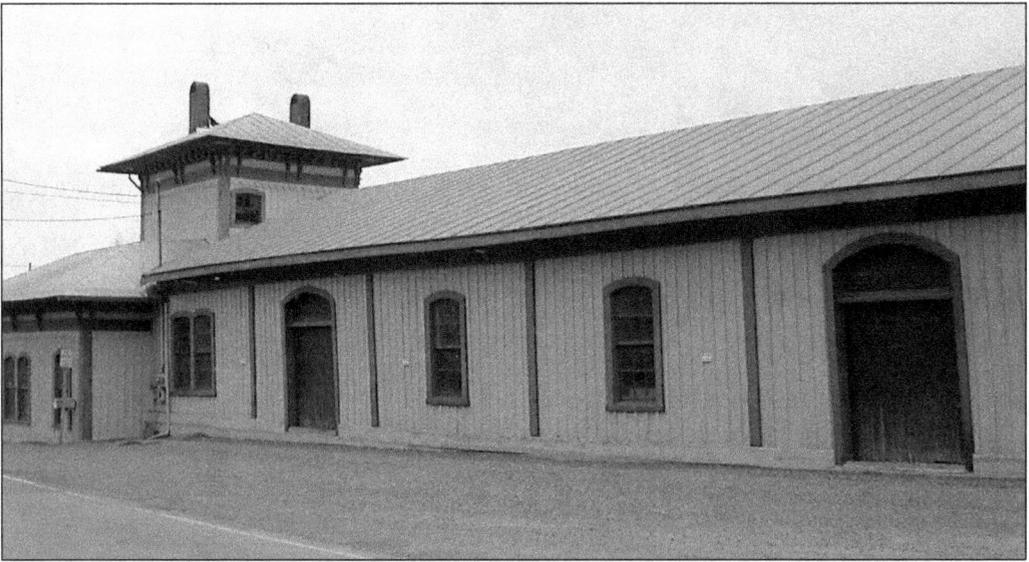

Cambria, with its general stores, furniture factories, mills, and dairy, conducted a steady business of shipping and receiving. In 1854, an Italianate frame building was constructed to accommodate passengers and goods. The restored depot station is the only intact wooden depot and one of a few structures along Virginia's rail line to survive the Civil War. (Photograph by Anna Fariello; courtesy of the author.)

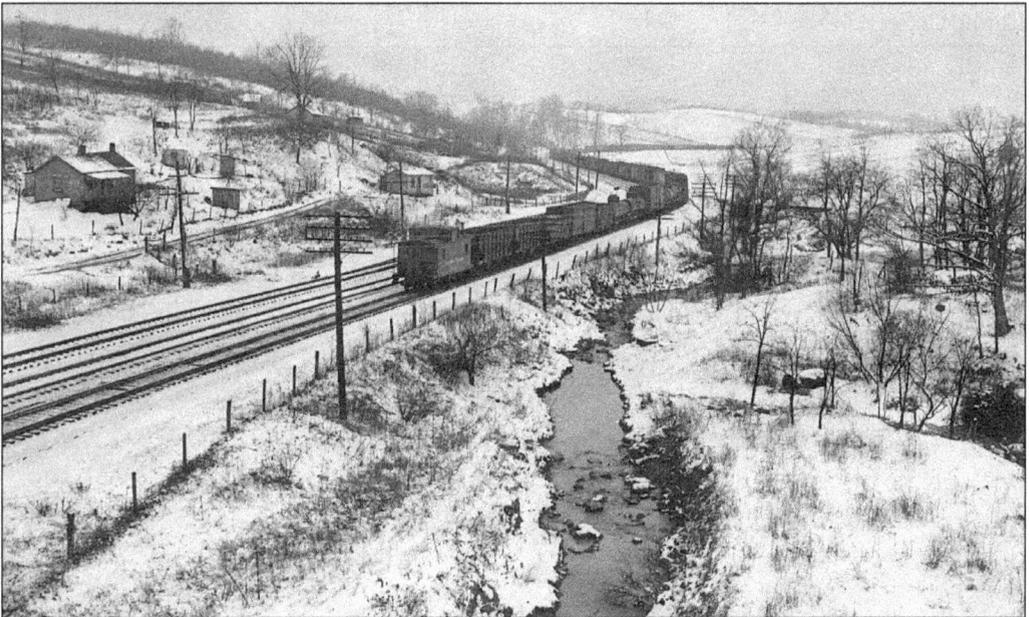

In 1883, the Virginia Tennessee Company constructed an extension to link Montgomery County with the rich coalfields of Pocahontas and West Virginia. The track followed the banks of Crab Creek into Christiansburg, transporting coal from West Virginia mines at the height of their production. This photograph of a westbound train, traveling on the track between Railroad Avenue and Crab Creek, is taken from the site of present-day Route 460. (Norfolk & Western Historical Photograph Collection, Digital Library and Archives, Virginia Polytechnic Institute and State University.)

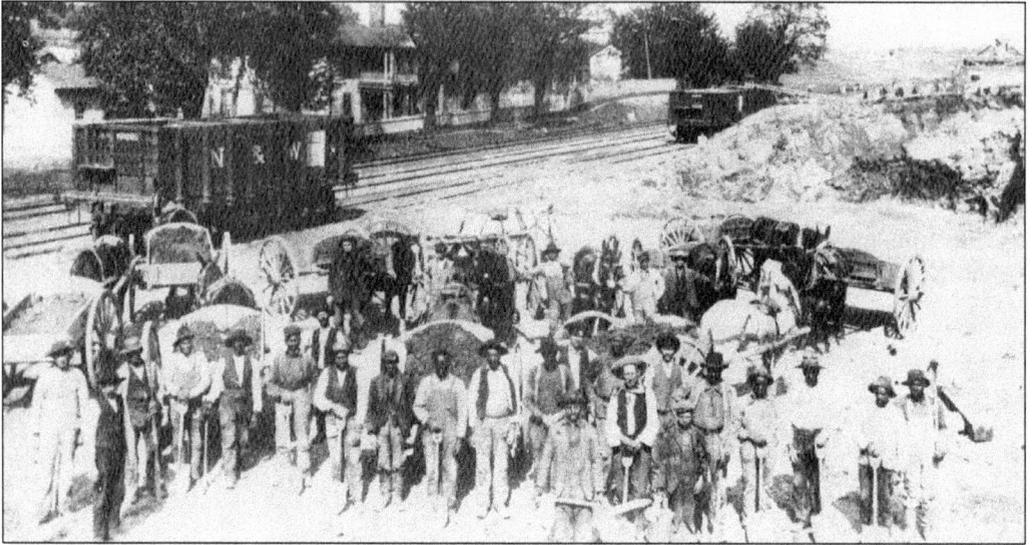

Since its construction in the 19th century, the depot at Christiansburg Station served passengers and freight out of the same facility. After the turn of the century, an additional station was built, separating travelers from freight and contributing to the comfortable ambiance that would come to characterize rail travel in its heyday. This 1910 image depicts a crew on break from construction of the new Norfolk & Western building. The workmen pose with their tools and wagons in front of the framed roof of the passenger station, visible at the right. (Horne Family Collection.)

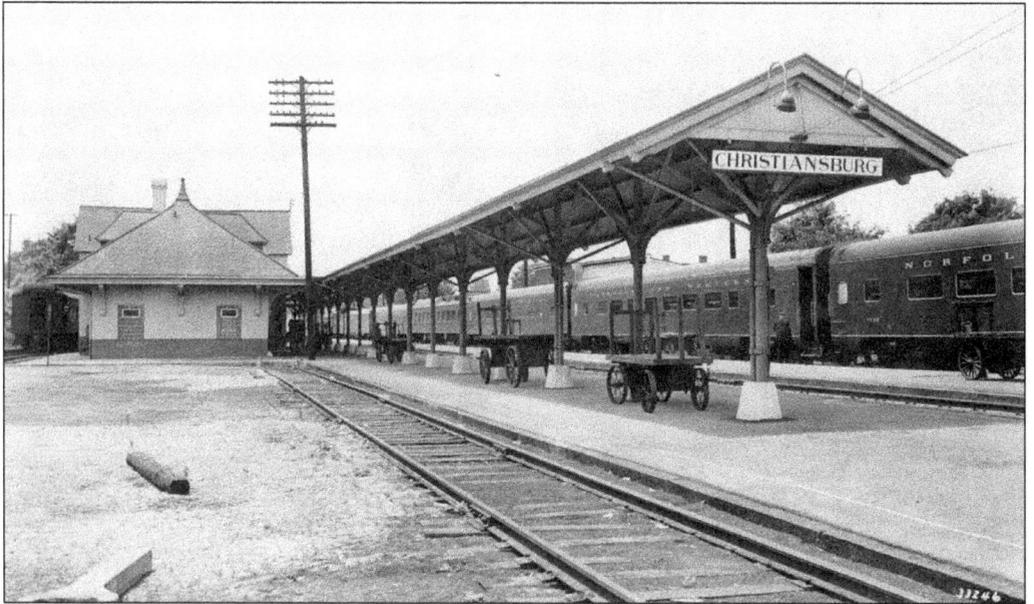

The completed passenger station was typical of the period, with its frame galley running the length of the track. Under the shade of the wide awning, Christiansburg residents readied their belongings to board out-going trains or waited excitedly for expected arrivals. In this 1949 photograph, wooden carts stand in waiting for their loads of luggage and goods. (Norfolk & Western Historical Photograph Collection, Digital Library and Archives, Virginia Polytechnic Institute and State University.)

50

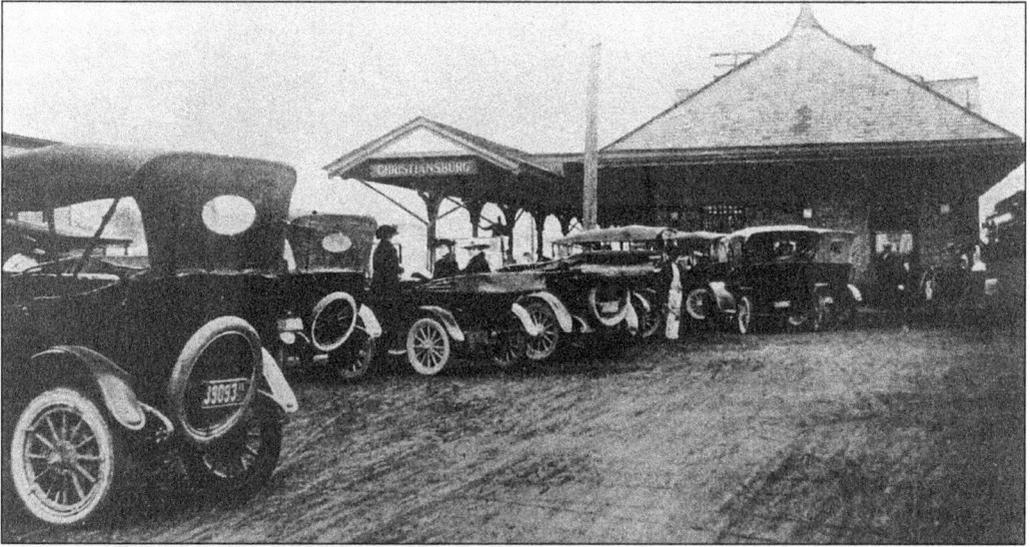

The Ford Model Ts, with their canvas tops, wooden wheel-spokes, and white-walled tires, date this depiction of the passenger station to the early 1920s. Half a century later, the Cambria community would become part of the town of Christiansburg; the depot sign on the station is a hint of that merger to come. Located just one mile north of the courthouse square, the rail stop was referred to as North Christiansburg or Christiansburg Station. East Main Street connected the courthouse square on one end and the passenger station at the other. (Southwest Virginia Images Collection, Digital Library and Archives, Virginia Polytechnic Institute and State University.)

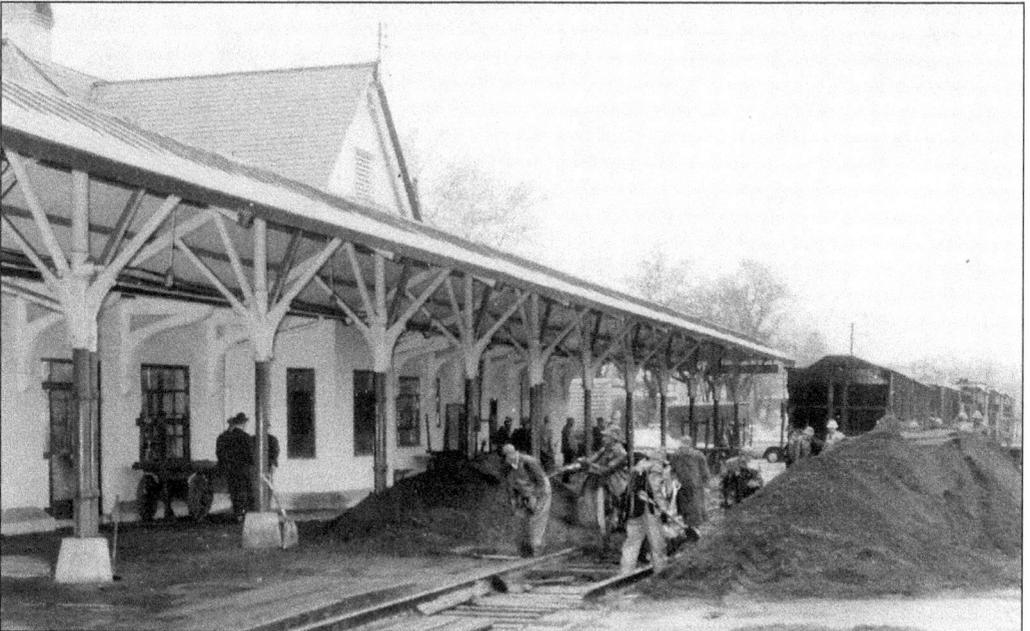

The men working beside the Norfolk & Western passenger station are "lining" the tracks. Railroad tracks, laid in sections, had to be periodically adjusted to keep trains running safely. Men with pry bars worked an end of each section to align the tracks. To synchronize their movements and make their labor more efficient, linemen sang work-themed songs with a strong rhythmic beat. (*Montgomery News Messenger* Photographic Archive.)

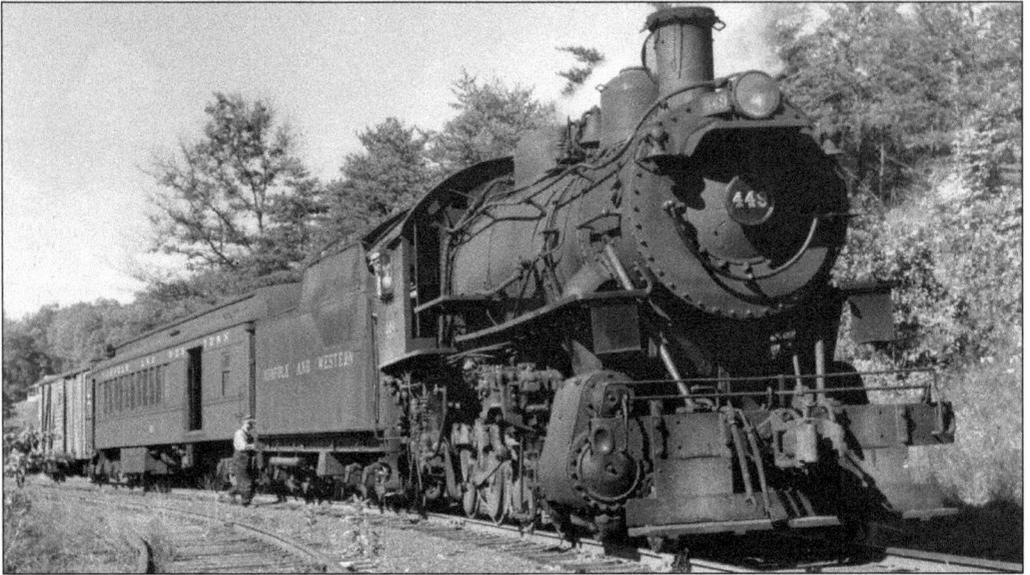

The railroad company named steam locomotives for towns that they passed through. The "Roanoke" often traveled through Cambria in the mid-19th century. Later, when tracks were laid between Blacksburg and Cambria, the "Huckleberry" was a familiar local engine. It made a daily run hauling goods and passengers to and from Blacksburg, connecting Virginia Polytechnic Institute with a powerful coal supply and early cadets with the main rail lines running from Norfolk to Cincinnati. (Special Collections, McConnell Library, Radford University.)

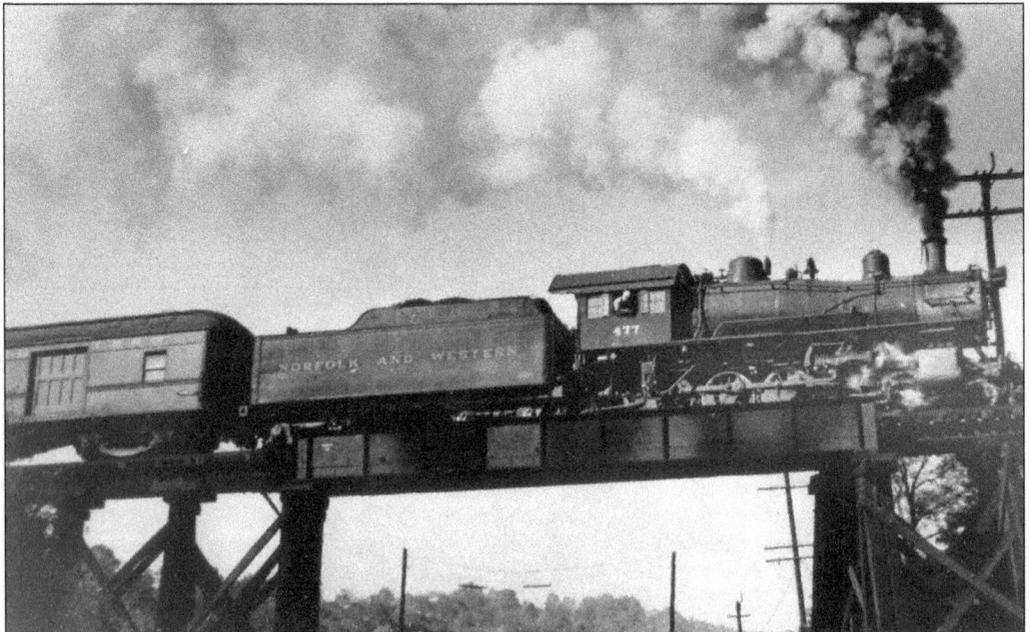

In this photograph, the familiar "Huckleberry" crosses a trestle at Ellett, north of the Cambria station. The rumor is that the steamer got its name because its rate of travel was slow enough that passengers could hop off to pick berries growing along the track and run to re-board the train before it could get away. In late August 1958, the "Huckleberry" made her last run. (John Kline Collection.)

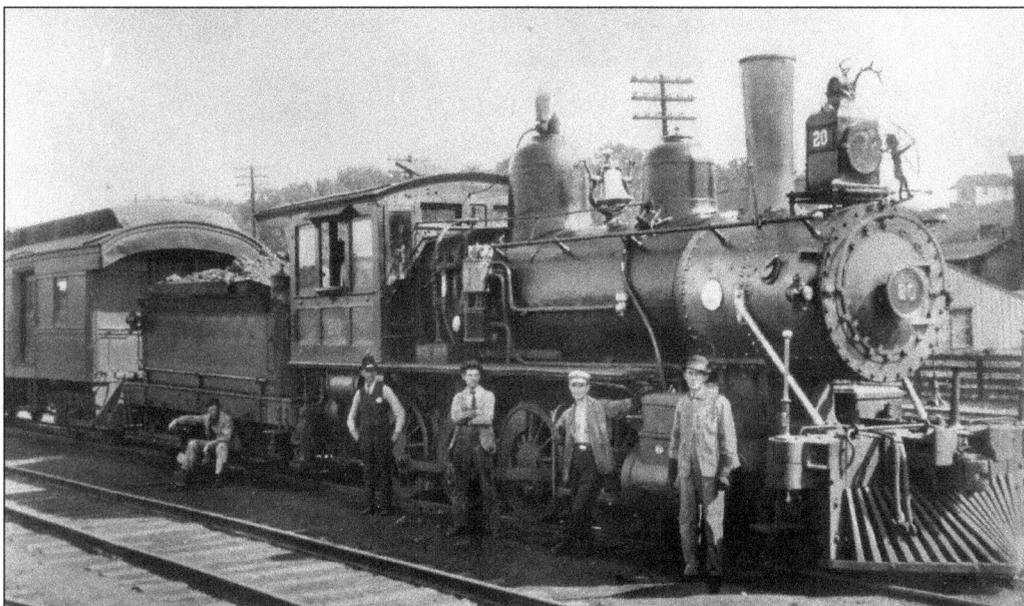

The "Huckleberry" crew posed in front of a steam engine that pulled its own small coal car piled high with fuel. Nineteenth-century engines were made with protruding fronts that helped push any accumulated debris off the tracks to prevent deadly derailments. Note the decorative additions at the front of the engine—a Native American with bow and arrow—no doubt put there by workmen such as these. (Mr. and Mrs. Richard Roberts Collection.)

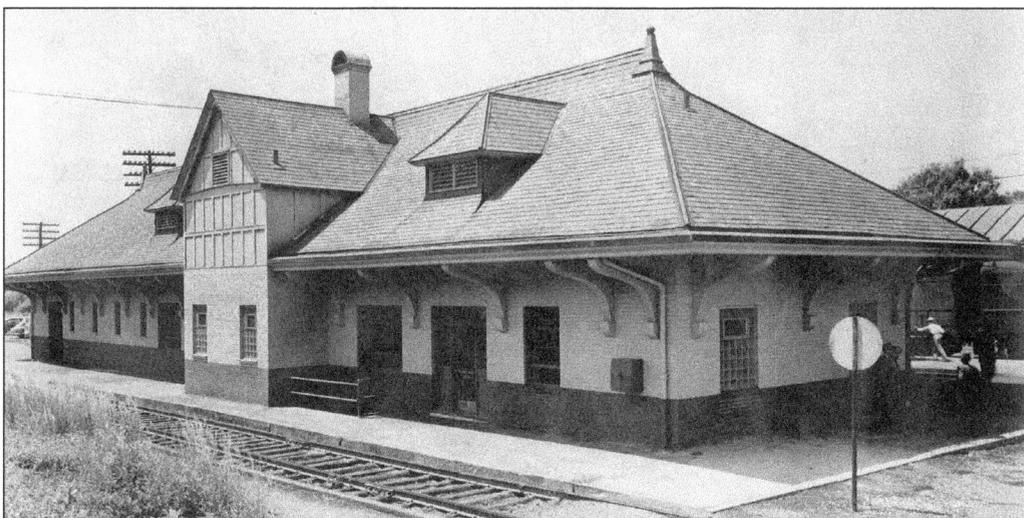

The 20th century saw the completion of a new interstate highway system serving families and professionals who traveled by automobile rather than by train. The advent of common car travel altered the atmosphere of rail stations throughout the region; discontinued passenger service cemented the change. Although the freight depot would continue to be used until 1960, the commercial center eventually lost the colorful exuberance that accompanied travelers dashing in with suitcases or waving with teary handkerchiefs as the train cars pulled away. Today, both stations are listed on the State and National Registers of Historic Places. (Norfolk & Western Historical Photograph Collection, Digital Library and Archives, Virginia Polytechnic Institute and State University.)

53

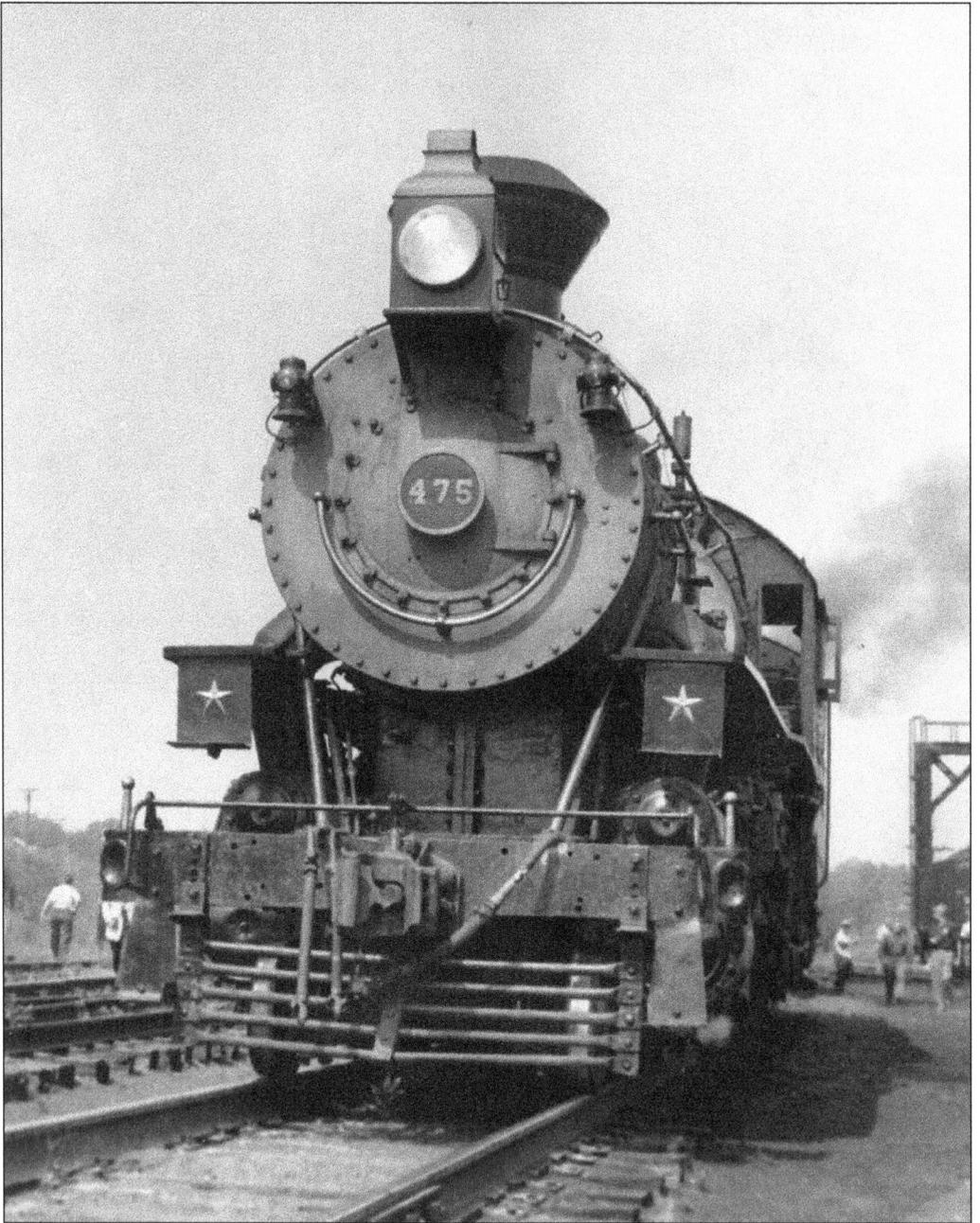

Norfolk & Western was the last Class A rail line to stop using steam engines. The depot would sorely miss the rush of steam from the stack and the cry of the whistle blowing from the Baldwin locomotive. Steam trains were brought back to life briefly, traveling their old track, on special excursions in the late 1970s and 1980s. (Photograph by Earl Palmer; Special Collections, McConnell Library, Radford University.)

SOUTHERN EXPRESS COMPANY.

EXPRESS FORWARDERS TO ALL PARTS OF THE COUNTRY.

Receives and Forwards Gold, Silver, Bullion, Currency, Valuable Packages and Freight, in Charge of Competent Special Messengers. Connects with Responsible Express Companies for all parts of the United States and Canada.

Christiansburg, Va. N. & W. NO. 4 9 — 8 1900

Va. P. Eng.

To **The Southern Express Company,** Dr.

For Transportation on 4 Carboys. 125

From Boston, to Christiansburg, Va. N. & W. NO. 4 $ 3.75

Advance Charges,

Received Payment for Southern Express Company. O. E. Lane

THE SOUTHERN EXPRESS COMPANY,

EXPRESS FORWARDERS TO ALL PARTS OF THE COUNTRY.

THE SOUTHERN EXPRESS COMPANY

AND ITS IMMEDIATE CONNECTIONS,

Represent 117,000 Miles of Express Routes, and Over 15,000 Agencies,

—WITH—

Lines in 46 States and Territories and the British Provinces, and Connections with European Expresses.

All matter shipped by Southern Express Company is forwarded in charge of experienced Messengers by the fastest trains.

Goods are handled at offices and en route with due care and consideration.

☞ This old responsible Express Company and its connections afford the QUICKEST and the SAFEST means for the transportation of CURRENCY, GOLD, SILVER, BULLION, JEWELRY, and VALUABLES of all descriptions, FREIGHT, PARCELS, &c.

Collections made with or without goods.

Favorable Rates on Farm Products, Fruit, Vegetables, Butter, Eggs, Etc., and Game, Fish and Osters.

REDUCED RATES ON ALL CURRENCY OR GOLD COIN REMITTANCES.

$ 20, or less	6c	$ 150 ... 25c to 60c
40	20c	175 ... 30c to 75c
50	25c	200 ... 30c to 85c
70	25c to 30c	225 ... 35c to 90c
80	25c to 40c	250 ... 35c to $1.00
100	25c to 45c	300 ... 35c to $1.25
125	25c to 50c	Larger sums in such smaller proportion.

Merchandise Packages at Low Rates where the Value does not Exceed $50.

1 Pound	25c
Over 1 pound to 2 pounds	25c to 30c
Over 2 pounds to 3 pounds	25c to 45c
Over 3 pounds to 4 pounds	25c to 60c
Over 4 pounds to 5 pounds	25c to 75c
Over 5 pounds to 7 pounds	30c to $1.00
	According to distance.

PRINTED MATTER

Books, Sheet Music, Seeds, Bulbs, Chromos, Engravings, Lithographs, Posters, and other matter wholly in print, sent by Manufacturers, Publishers or Dealers, (charges prepaid) will be carried in Packages of 1½ lbs. or less, 10 cents each. Over 1½ lbs. and not exceeding 4 lbs. ¼ cent for each additional ounce, to any office of this Company.

BUY ALL YOUR MONEY ORDERS FROM THE SOUTHERN EXPRESS COMPANY.

RATES ARE AS FOLLOWS:

	Express Co.'s Charges	Value of Revenue Stamps to be Attached	Amount to be Charged Remitter		Express Co.'s Charges	Value of Revenue Stamps to be Attached	Amount to be Charged Remitter
Not Over	$ 2.50	.03	.05	Not Over	$ 40.00	.15	.17
Not Over	5.00	.05	.07	Not Over	50.00	.18	.20
Not Over	10.00	.08	.10	Not Over	60.00	.18	.22
Not Over	20.00	.10	.12	Not Over	75.00	.23	.27
Not Over	30.00	.12	.14	Not Over	100.00	.28	.32
				Over	100.00	at above rates.	

This shipping receipt, dated September 8, 1900, lists charges by the Southern Express Company for a shipment from Boston to Christiansburg. The Southern Express Company's office was located on Depot Street near its intersection with the tracks at the center of Cambria. (Norfolk & Western Historical Photograph Collection, Digital Library and Archives, Virginia Polytechnic Institute and State University.)

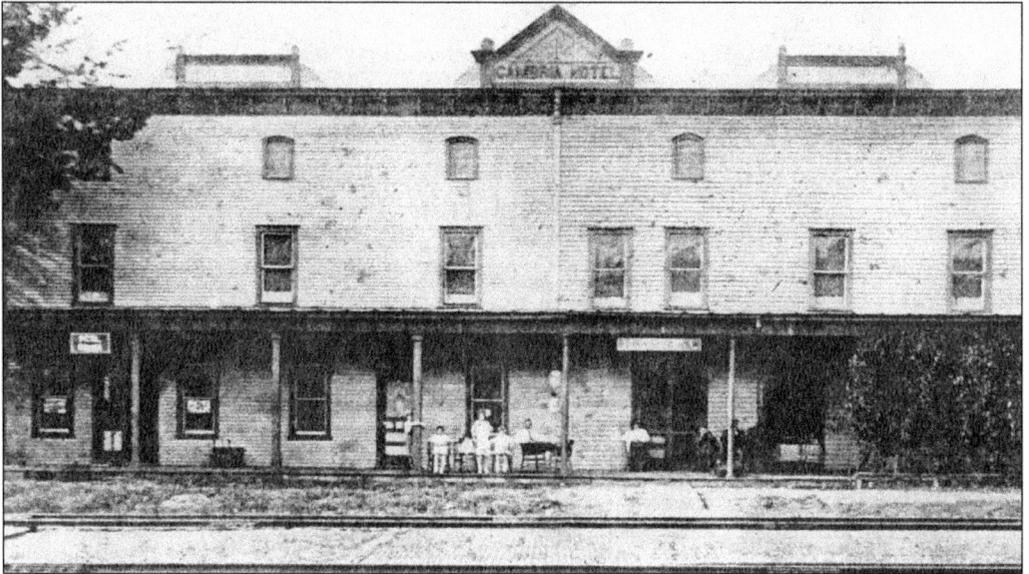

The 1890s Alleghany Hotel was located across the track from the newly constructed passenger station, where East Main Street met the rail line. By 1902, the hotel had been renamed for the district. The Hotel Cambria's street-level, covered porch ran the length of the building and was lined with chairs for weary travelers and locals alike. Its comfortable, full-service dining room bustled with business until the entire operation closed in the early 1940s. (Horne Family Collection.)

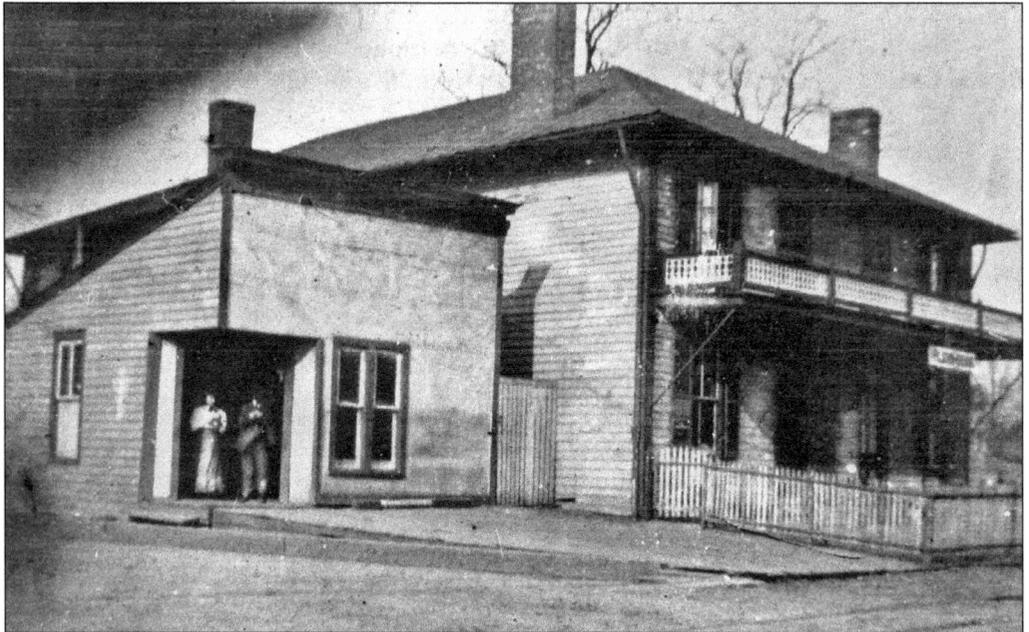

At one time, in the early 1900s, the Christiansburg Station was served by three hotels. This building was constructed in a style typical of a turn-of-the-century depot hotel, a lanky, rectangular building with a second-story balcony that unfolded along the track. Adjacent to the hotel was the local post office with its unique cut-away corner entry at left, a distinct architectural detail. (Mr. and Mrs. Richard Roberts Collection.)

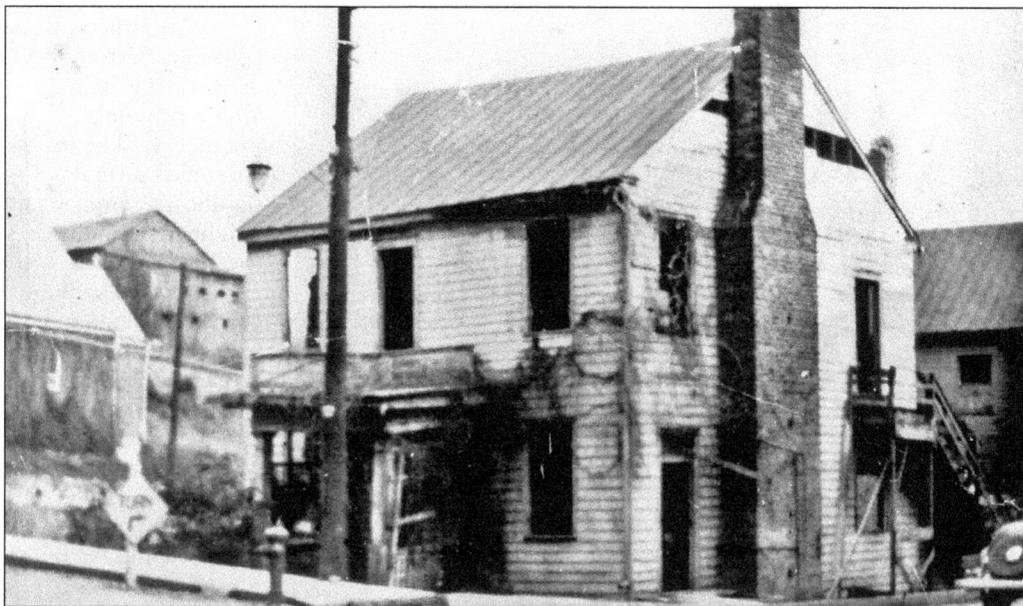

By 1891, the area surrounding the intersection of the railroad at Depot Street included the Allegheny Hotel, Martin & Fagg Livery, the Cambria Post Office, and four small grocery stores. The Duplex Roller Mill (which ground both wheat and corn) was located along the tracks west of the depot. By 1926, the Phoenix Furniture Corporation's factory and lumberyard occupied several large buildings along the length of track behind Depot Street. Abandoned buildings such as this reflect the bare bones of this once-thriving commercial center. (Mr. and Mrs. Richard Roberts Collection.)

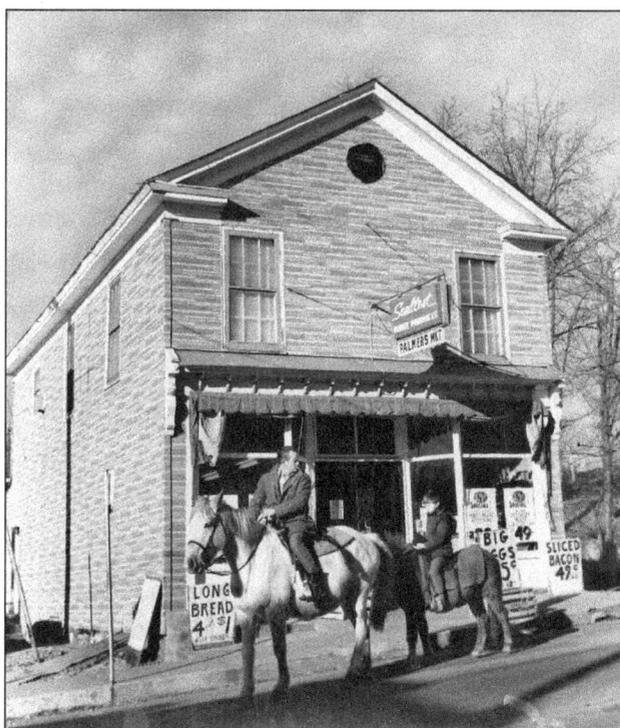

Constructed in 1885, this building housed Dr. A.M. Showalter's first medical practice. He had an office here before he opened Altamont Hospital nearer the train track. The structure's significance, however, rests in its representation of an entire genre of old-time markets. Every rural community was home to one or more of these mom-and-pop establishments that stocked groceries and dry goods, overalls and farming tools. Known as Palmer's Market, this building is fondly remembered by longtime residents of the Cambria community. Its authenticity is acknowledged by its listing on the State Register of Historic Places. (Photograph by Earl Palmer; Earl Palmer Collection, Digital Library and Archives, Virginia Polytechnic Institute and State University.)

Cambria's structural appearance was dramatically altered after a two-night fire in 1947. The fire consumed several significant commercial buildings, including the 1908 Cambria Bank, located at the corner of Depot and Cambria Streets below the Exchange Mill. In 1964, Cambria was annexed into the town of Christiansburg. (*Montgomery News Messenger* Photographic Archive.)

Earl Palmer, known throughout the region for his photographic depictions of Appalachian life, shot several of the photographs included in this volume. Calling himself the "Blue Ridge Mountains Roamin' Cameraman," Palmer is also remembered for his dedicated service to the town of Cambria. Serving eight consecutive two-year terms as mayor of the small community, Palmer was influential in the joining of the two towns. Although historical documents differentiate between the towns of Cambria and Christiansburg, today, Cambria is part of the incorporated county seat. (Special Collections, McConnell Library, Radford University.)

Six

WORKING IN THE
COUNTRYSIDE

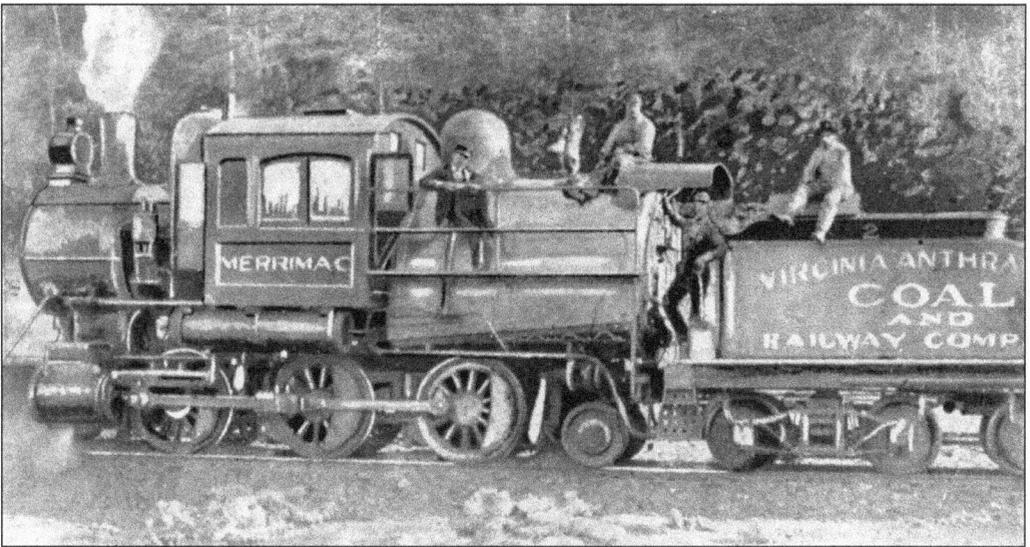

During the Civil War, Montgomery County's coal deposits were mined by hand, the product then transported by wagon to Buchanan and the James River, where transport continued by water. In the early 1900s, the Virginia Anthracite Coal and Railway Company sponsored the construction of a length of track from Christiansburg Station to Virginia Polytechnic Institute (VPI) in Blacksburg. No longer tied to the tedious wagon trip, the coal industry at Merrimac flourished. The new rail line connected VPI with a steady coal supply and provided Merrimac with rail transport to growing seaport cities and industrial centers to the east. A one-mile tunnel, running under present-day 460, was completed in 1909. (Southwest Virginia Images Collection, Digital Library and Archives, Virginia Polytechnic Institute and State University.)

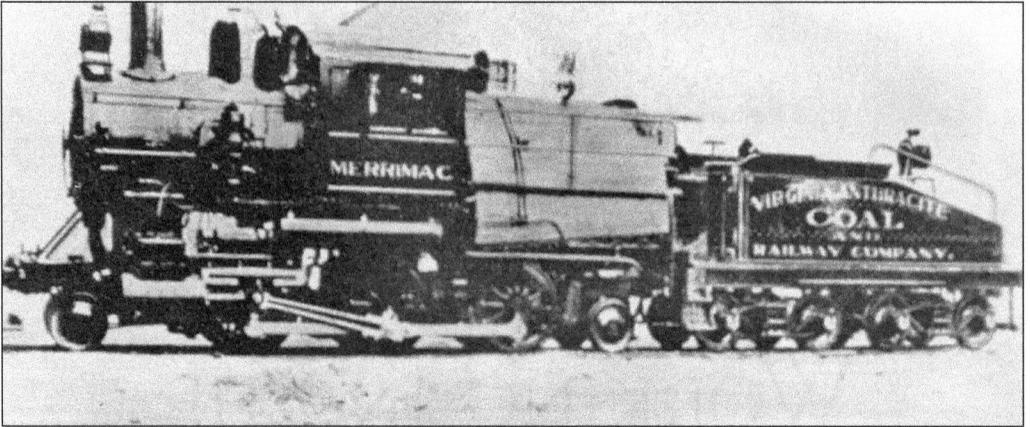

This Camelback Prairie steam engine was built by a Richmond factory and purchased by the Virginia Rail Company in 1904. True to its name, it had the largest firebox of the service's early fleet, allowing it to carry a heavier load of coal. With the completion of the Price Mountain Tunnel, engines could travel on a level track, rather than up and then down the 100-foot ridge separating Merrimac and Ellett Valley. This "workhorse" train operated for over a decade, making its last run to the Roanoke scrap yard in 1916. (Special Collections, McConnell Library, Radford University.)

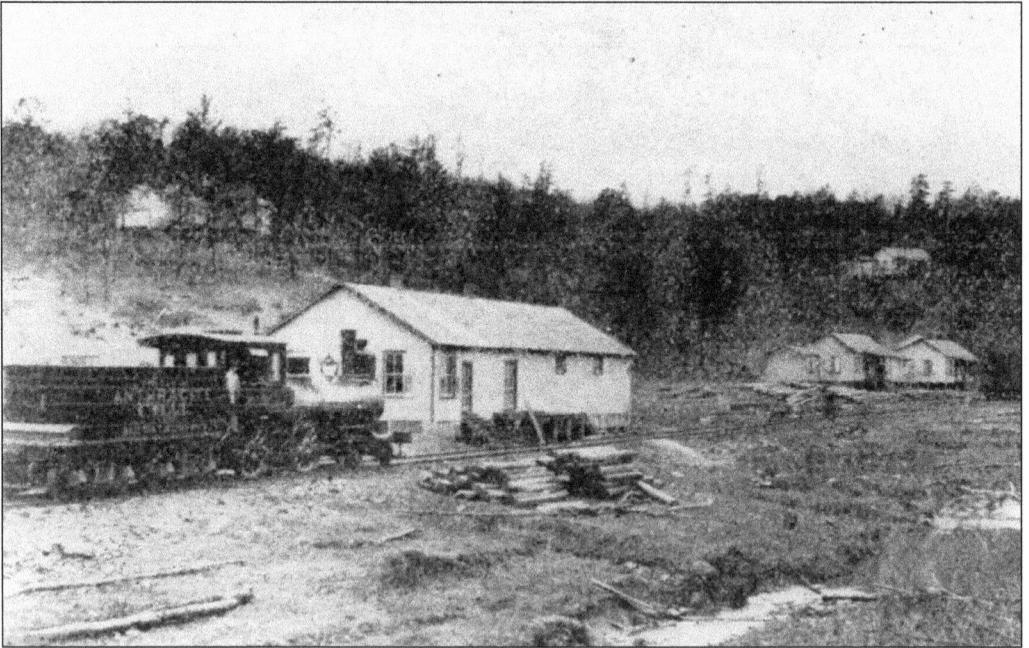

This 1904 photograph depicts the station yard at Merrimac. A Baldwin locomotive awaits a load of slate, extracted from the nearby mine site. Early 20th-century industrialization contributed to the growth of many Appalachian communities. Along with Merrimac's operation center, new homes were constructed and a general store was built to serve the needs of the developing settlement. The community was also served by a wood-frame grade school building. (Norfolk & Western Historical Photograph Collection, Digital Library and Archives, Virginia Polytechnic Institute and State University.)

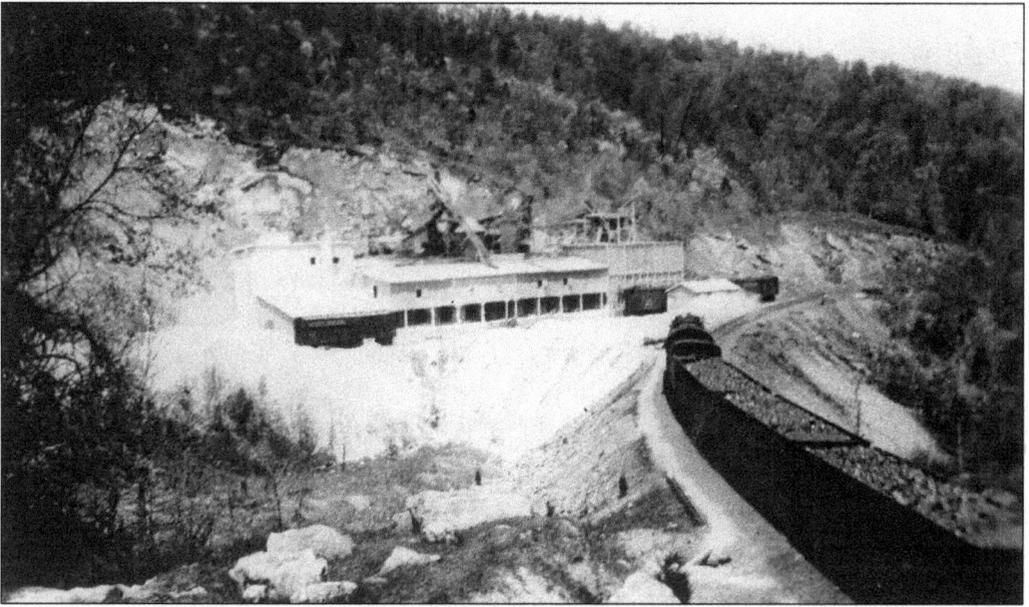

The train yard at Merrimac was located five miles northwest of Christiansburg proper. From this rudimentary station, the engine pulled its cars along a 1,300-foot siding to a loading dock more convenient to the extraction site. (Southwest Virginia Images Collection; Digital Library and Archives, Virginia Polytechnic Institute and State University.)

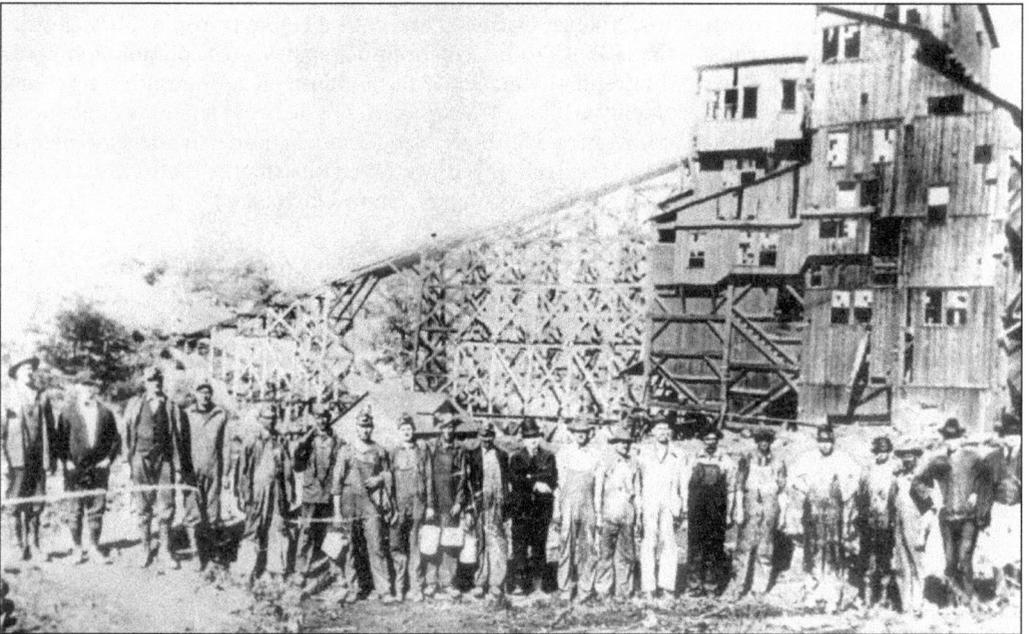

Miners pose with General Manager Davenport in front of the Merrimac tipple in 1922. Among those identified in this picture are Lee Bartlett, James Cupp, Harvey Cromer, Ed Dobbins, Will Gearheart, Davy Jones, Alvin Reynolds, Henry Stone, Clyde Vaught, and John Wright. Several members of the Linkous family were miners, including Dallas, David, Driscoll, Jessie, and Tommy Linkous. (Southwest Virginia Images Collection; Digital Library and Archives, Virginia Polytechnic Institute and State University.)

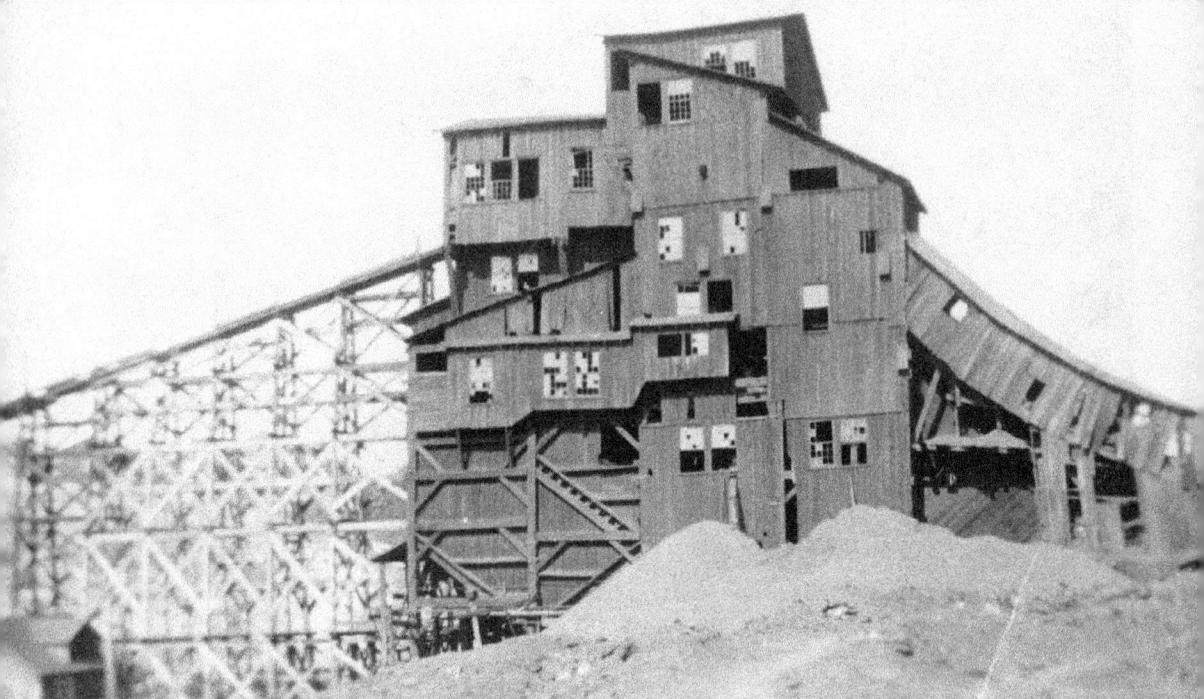

A coal tipple, the wooden structure pictured here, is at the center of a mine's production. This was the site where the harvested material was gathered and sorted before transport to wagons or to the rail platform. Merrimac's tipple looks to be in serious disrepair in this photograph taken in the spring of 1923. Following the trend of many early rural industrial communities, resources were ultimately depleted and companies closed. Very little physical evidence of Merrimac's history remains, although the Coal Mining Heritage Association supports the development of a park along the present-day Huckleberry Trail. (Southwest Virginia Images Collection; Digital Library and Archives, Virginia Polytechnic Institute and State University.)

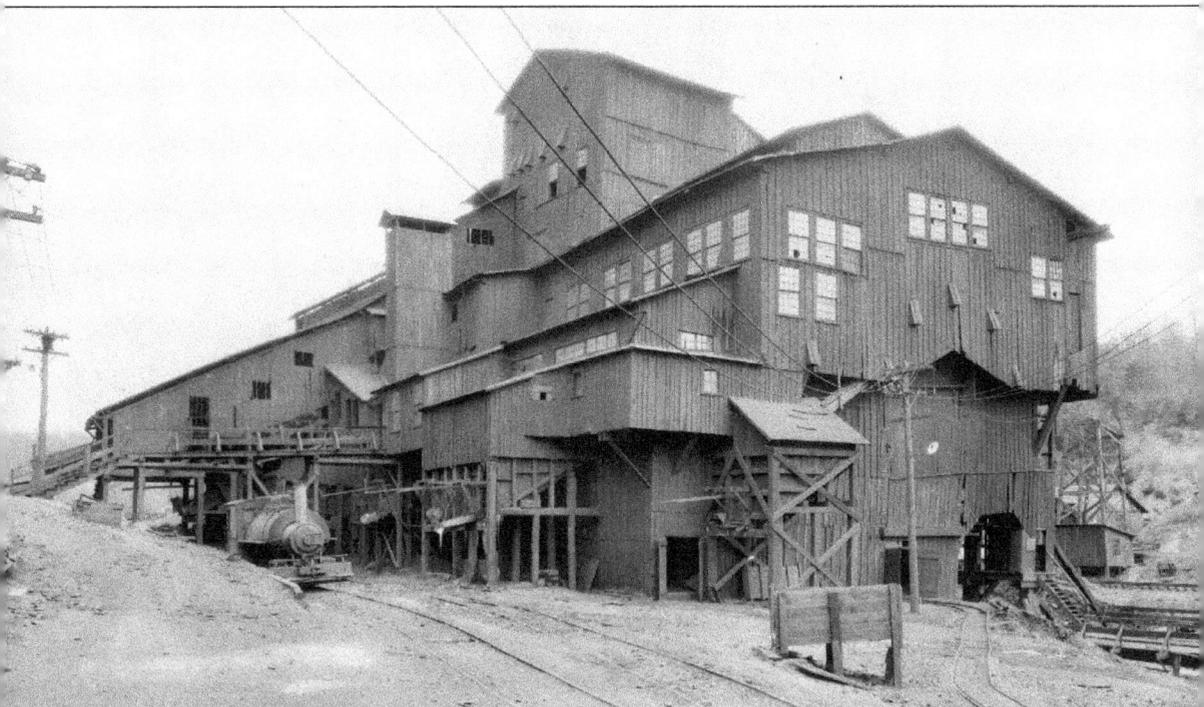

The Merrimac mine was officially closed in the early 1930s. Twenty years later, the Blacksburg Branch of the rail line was purchased by Norfolk & Western. Today, Christiansburg's Merrimac community celebrates its mining traditions in an annual festival, and a rails-to-trails project has turned the old rail bed into a contemporary recreational trail. (Norfolk & Western Historical Photograph Collection, Digital Library and Archives, Virginia Polytechnic Institute and State University.)

The mining companies and the community of Merrimac could not have flourished without the hard work of local miners. Digging coal from seams embedded in rock was slow, tedious, difficult, and dangerous. Photographer Earl Palmer took this picture of Walter Dobbins ready to begin another day in the Merrimac mine. The head lamp on his forehead helped illuminate his work in the dark interior of the underground mine. (Photograph by Earl Palmer; courtesy of Clara Lee Dobbins and Katie May.)

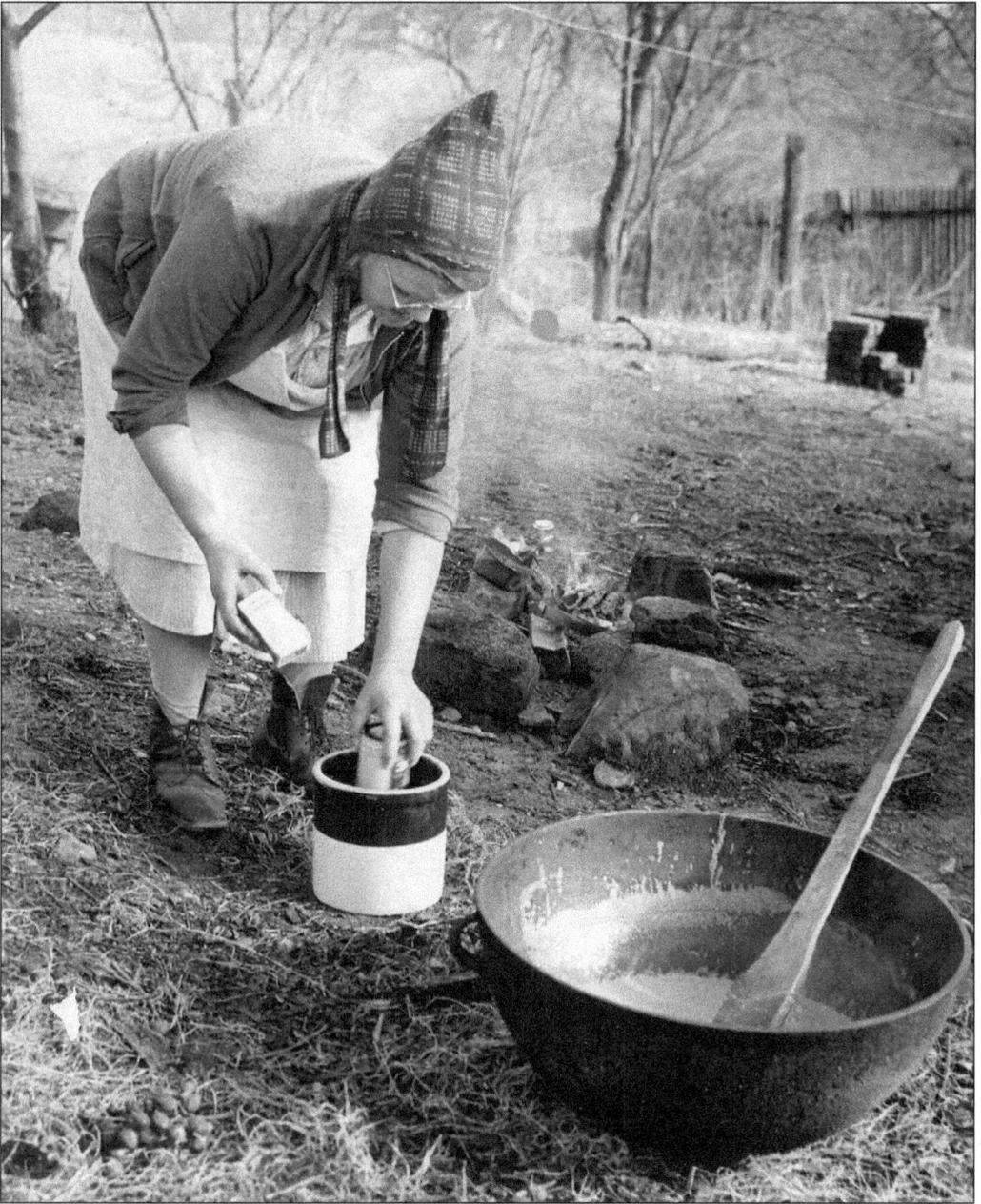

The topography and climate surrounding Christiansburg was conducive to growing certain crops. Community records and old photographs attest that orchards abounded in the valley hills, offering a yearly blush of peaches, pears, and apples. Early pioneers, known for their resourcefulness, could fashion a side dish, condiment, beverage, or dessert from a single fruit. The woman bent over a clay crock in this Earl Palmer photograph has readied a cast-iron kettle and wooden stirring paddle in preparation for cooking over an open fire. (Earl Palmer Collection, Digital Library and Archives, Virginia Polytechnic Institute and State University.)

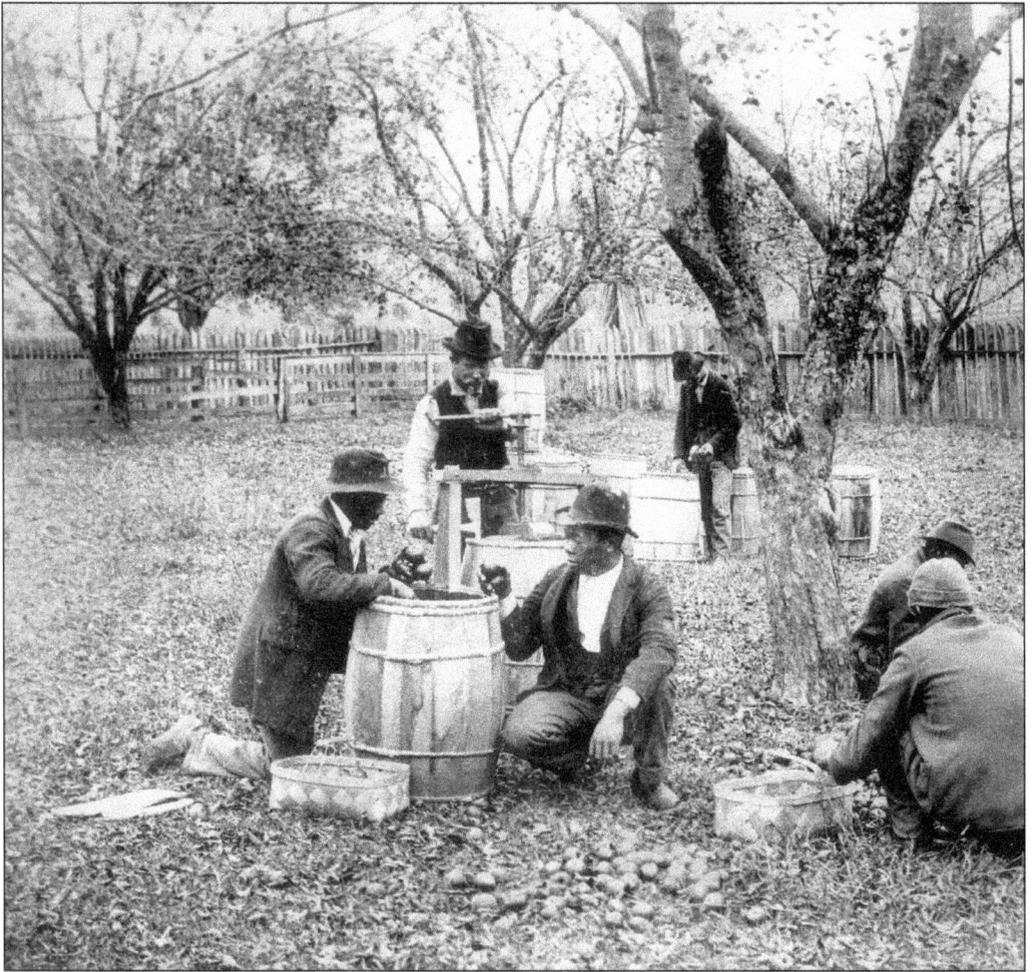

In the fall, after the corn was shucked and the squash gathered, farmers turned their attention to their apple trees. Apple butter making called for gathering, peeling, and quartering bushels of apples that were stewed and seasoned in vast copper kettles over an open fire. Such all-day stirrings were accompanied by music, storytelling, or newsy chatter, contributing to the region's hallmark agricultural customs and celebrations. In this 1897 photograph, men gather apples into small baskets before putting them through the barrel press (at center). Apples were sorted, sweated, and pressed to produce cider, as common to the early American farmhouse table as home-baked bread. (Southwest Virginia Images Collection; Digital Library and Archives, Virginia Polytechnic Institute and State University.)

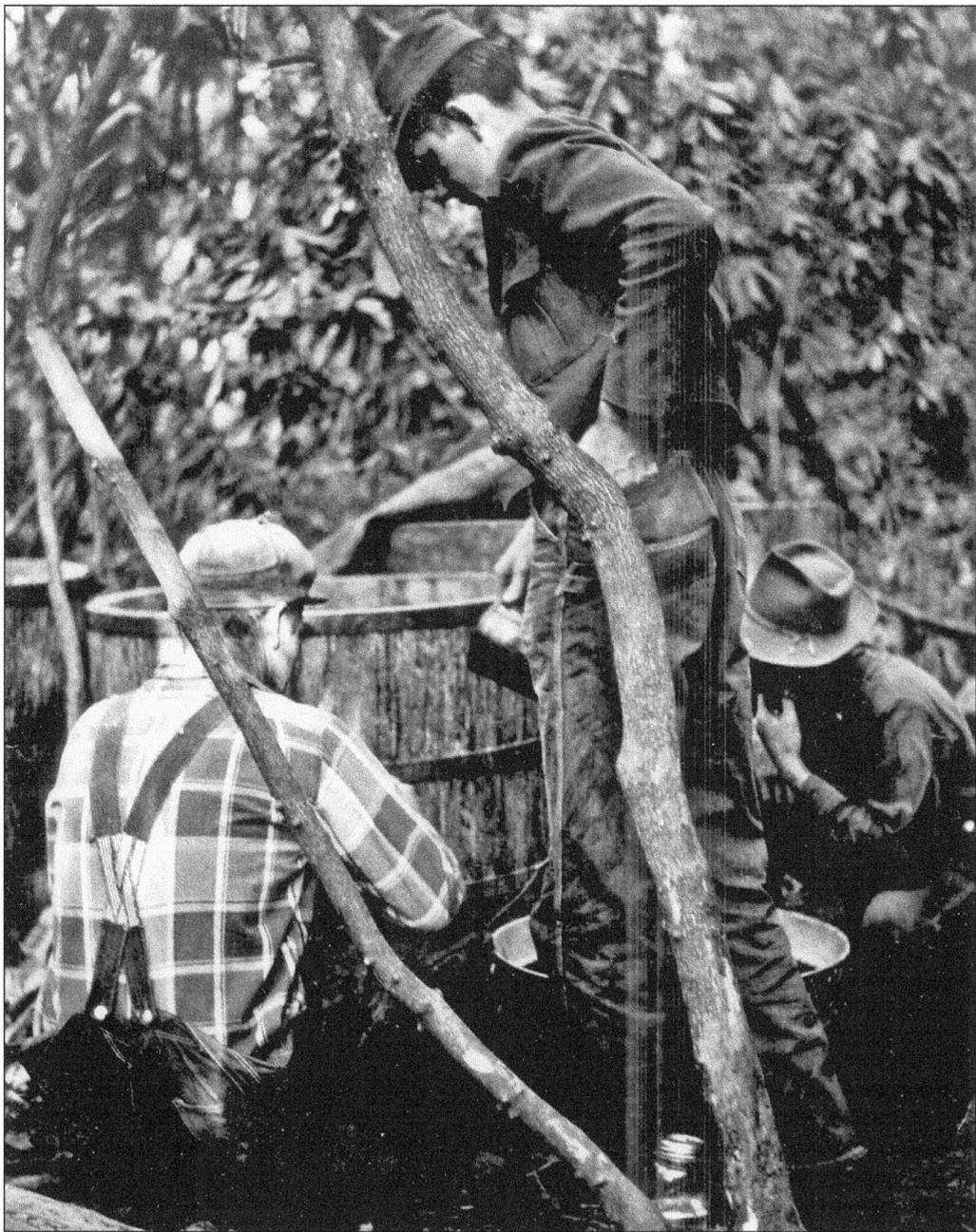

Captured by local photographer Earl Palmer, this scene depicts an Appalachian tradition and stereotype. In the lowland South, tobacco was the money crop, but the mountainous landscape of the Blue Ridge region was not suited to growing it. One way for upland residents to make money during the tobacco boom was to manufacture whiskey. Farming families who legally produced corn liquor or apple brandy for medicinal purposes and personal use might make a batch for "trade." Once the practice was outlawed, such fermented spirits came to be known as "moonshine" because much of the work was done after dark by the light of the moon. (*Montgomery News Messenger* Photographic Archive.)

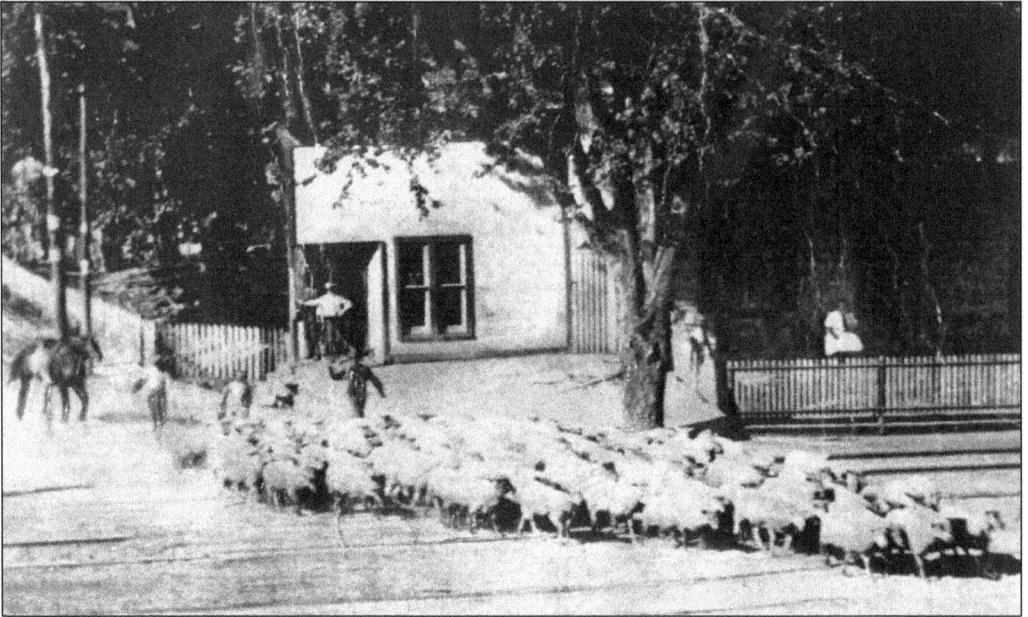

On market days, Christiansburg bustled with wagons and drovers on their way to the wagon lot or depot. In this 1910 photograph, a flock of sheep is herded across the tracks in front of the Cambria Post Office. The character of the developing commercial center reflected the town's agrarian roots, but where past met progress, transportation arteries were shared with new Ford motorcars. (Earl Palmer Collection, Digital Library and Archives, Virginia Polytechnic Institute and State University.)

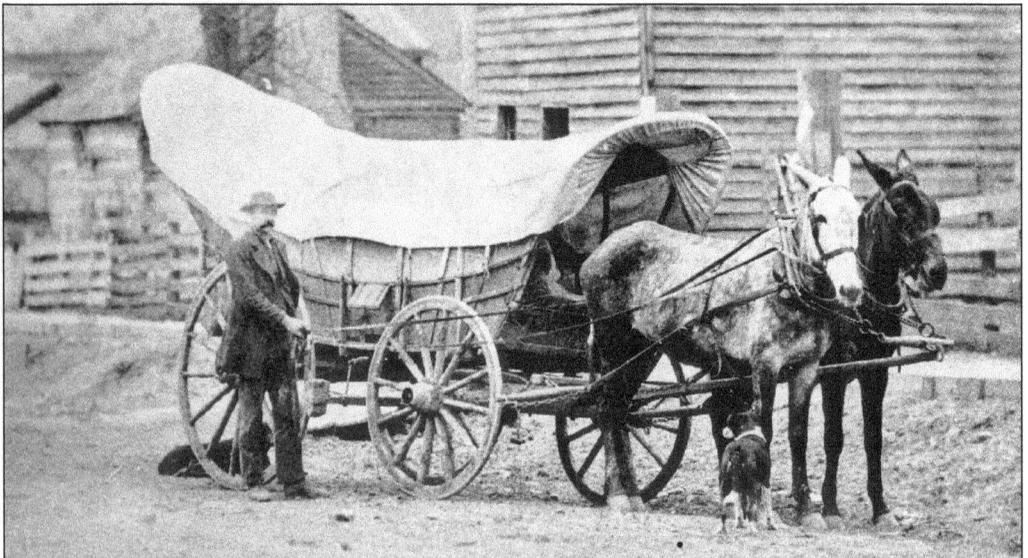

While farmers frequently transported their own products, a few enterprising young men devoted themselves to hauling produce and goods from one location to another. Hath Parker is depicted with the covered wagon he drove between Floyd and Christiansburg near the turn of the century. The photograph carried the motto, "When it positively had to be there," suggesting that this method of delivery was reliable and secure. (Southwest Virginia Images Collection; Digital Library and Archives, Virginia Polytechnic Institute and State University.)

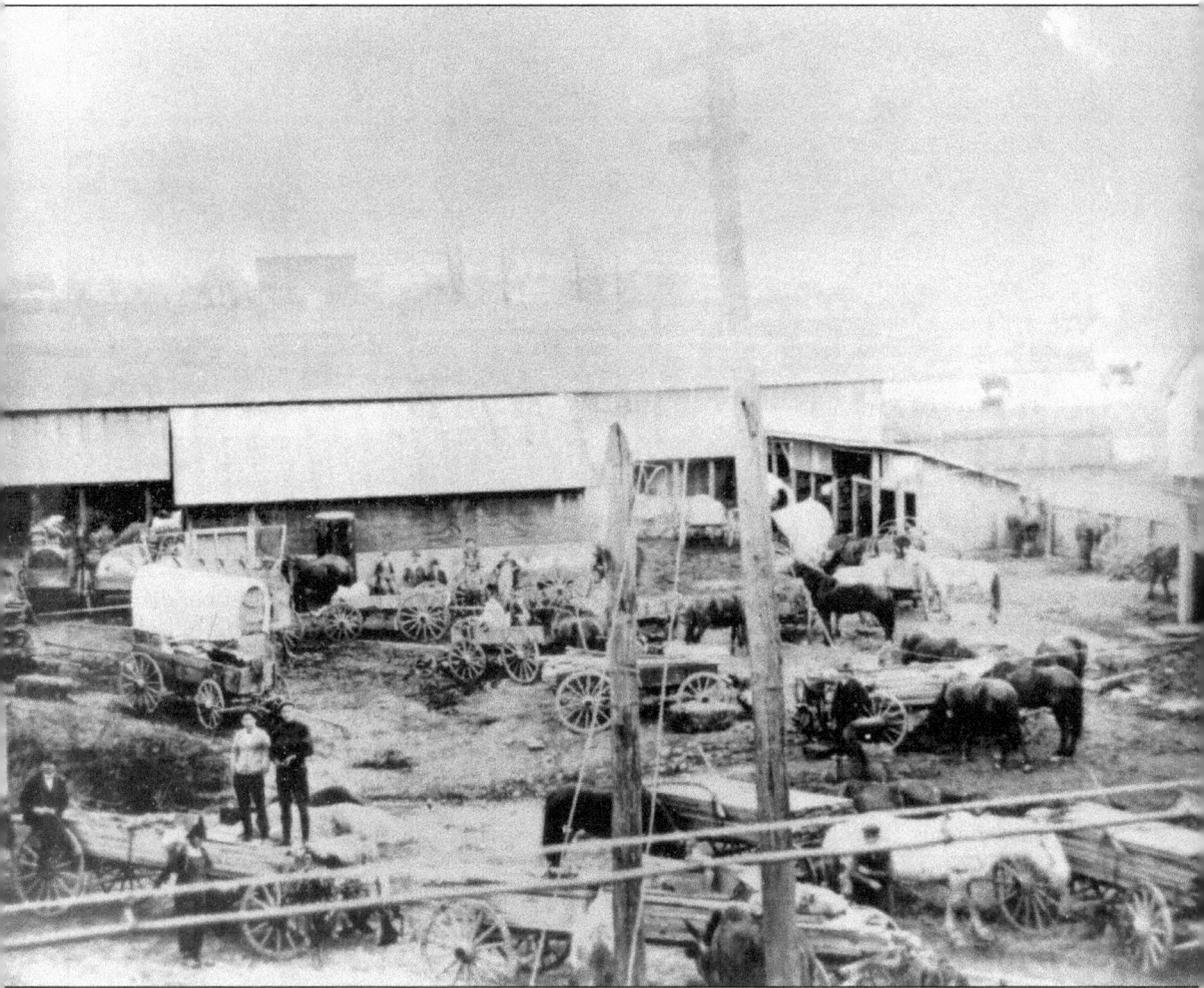

The Aaron Graham Grocery and Wagon Lot was a popular destination for local farmers and traders who sometimes traveled two or three days to reach Christiansburg. Many camped overnight with their wagons along the way. In Christiansburg and Cambria, farmers bought and sold lumber and dry goods, livestock and produce, and bartered for as much as they sold. The lot was located along present-day North Franklin Street. (Mr. and Mrs. Richard Roberts Collection.)

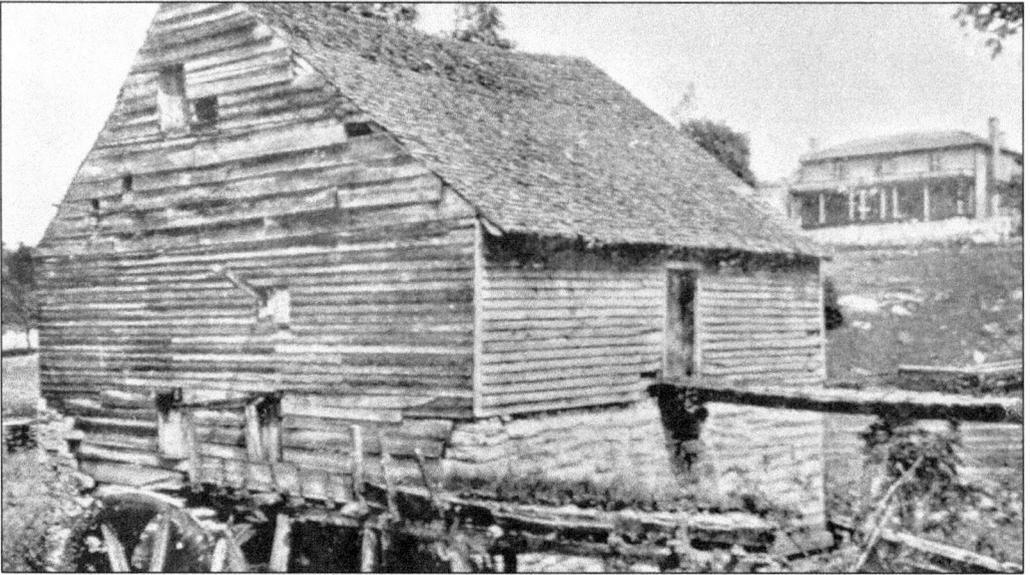

Eighteenth-century immigrants from Europe and the British Isles settled in the abundant river valleys of western Virginia. There, they cleared a spot of land along the sloping hillsides and carved out subsistence farms that produced a variety of foodstuffs to suit their needs. Early mountain settlements included a gristmill that ground corn and wheat for farm residents and neighbors. Typical of many water-powered mills, Lattimer's was built on the banks of rushing Crab Creek in 1769. The mill represented one of many tiny commercial centers in the broader rural district. The community supported by the Lattimer mill was also serviced by a blacksmith's shop, tannery, and general store. The property above the mill was part of the Christiansburg Institute campus. (Special Collections, McConnell Library, Radford University.)

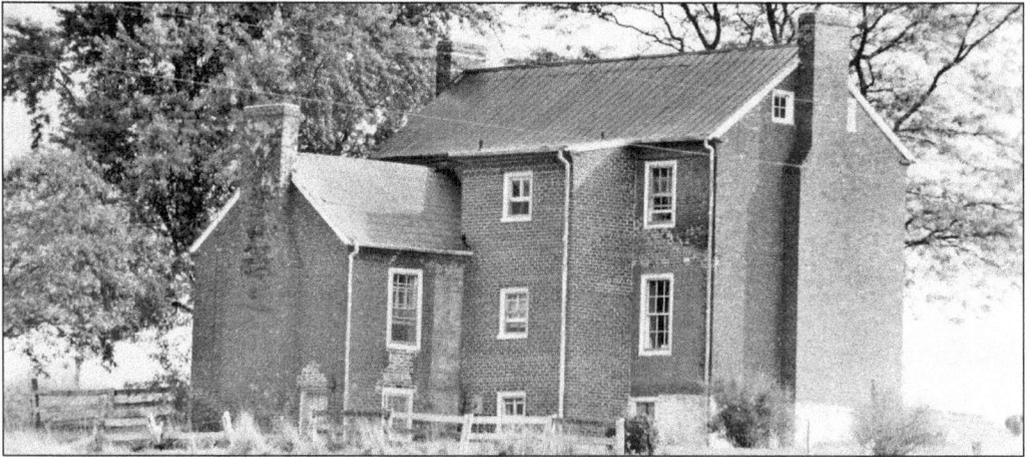

The Montgomery County Poor Farm was located northeast of Christiansburg in the community of Ellett. The brick structure was most likely the main building of a 19th-century farmstead where needy community members could sow crops and raise farm animals to feed their families. With three chimneys and three floors, the farmhouse was designed for maximum use and occupancy. Poor farms like this one began to appear across the southwestern Virginia landscape in the mid-19th century as a locally supported solution to aid the large portion of the general public that was living in poverty. Along with the Ellett farm, the Wythe County Poor Farm was established in 1858. (*Montgomery News Messenger* Photographic Archive.)

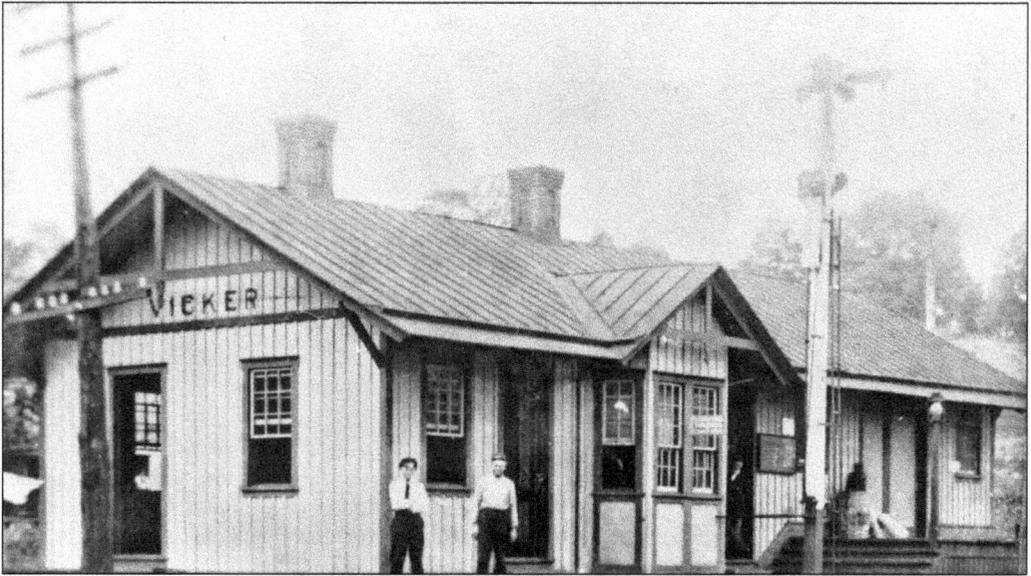

With the arrival of the railroad in the mid-19th century, farmers began to shift from traditional subsistence methods that supplied their own families to more commercial production. Sending products from the farm depended on developed transportation systems. Steam trains departed from the Christiansburg depot with cars full of homegrown produce. Along the way, they stopped to pick up stock from local depots, such as this one at Vicker. (Mr. and Mrs. Richard Roberts Collection.)

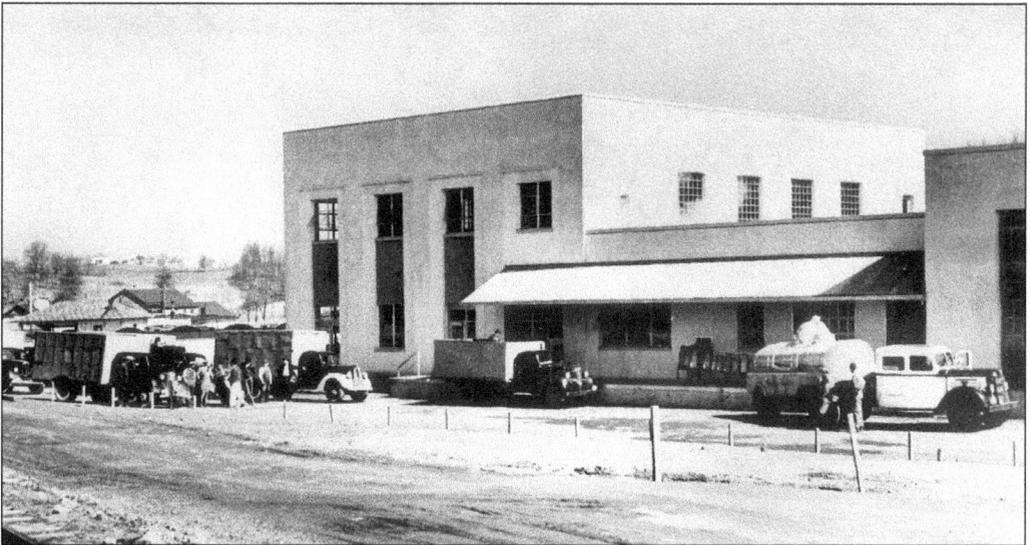

As the new century unfolded, farm duties became increasingly mechanized as agriculture shifted toward larger-scale production and mass marketing. These early industrial developments were met by the concept of farmer's cooperatives but eventually gave way to developing agribusiness. Local farmers hauled their milk to the Southern Dairies Plant, which opened in the spring of 1940. Operated by the Sealtest Company for 30 years, the plant closed in 1969. The structure remains standing on Roanoke Street and is currently home to the Southern States Farm Supply Store. (Southwest Virginia Images Collection; Digital Library and Archives, Virginia Polytechnic Institute and State University.)

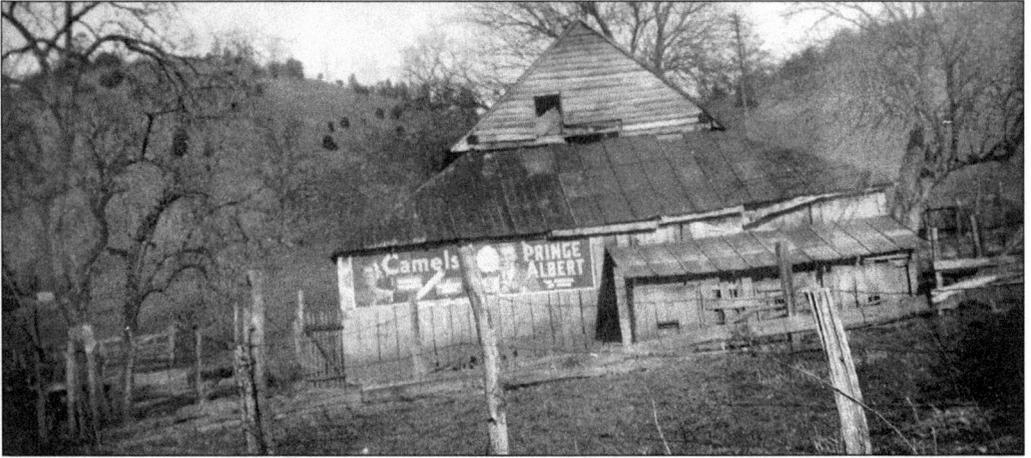

The 1806 William Sublett farmhouse was constructed as an early log residential home place. By the time of this WPA photograph in 1937, the site had been abandoned for almost three decades and given over to agricultural use. The original cabin included four small rooms with pinewood floors. The building's shingled roof is still identifiable, barely visible behind a large frame addition. Many such residential structures marked the local landscape in the early 20th century as individual family farms gave way to public sector jobs. (Photograph by Pearl C. Vest; WPA Virginia Historical Inventory, The Library of Virginia.)

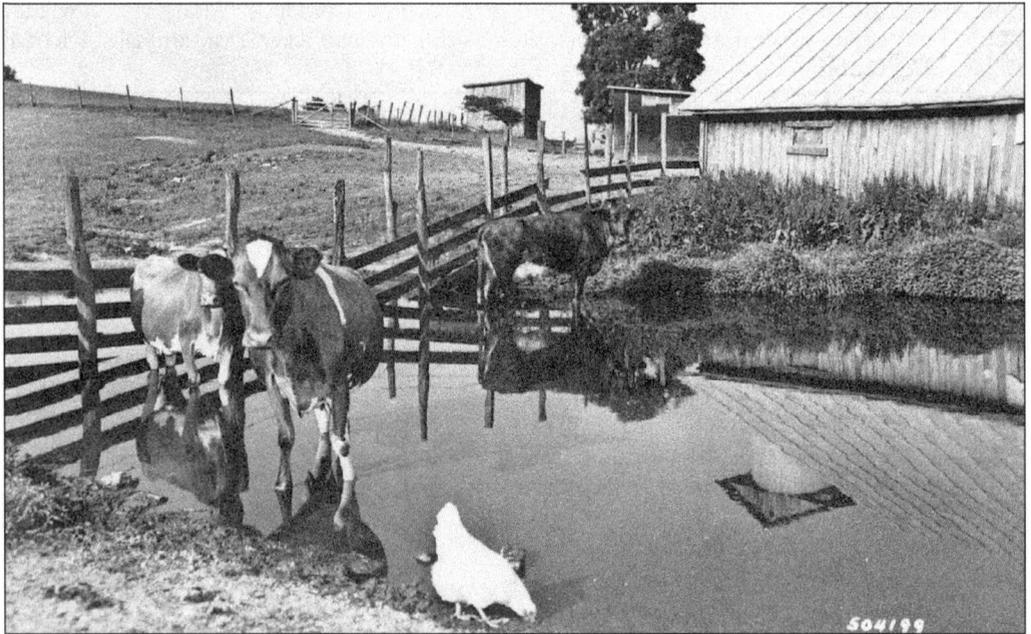

During the 18th and 19th centuries, the majority of Americans lived on family farms; by the turn of the century, their declining numbers precipitated an identity crisis nationwide. President Theodore Roosevelt struggled with the issue, stating flatly, "We are founded as a nation of farmers." Although rural areas declined in population as hopeful citizens departed for industrializing cities, farming persisted for some time in places like Christiansburg. Many families continued to keep chickens and a cow or two, as this 1946 photograph illustrates. (Norfolk & Western Historical Photograph Collection, Digital Library and Archives, Virginia Polytechnic Institute and State University.)

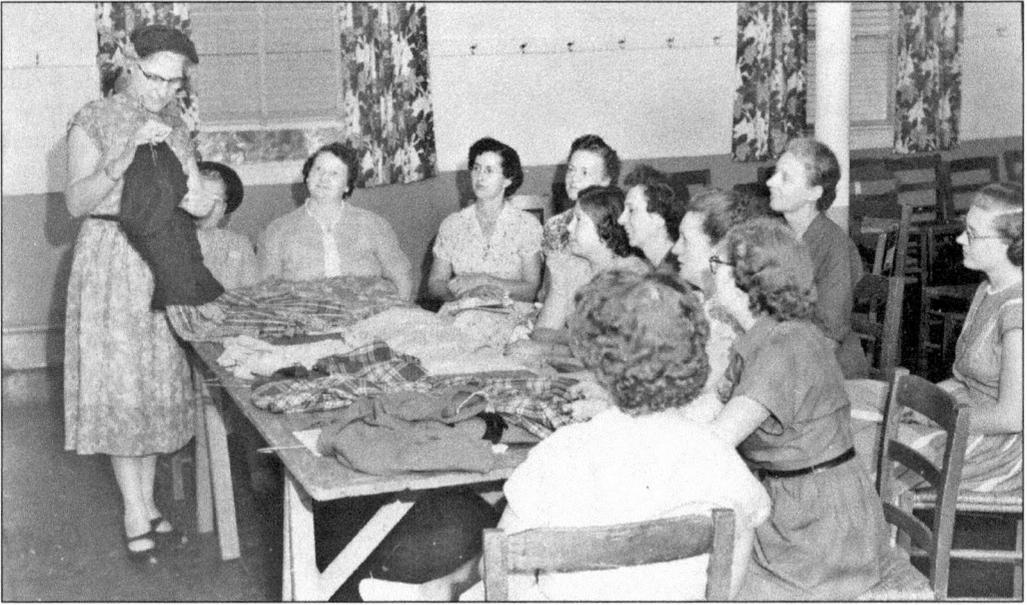

The Virginia Agricultural Extension Service was a government-funded initiative that provided research-based information to communities. Topics included housing and farm structures, crops and grain cultivation, environmental management, and financial planning. This 1952 image depicts Virginia Extension Service Agent I.B. Johnson in the process of conducting an educational session for Christiansburg homemakers. Here Miss Johnson is advising a group of community women on how to buy better dresses. The extension office in Montgomery County, which also ran 4-H clubs for local youth, was based at the Commonwealth's land-grant university, Virginia Polytechnic Institute, known locally as VPI. (Virginia Cooperative Extension Collection, Digital Library and Archives, Virginia Polytechnic Institute and State University.)

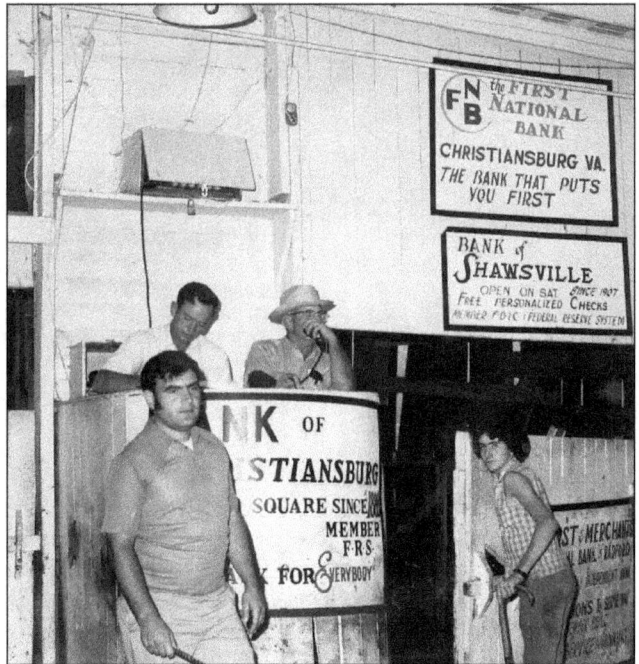

In the 1960s, the Christiansburg Livestock Market opened on Thursday, providing a venue for local farmers and citizens to trade, sell, and discuss agricultural trends and happenings about town. The woman at lower right has just opened the gate to let in the next animal for bid. The man at the podium stands ready to start the bidding in the fast-paced, singsong style typical of auctioneers. (Earl Palmer Collection, Digital Library and Archives, Virginia Polytechnic Institute and State University.)

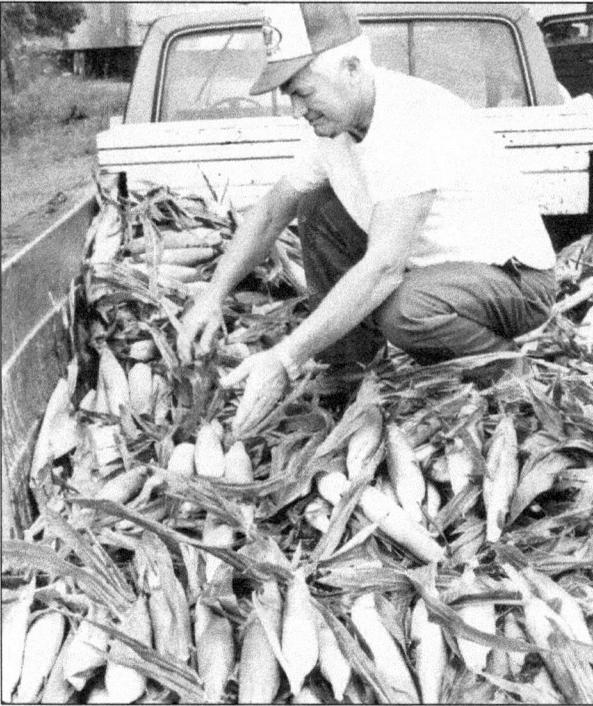

Although the area has turned to residential and commercial development, the countryside is still vital enough to support a steady amount of smaller scale agricultural operations. Christiansburg resident Cecil Underwood, who continued to grow a single acre of corn, harvested and sold his product in town from the flatbed of his pickup truck. A favorite local variety is a sweet white corn known as Silver Queen. (*Montgomery News Messenger* Photographic Archive.)

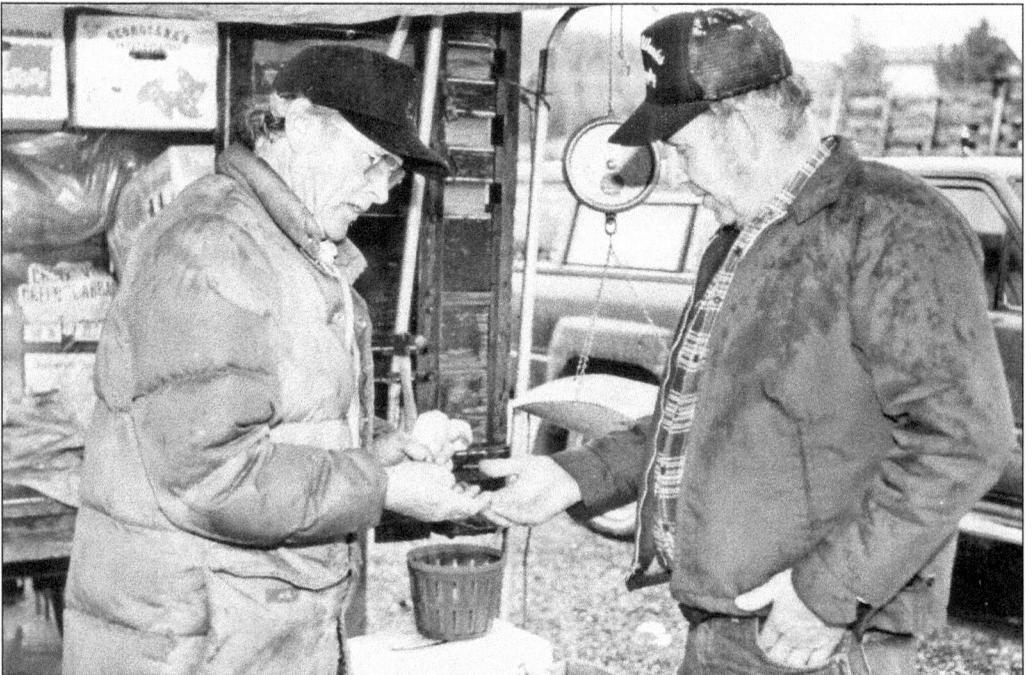

Today, Virginia's challenge to preserve her agricultural heritage and encourage contemporary sustainable agricultural methods is met by local farmers markets. In Christiansburg, citizens gather to trade and sell produce, cut flowers, baked goods, and handmade wares. The tradition continues to gain support and confirms a sense of camaraderie and hard work among community members. (*Montgomery News Messenger* Photographic Archive.)

Seven

WORKING IN TOWN

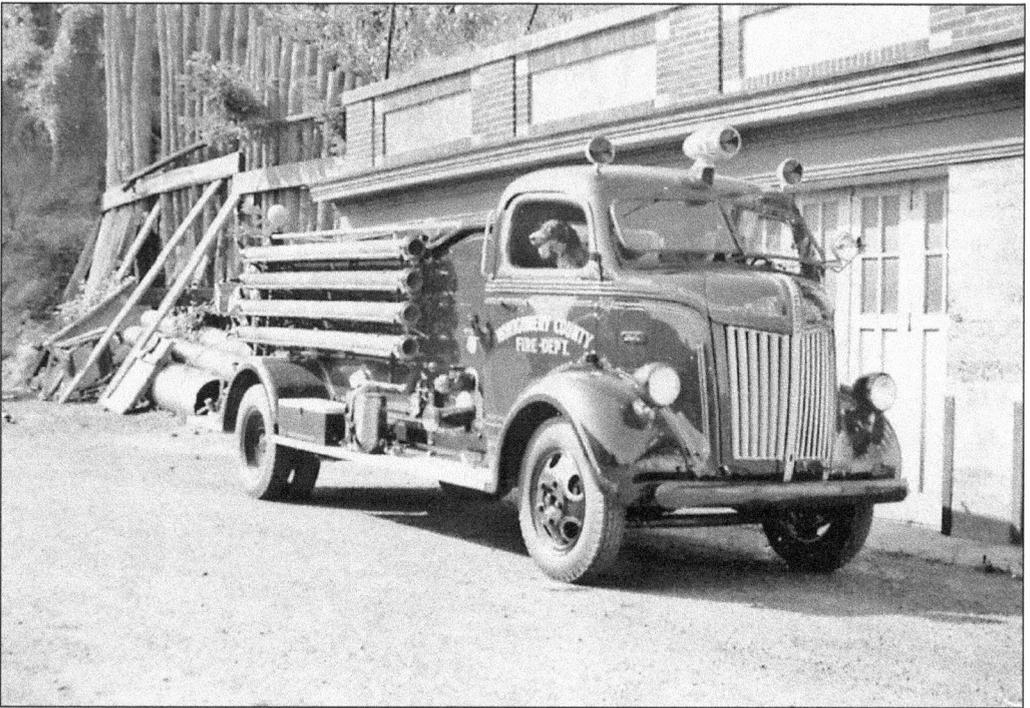

The commercial and industrial centers of Christiansburg and Cambria were devastated by several major fires in the early 20th century. Each blaze was a singular event that changed the townscape gradually, but surely, over a 30-year period. Devastating fires in the 1940s and 1950s dramatically altered the town's main street. This 1942 Ford Oren 500 is parked in front of the original fire station, which had four bays to accommodate a fleet of engines. The passenger's seat is reserved for the company mascot. (Robert B. Basham Collection.)

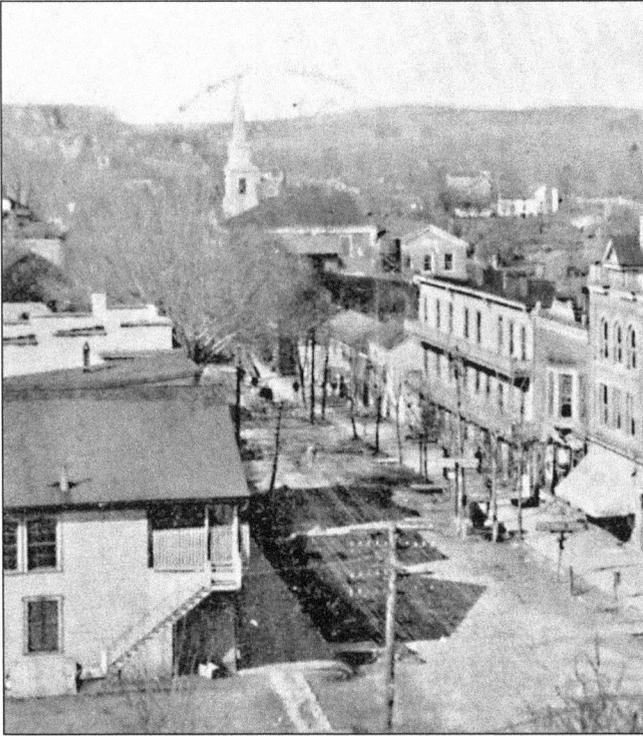

In the years immediately following the turn of the 20th century, Christiansburg's commercial downtown continued to develop and expand. The townsfolk were served by a newspaper, several hotels, general stores, a local band, and a depot station. The first telephone switchboard was patented in 1882, and early "talking machines" were sold to individuals who strung wires between homes and businesses. Later, work crews manipulated stringing mechanisms, positioned on a motor-led, 16-wheel flatbed. At lower left, multiple power lines held in place by glass insulators were strung along the main streets to supply the town's electricity. (History Museum of Western Virginia's Clare White Library Collection.)

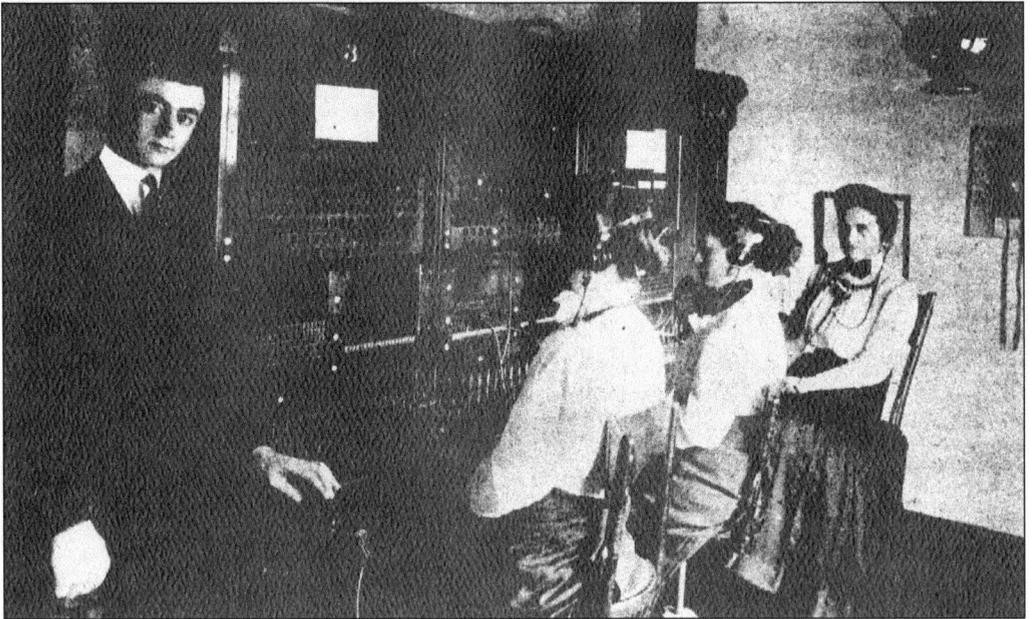

By the first decade of the new century, the developing telephone system accommodated nearly 300 telephone lines strung throughout the town. A central switchboard managed incoming and outgoing calls. Adventurous local women stepped out of their domestic roles to become the "Central Girls," who staffed the old-fashioned communications grid. In this photograph, c. 1910, three such young women, wearing turn-of-the-century headsets, complete calls by hand, plugging in cables that dangle from connection points in front of them. (Horne Family Collection.)

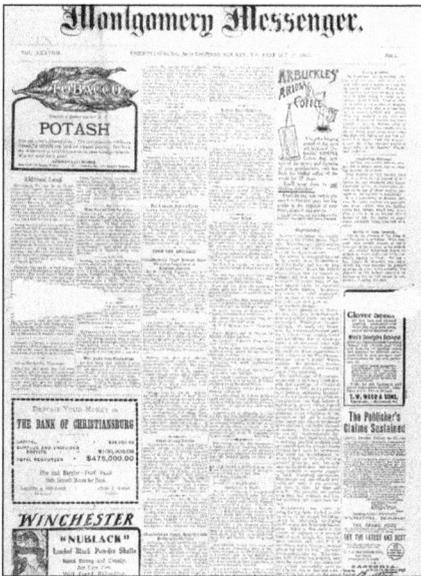

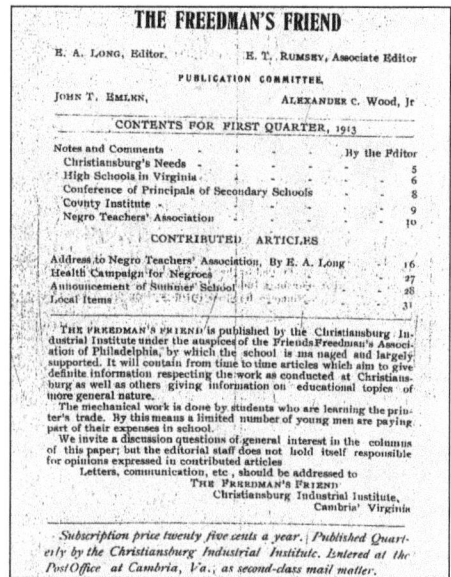

(*above left*) A sign of a progressive and educated community, the first edition of the *Montgomery News Messenger* was printed in 1869. This front page, with ads for tobacco, coffee, and a rifle made in Winchester, dates to January 1907. The oldest continuously operating business in the county, the newspaper today makes its home in the historic 1905 bank building on West Main a block from the courthouse. (Norfolk & Western Historical Photograph Collection, Digital Library and Archives, Virginia Polytechnic Institute and State University.)

(*above right*) The *Freedman's Friend* was printed on the Christiansburg Institute campus and sold as an annual subscription to patrons of the school. News of the school was always included, but each issue also contained state educational news, editorials, inspirational messages, and national events affecting racial progress, as well as articles relevant to the school's Quaker supporters. Typically, the quarterly magazine ran to 50 pages, with more than half the pages penned "by the Editor." (Christiansburg Institute Museum and Archive.)

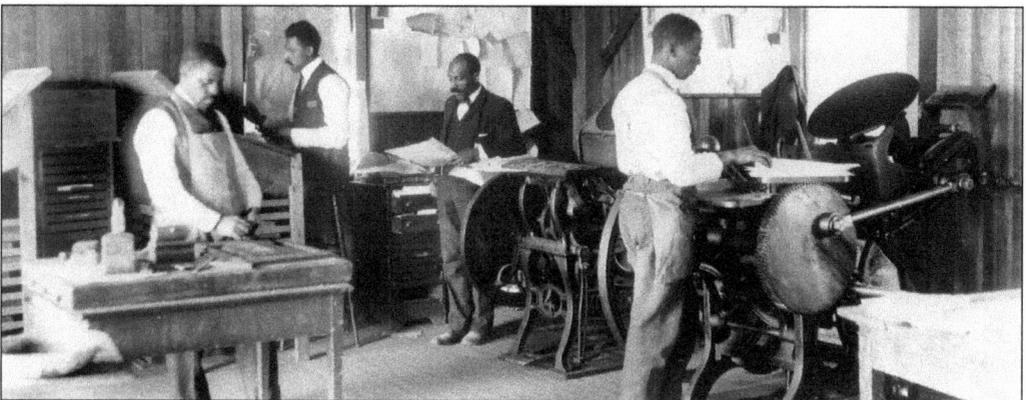

The original trades building constructed on the campus of Christiansburg Institute was completed in 1902. With three small bays, the shop was constructed to house the trades of blacksmithing, carpentry, and printing. Here, the *Freedman's Friend*, edited by Edgar Long, was published regularly from 1904 until sometime after his death in 1924. Under Long's supervision, all typesetting and production were done by students. The historic trades building burned in 1924 and was reconstructed where it still stands on a portion of the school's historic campus. (Christiansburg Institute Museum and Archive.)

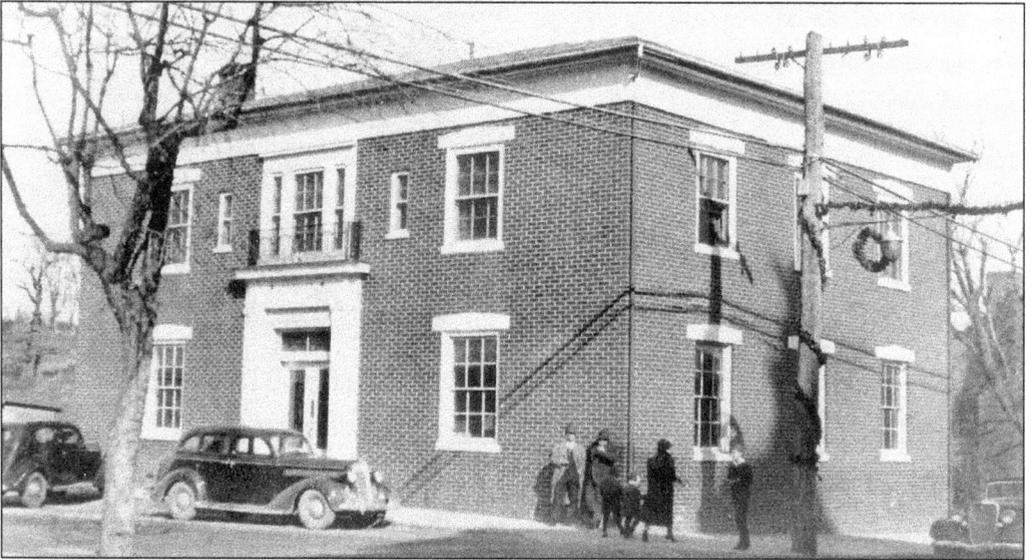

The Bank of Christiansburg is often mentioned as one of the community's oldest commercial institutions. This image dates to 1937, when the town's economy was on the rebound from the Great Depression and, according to a publicity brochure of the same year, maintained one of the lowest tax rates in the state. Originally constructed by private banker Charles Gardner in 1853, the Colonial-style building was located on the public square. The Bank of Christiansburg purchased the building from Gardner with the provision that his daughters could continue to live in the building. (Southwest Virginia Images Collection, Digital Library and Archives, Virginia Polytechnic Institute and State University.)

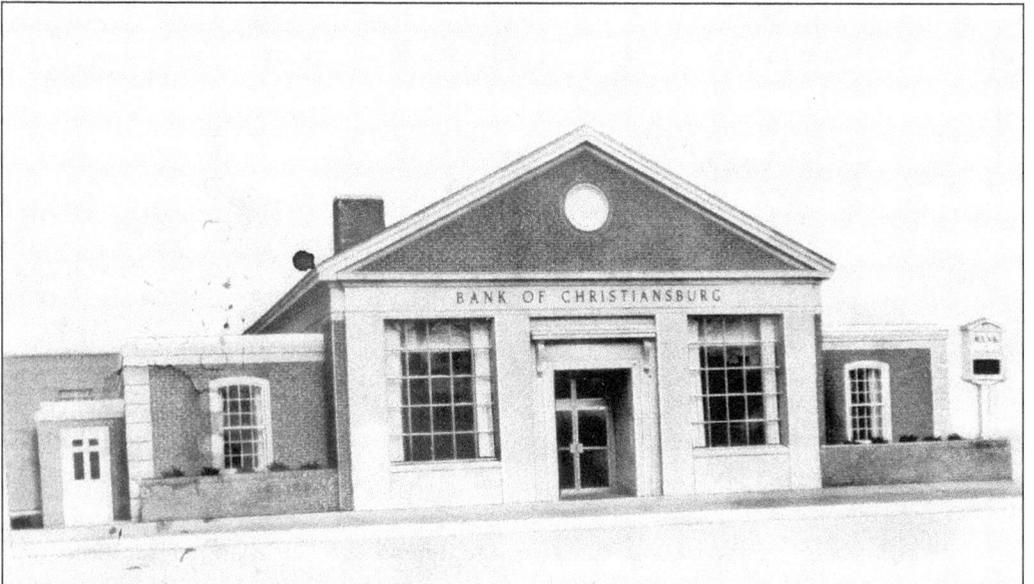

In the mid-1960s, this structure replaced the original built in 1853. Eventually the financial institution was incorporated by Central Fidelity Trust, although an older generation of Christiansburg citizens still refers to the site by its original name. The Bank of Christiansburg's history is reflective of the sophisticated economic and commercial development of the town's early days. (*Montgomery New Messenger* Photographic Archive.)

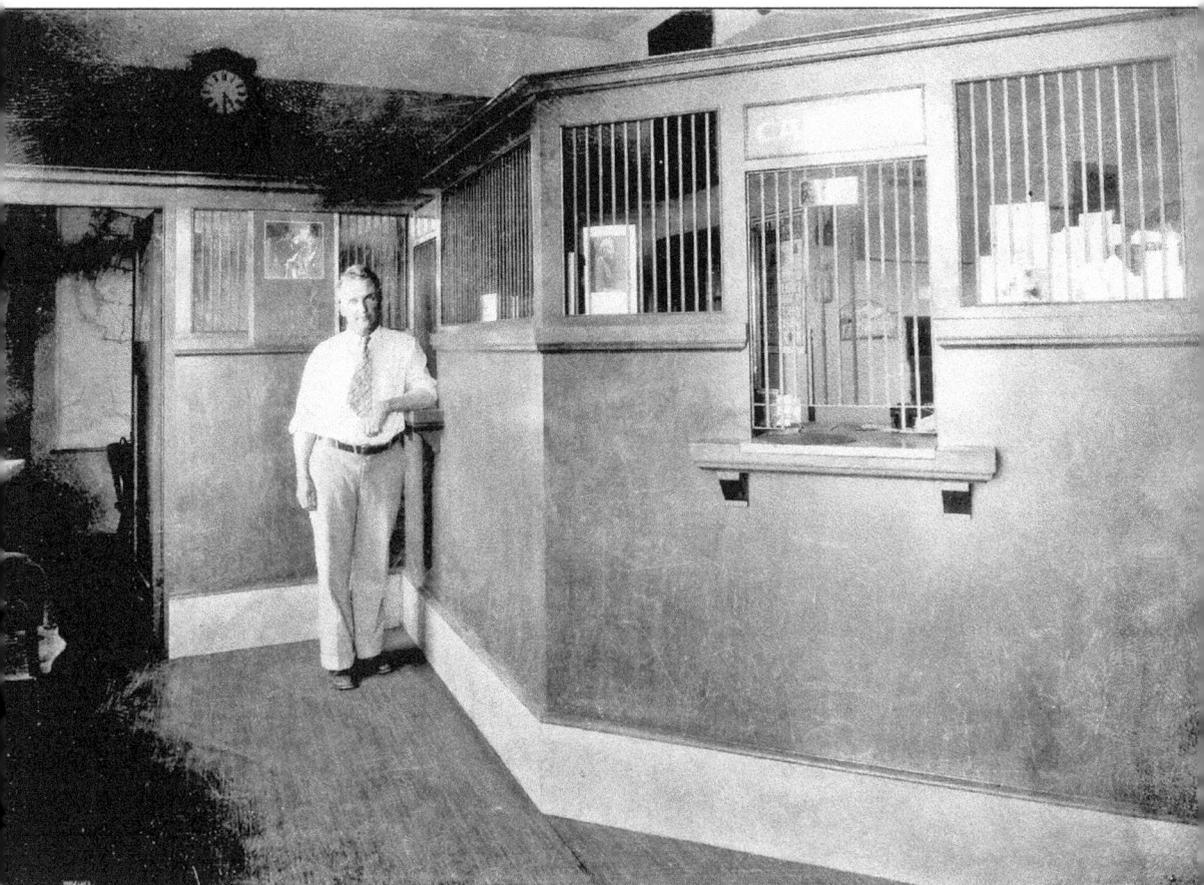

An unidentified man, presumably a bank employee, leans against an old-fashioned teller's window. The interior structure is laid out in essentially the same fashion as when it was first constructed—back when the in-house security system was a gun stashed in a holster below the teller's register. Although the floor plan is not dramatically new, there have been several improvements made, such as the installation of a permanent vault to replace the antiquated, hand-dial safe. (John Kline Collection.)

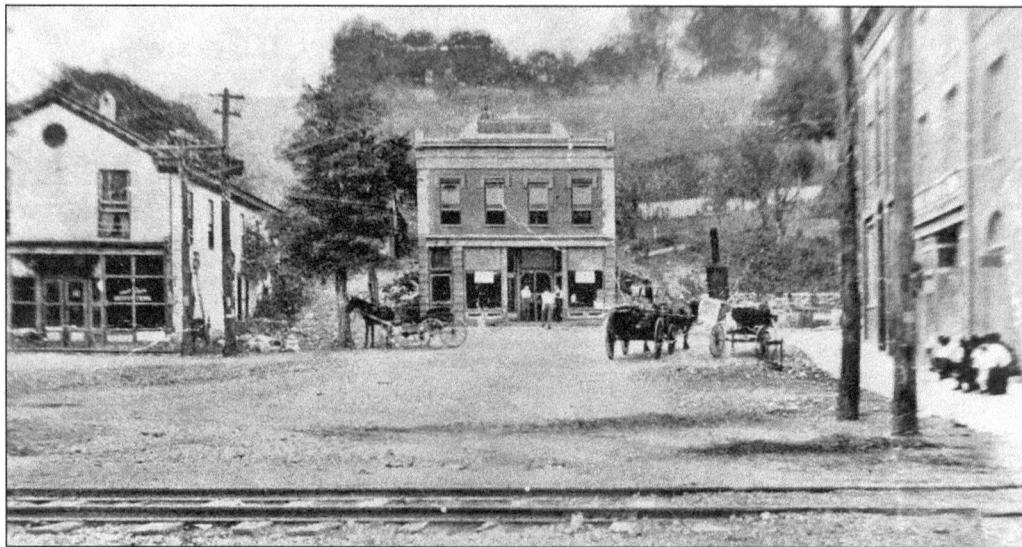

Montgomery County's first hospital was founded by Dr. A.M. Showalter in 1912. Called Altamont, it occupied the second floor of the building shown here at center. The Cambria hospital accommodated 12 beds and an operating room with a large skylight. Showalter ran the hospital here for another decade until he transitioned to a larger facility in town. The first floor of the building was occupied by Hickok's Pharmacy. Later, after the hospital was relocated, the building was home to the Do Drop Inn. (Mr. and Mrs. Richard Roberts Collection.)

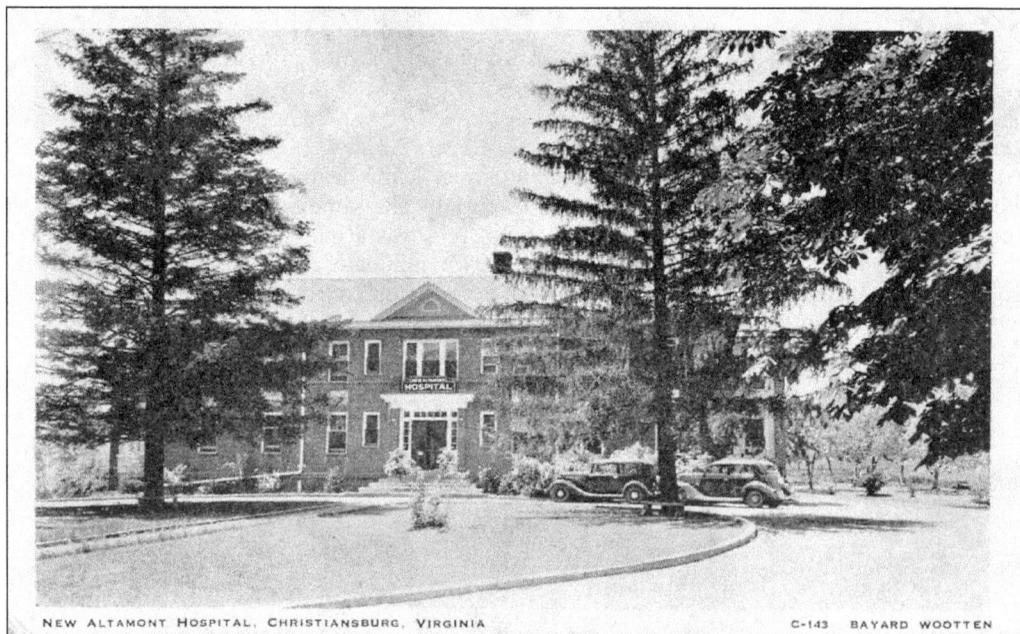

NEW ALTAMONT HOSPITAL, CHRISTIANSBURG, VIRGINIA C-143 BAYARD WOOTTEN

Dr. Showalter's Cambria hospital building was too small to keep pace with a growing community's health care demands, so the physician decided to relocate the medical service to Christiansburg town center in 1923. A stately structure was built at the head of a dramatic circular drive. The "new" Altamont Hospital accommodated 28 beds, rather than 12, and offered a pre-natal wing with 10 bassinets. The postcard is a depiction of the hospital by renowned North Carolina photographer Bayard Wootten. (Robert B. Basham Collection.)

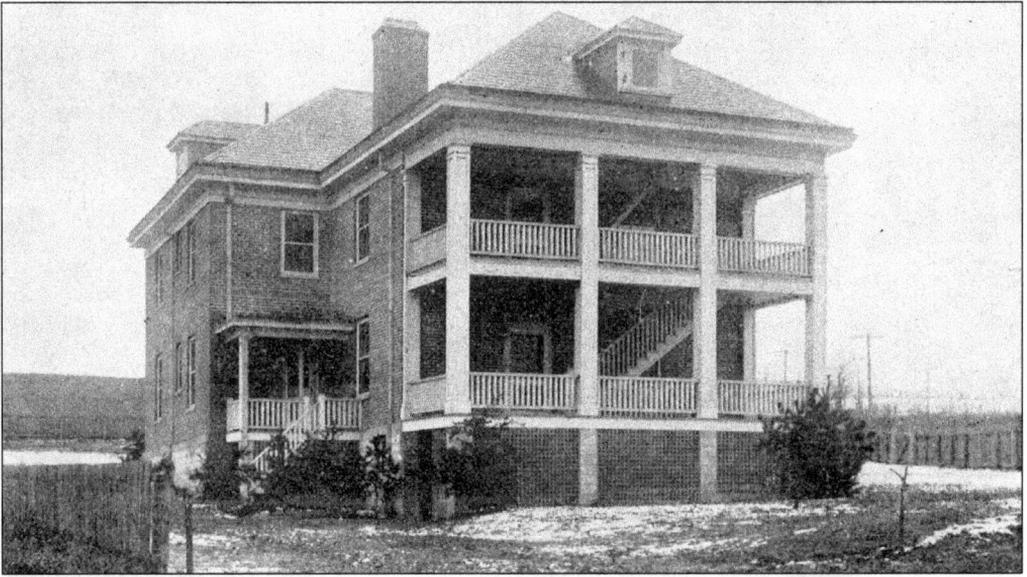

When Principal Long proposed to construct a hospital to serve the African-American community on the campus of Christiansburg Institute, he met with support from Dr. Showalter. In May 1918, the hospital was constructed on the school's campus at its eastern edge, close to where today's Scattergood Drive meets State Route 460. The hospital included porches on each of its two stories so that patients could take fresh air as part of their recuperative treatment. The medical facility provided health services and functioned as an experiential classroom for young women interested in professional and private health care. (Christiansburg Institute Museum and Archive.)

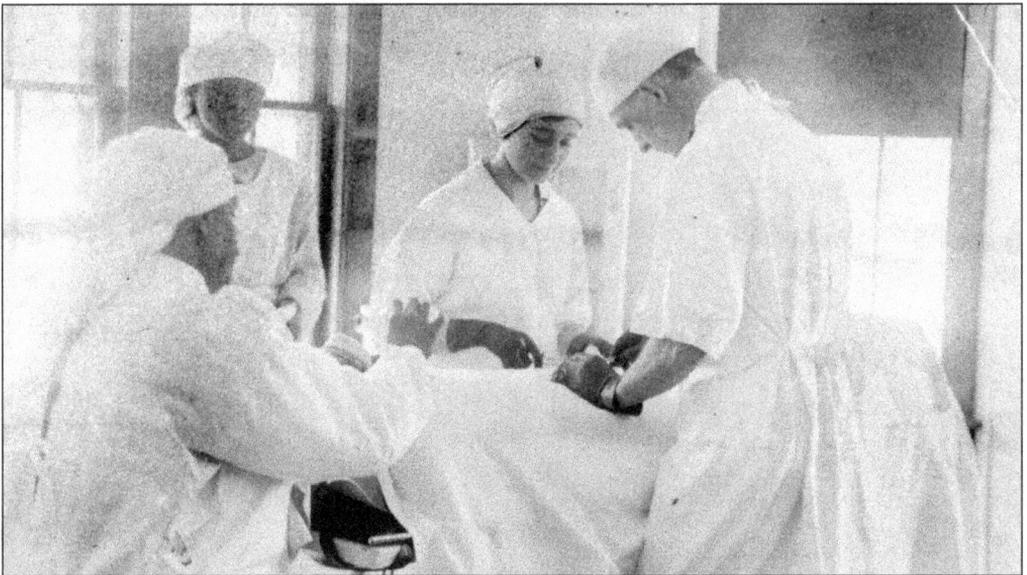

The Quakers, who provided the financial backing to construct the hospital, called it the "Christiansburg Experiment." The unique situation of having a hospital on a school campus was not what was experimental, however. The experiment that interested them was the hospital's interracial management. During a period of strict segregation, the Christiansburg Institute hospital's Board of Directors included Long and Showalter and was staffed by white doctors and African-American student nurses. (Christiansburg Institute Museum and Archive.)

This picture of a uniformed Hubert Horne (leaning against a brand-new Packard ambulance) was taken in the early 1940s. Horne's service epitomized the height of rural medical practice in that era. It was typical of early 20th-century funeral homes to provide emergency medical service. For many such companies, the hearse doubled as an ambulance. The Horne service was fairly unique in that its ambulance was a specifically designed, extended vehicle with room in the back for a stretcher and a full supply of up-to-date medical equipment. (Horne Family Collection.)

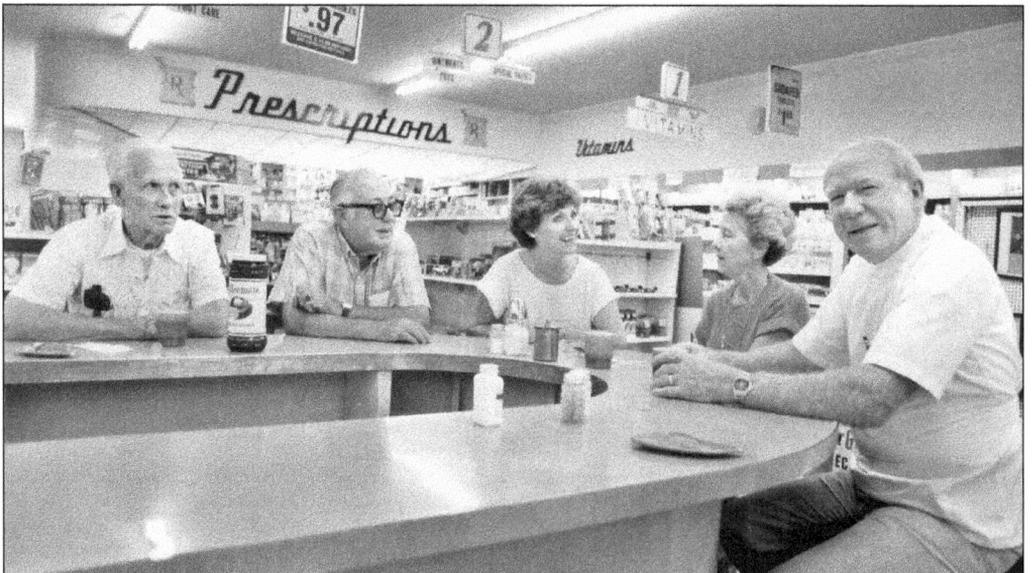

Christiansburg's pharmaceutical needs were served by Scottie Drugs on West Main Street and Thomson-Hagan Drugs on East Main. Owned by Dr. Nelson Ridinger, at far right, Thomson-Hagan included a soda fountain popular with the "regulars." Seated from left to right are Byron West, J.P. Joyner, Sandra Ridinger, and Georgia Cox. (*Montgomery News Messenger* Photographic Archive.)

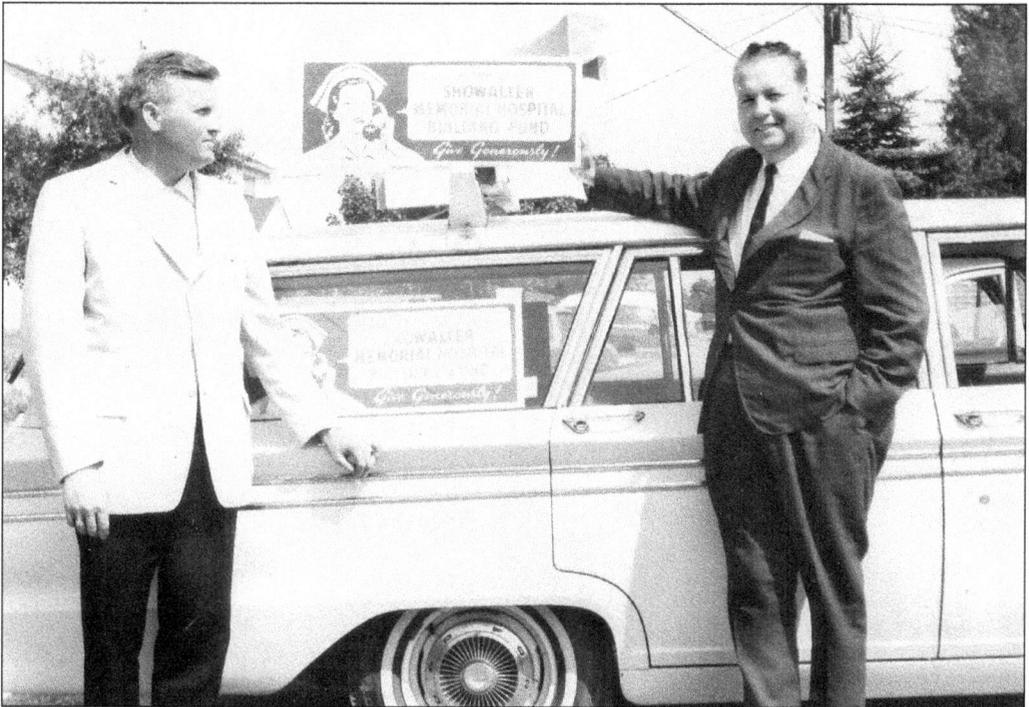

The new Altamont Hospital, founded by "Doc" Showalter, was renamed Showalter Memorial after his passing. His son, known by many locally as Dr. Joe, continued the Showalter name as a practicing physician at the hospital. This image depicts an on-the-road advertisement for the hospital's fund drive. Showalter Memorial closed in 1970, when a large community hospital was built on Route 460. (*Montgomery News Messenger* Photographic Archive.)

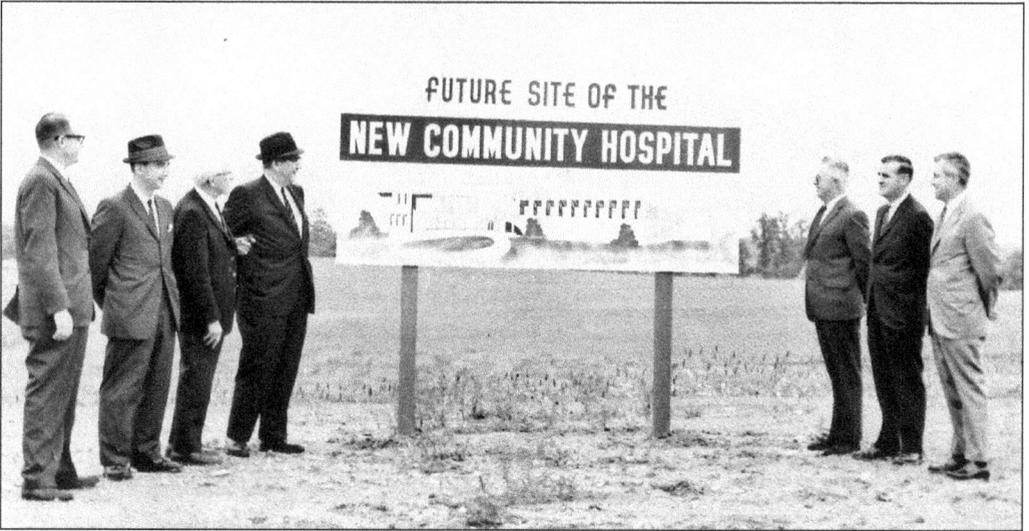

These gentlemen mark the future site of the Montgomery County Regional Hospital, opened in 1971 on Route 460 north of town. The new medical center signified the area's intensive commercial and residential development and brought state-of-the-art treatment and resources to the ever-increasing New River Valley population. (*Montgomery News Messenger* Photographic Archive.)

This three-story brick mercantile building was home to Hall Brothers Furniture Store and, by the time of this photograph, to Kittinger TV & Appliance. Located on East Main Street close to the town center, the turn-of-the-century structure was one of several historic commercial properties along this stretch of road that operated until the 1990s. (*Montgomery News Messenger* Photographic Archive.)

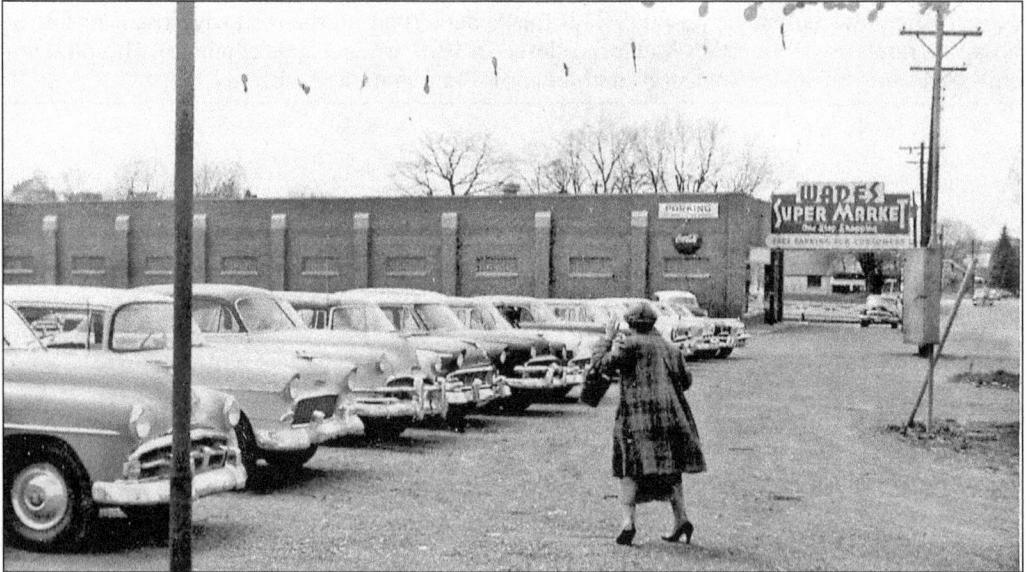

Wade's Super Market traces its history back to a turn-of-the-century general store operated by Mr. and Mrs. V.O. Light in the Alum Ridge area of Floyd County. The Lights' daughter and her husband, Haden Wade, purchased and expanded the Floyd business. Eventually, the Wades relocated to Christiansburg and opened the market under their own name. A century later, the modest grocery is now a regional chain, still managed by the Wade family. The woman pictured waves to an incoming automobile in April 1957 beneath a sign that promises "One Stop Shopping." (Robert B. Basham Collection.)

84

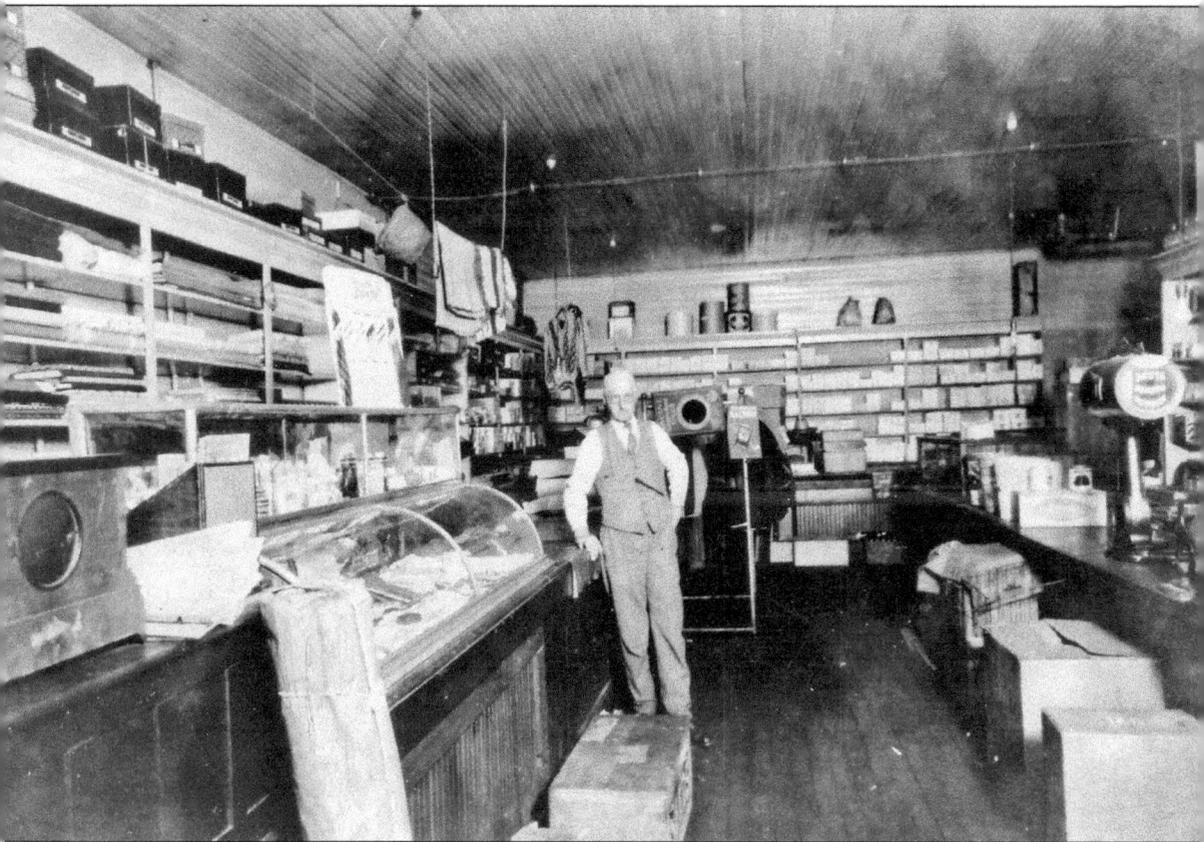

A distinguished merchant leans on the counter of his general store. Items of interest in the photo include bolts of fabric stacked on shelves behind the counter (at left) and a scale advertising Davis Baking Powder (at right). Glass cases are stocked with toiletries and notions, while shelving is stacked with an assortment of boxes and canned goods. A radio is perched on the end of the counter at lower left. (Mr. and Mrs. Richard Roberts Collection.)

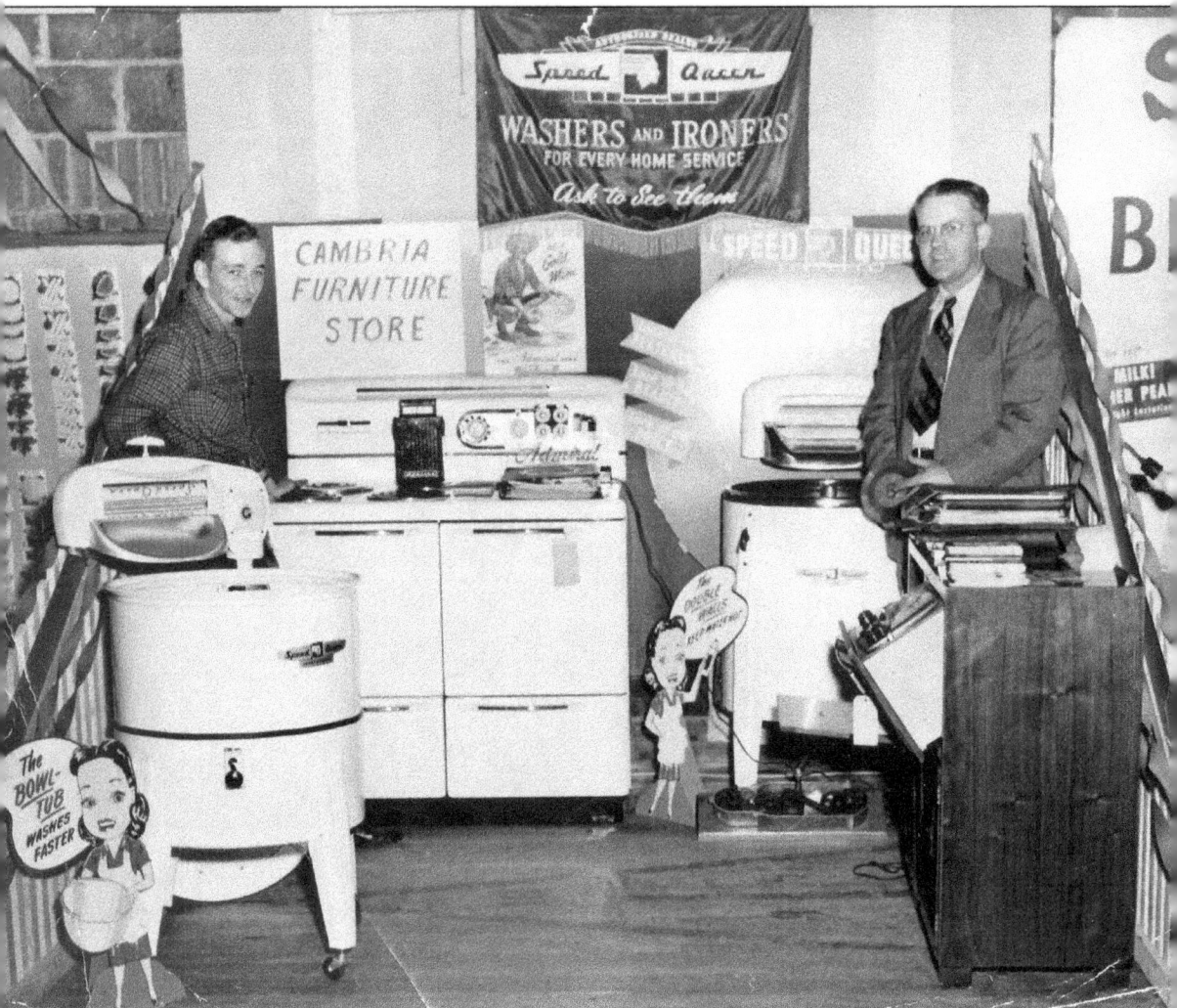

Howard Roberts opened the Cambria Furniture Store in the 1930s. He offered something for every local home, pairing traditional domestic accessories with up-to-the-minute appliances. Streamers highlight a new item while his employee at left is flanked by a neatly organized selection of seed packets. The Roberts family lived in a comfortable home just up the street. Howard's son Richard would skip down for a penny candy at the neighboring market before stopping in to visit his father at the store. (Mr. and Mrs. Richard Roberts Collection.)

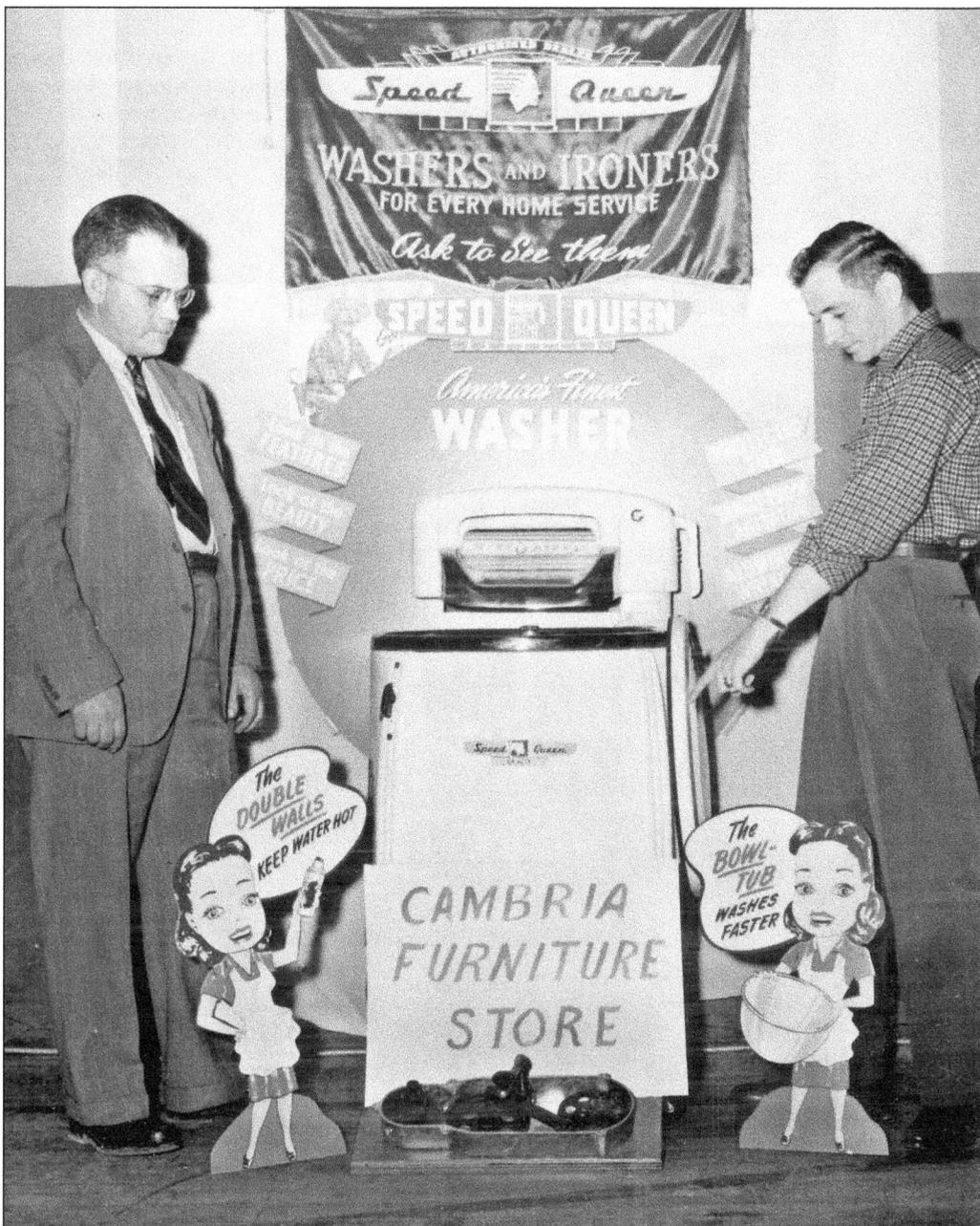

Roberts and his right-hand man pose with an impressive new washing machine. The Speed Queen advertising package displayed with the washer encouraged customers to "Look at the features, Look at the Beauty, and Look at the Price," in that order. The logo recalls a pre-discount superstore era, when quality and service were valued above cost. The Roberts' successful business was located on the lot now occupied by the First Virginia Bank. His shop burned in 1959 and was not reopened. (Mr. and Mrs. Richard Roberts Collection.)

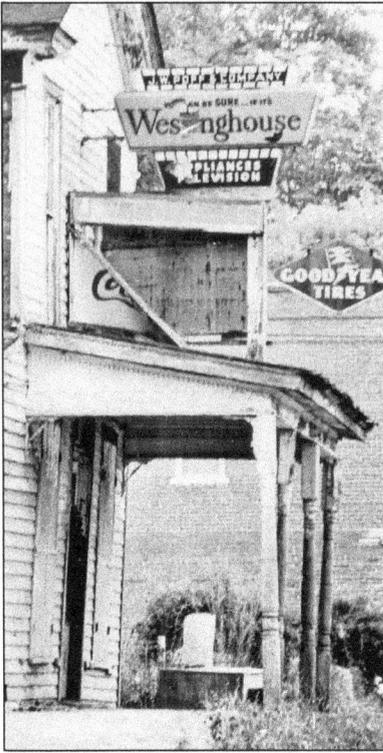

Throughout the 20th century, Christiansburg's citizens ran local stores that carried national brands like these, advertised by this array of signs appearing street side on a vacant house. Up until the development of the shopping malls at the intersection of Routes 460 and 114 on the northern edge of town, most businesses were locally owned and operated. (*Montgomery News Messenger* Photographic Archive.)

The town of Christiansburg felt the impact of the region's tremendous growth. What was once an original tract of farmland north of town along State Route 460 has become a major shopping district represented by international retail chains. Not everyone was happy with the expansion, however. A prophetic warning, "On the 8th day we paved it!" appeared on the front of Kmart during its construction in the 1980s. (Photograph by Anna Fariello; courtesy of the author.)

88

Eight

GOING TO SCHOOL

Sponsored by the local Kiwanis organization, Christiansburg High School's Key Club was actively involved in both school and community activities. In addition to organizing fundraisers and events, Key Club students raised and lowered the campus flag daily. Club members were chosen for their ability to represent standards of leadership, initiative, service, and civic responsibility. Members of the club raise their hands in a signature salute. (Photograph from a 1973 Christiansburg High School yearbook; courtesy of Shelda Wills; Collection of Montgomery County Public Schools.)

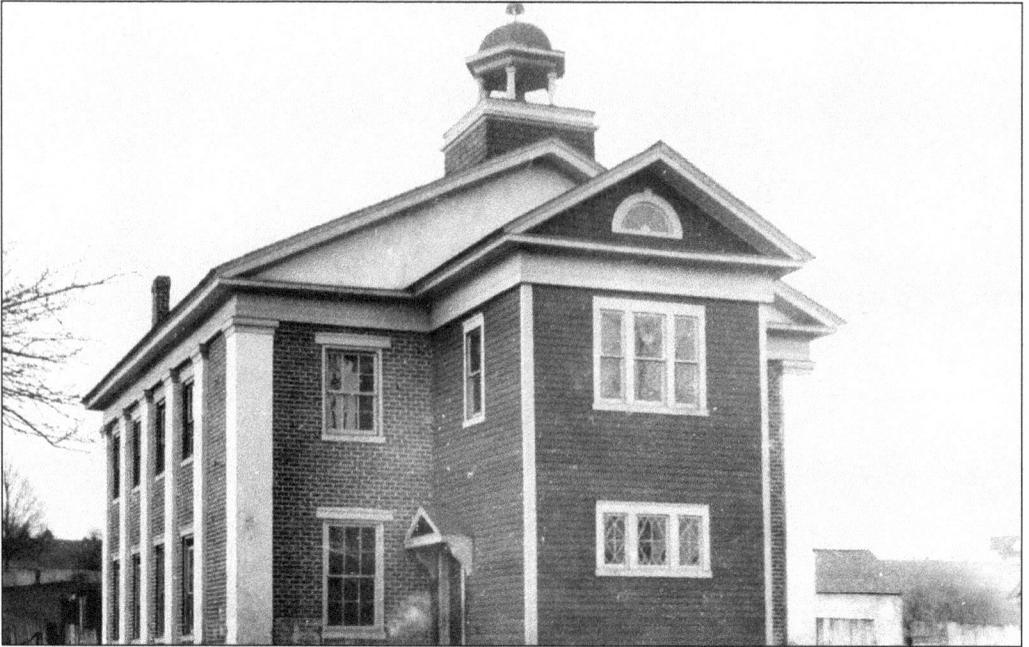

Christiansburg and its surrounds saw tremendous progress in education during the 19th century. Typical of this period, early academic institutions were often church-guided initiatives. The Montgomery Academy, shown here, was established by the Montgomery County Presbytery in 1849. The private college was located on the outskirts of Christiansburg proper on what is currently State Route 11. Many historical records describe the two-story brick building; its four rooms accommodated up to 70 young men. The building seems simple in structure at first glance, but the fancy paning on its first-floor windows and capped bell tower were distinguishing features. The academy operated until 1907, when a public program was offered at a new school on East Main Street. (*Montgomery News Messenger* Photographic Archive.)

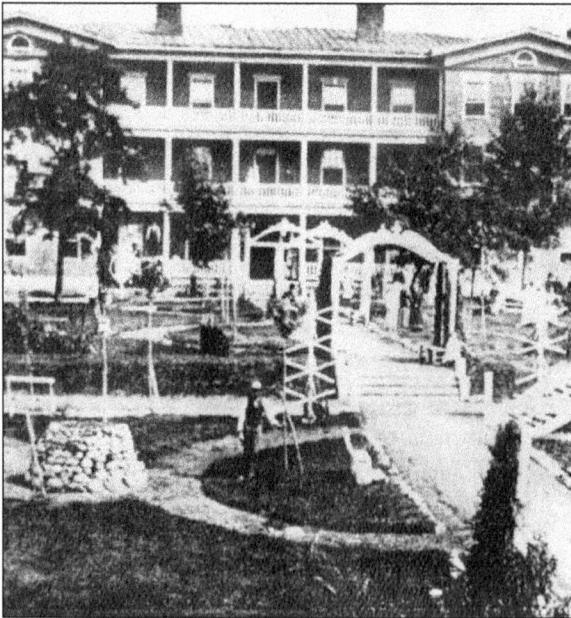

Within three years of the Male Academy opening, a Presbyterian Female Academy was established at Franklin and First Streets. By 1854, the women's program was served by newly constructed Montgomery Collegiate Institute at 208 College Street. The handsome building, on the seven-acre site of the former middle and high school, was built of bricks hand fired on the premises. As the Female Academy's reputation grew, it was known throughout the region as a prestigious finishing school for young Southern ladies. But under the direction of the three Black sisters in charge, mysterious accidents (falling off a train, a near drowning, and a bed set on fire) befell employees and diminished the school's attendance. (Horne Family Collection.)

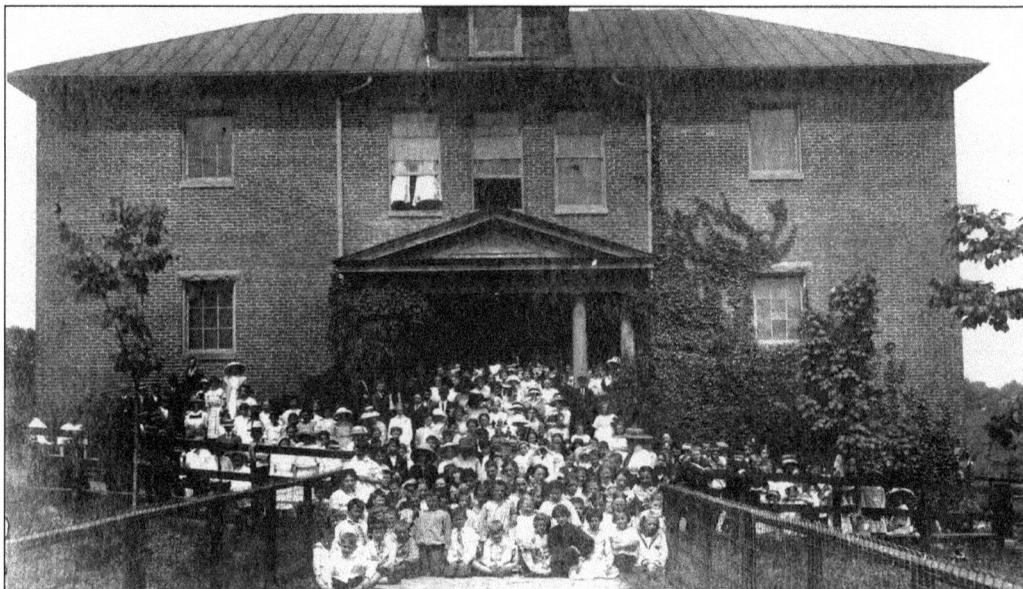

This two-story brick building on East Main Street was the first public school structure erected by the Montgomery County Board of Education. Designed in a style typical of academic buildings of the early 1900s, the school contained six to eight classrooms. A lightning rod atop the cupola was visible above the residential landscape. This classroom building served the town until the mid-1920s, when a larger facility was constructed on Junkin Street. This graduating class posed with their instructors spilling out the door onto the school's front steps on a bright May Day in 1911. (D.D. Lester Family Collection, Montgomery Museum and Lewis Miller Gallery.)

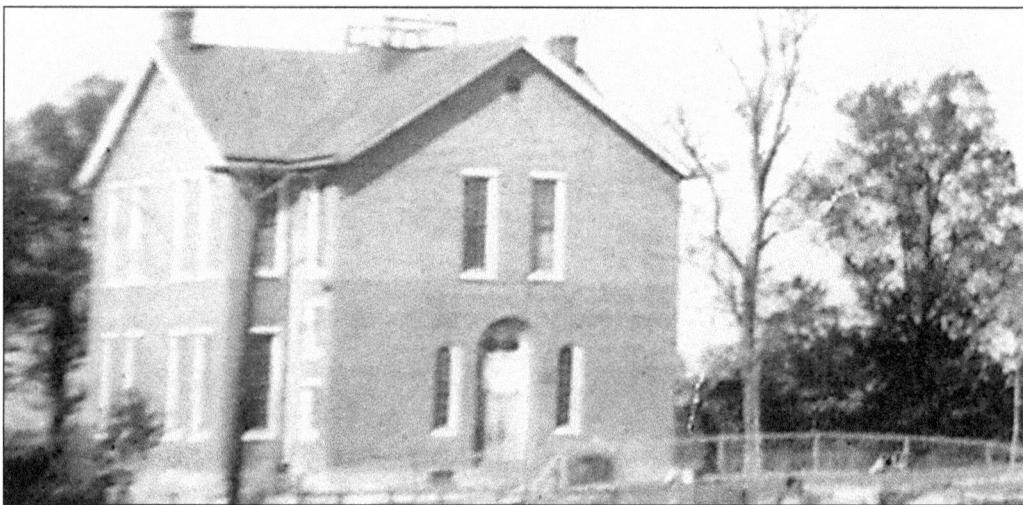

The East Main Street school (top photo) was limited to serving local white students; black citizens of Christiansburg maintained their own schools. In 1866, a Freedmen's Bureau school was established in a rented log school building on Zion Hill above Cambria. When the bureau closed in 1870, agent Charles Schaeffer ran the school using his own resources. A Pennsylvanian, Schaeffer sought the help of the Philadelphia-based Friends' Freedmen's Association, a philanthropic Quaker organization. In 1885, a new brick academic hall was dedicated with 13-inch-thick walls. Its five classrooms served Christiansburg Institute's needs until 1900, when the school expanded to a new campus. (Christiansburg Institute Museum and Archive.)

In 1872, Virginia Agricultural and Mechanical College was established in a single building located on five acres of land. Within a few years, it expanded to over 300 acres that formed its campus core. In its earliest days, the all-male student body lived in barracks and participated in a compulsory military program. In 1896, the school changed its name to Virginia Polytechnic Institute and was known locally as VPI for the better part of a century. The building pictured here is the 1907 Agricultural Hall. (Campus Views and Maps Collection, Digital Library and Archives, Virginia Polytechnic Institute and State University.)

Most of Virginia Tech's campus has been constructed from what is known locally as "Hokie stone," mined from the university's own limestone quarry. Today's educational institution—with the official name of Virginia Polytechnic Institute and State University—includes over 100 buildings located on a 2,600-acre campus at the northern edge of Montgomery County. Virginia Tech provides education and employment to many Christiansburg citizens. The 1926 War Memorial Gymnasium was constructed along the southern side of the campus drill field. Until its demolition, the gym mirrored Burrus Hall at the opposite side of the field. (Campus Views and Maps Collection, Digital Library and Archives, Virginia Polytechnic Institute and State University.)

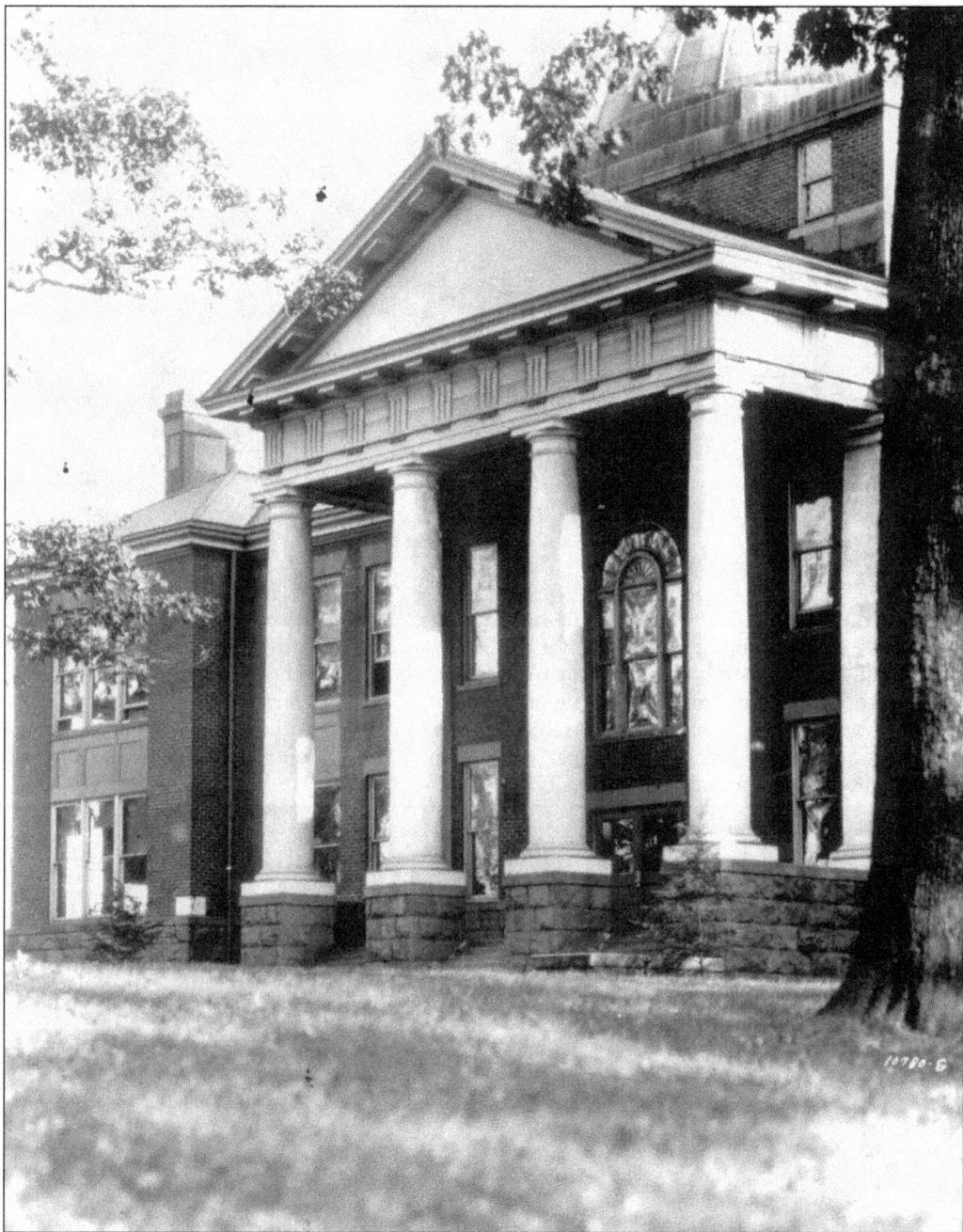

As counties built schools during the first half of the 20th century, there were not enough teachers to instruct local students. Normal colleges were those specifically created to train teachers during a time of tremendous growth in the region's educational system. In 1910, Radford University was established as one of the state's public normal colleges. Originally only for women, during the 1970s, the school became coeducational and earned university status. This image is of its handsome library, named for John Preston McConnell, president of Radford College from 1911 until 1937. (Norfolk & Western Historical Photograph Collection, Digital Library and Archives, Virginia Polytechnic Institute and State University.)

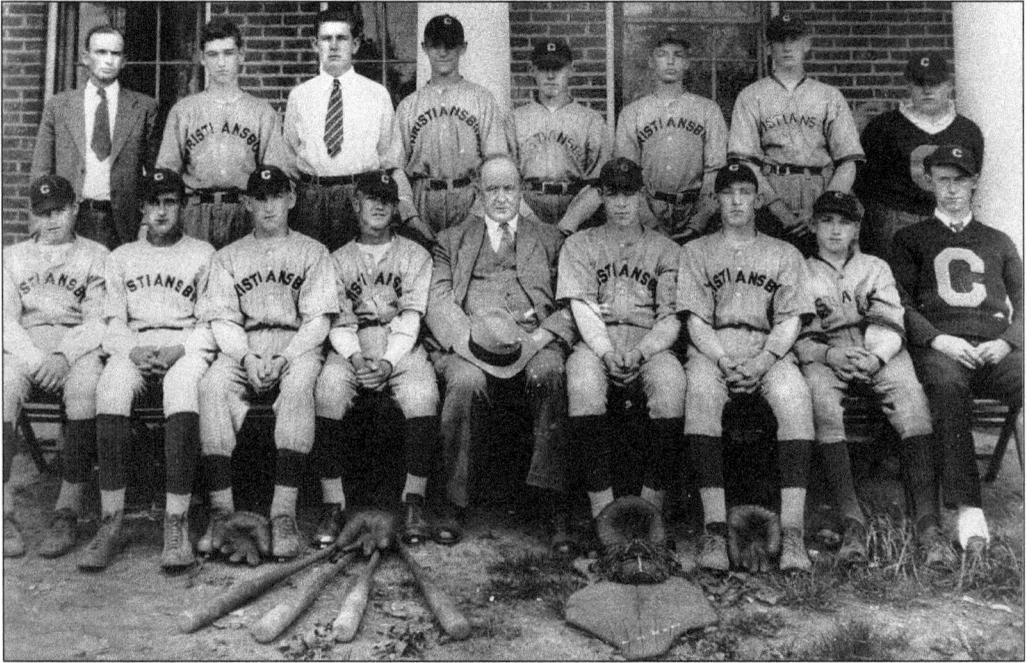

A serious-looking group of athletes sat for this uniformed portrait in front of the Junkin Street school building. Constructed as the town's second public high school building, it was named for George Junkin, the county's first superintendent of public instruction. In this early 20th-century portrait, the Christiansburg baseball team posed with their wooden bats, blunt-fingered gloves, and catcher's gear. (Earl Palmer Collection, Digital Library and Archives, Virginia Polytechnic Institute and State University.)

Christiansburg High School taught courses that were practical as well as theoretical, providing students with an academic education and important life skills. The young woman at center proudly posed in the school's new driver education vehicle, flanked by instructors and staff. The automobile door advertises the support of the Adair Chevrolet Corporation and promises "Driver & Safety Education." The handsome Chevy is parked in front of the brick facade of the 1930s school building, visible in the background. (*Montgomery News Messenger* Photographic Archive.)

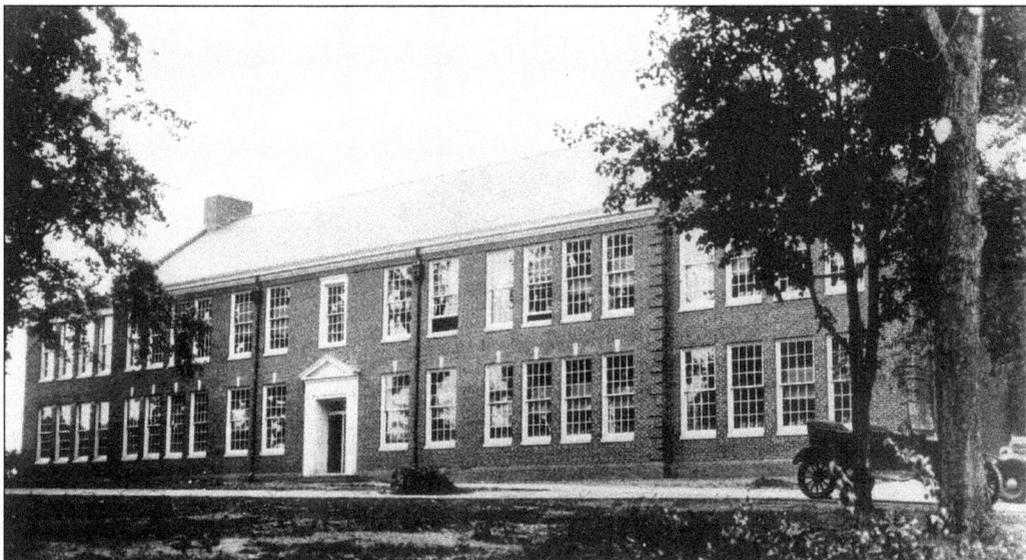

In the 1930s, a new and much larger Christiansburg High School was constructed on the site of the former Montgomery Female Academy. This 1936 photograph shows a much older car parked down the drive to the right, awaiting its passenger. The high school building sits on a rise a mile west of the courthouse square. (Southwest Virginia Images Collection, Digital Library and Archives, Virginia Polytechnic Institute and State University.)

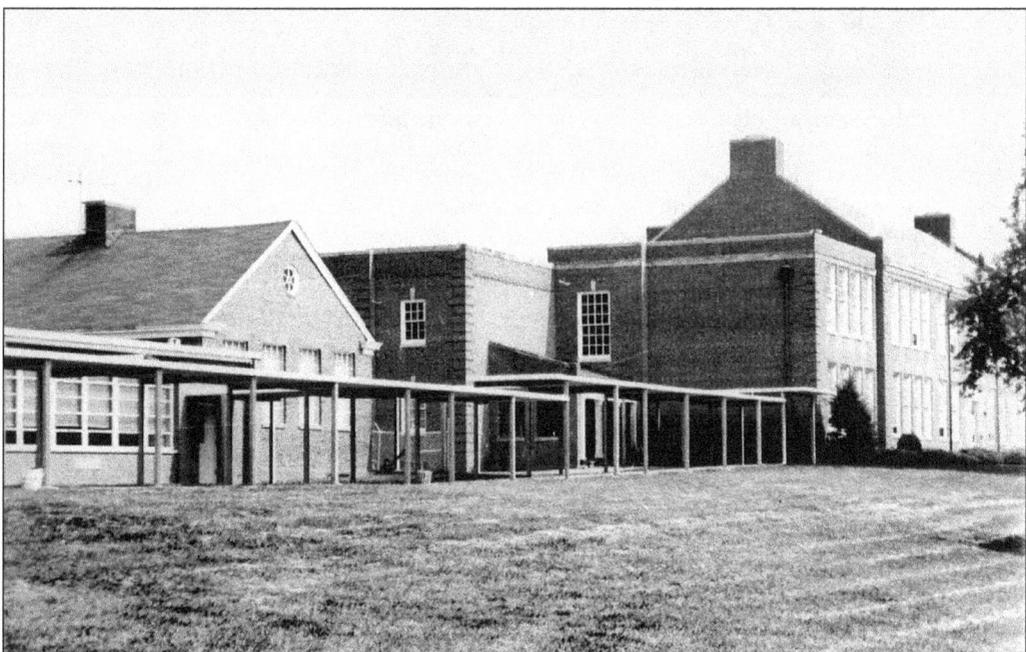

This view of Christiansburg High School dates to the mid-20th century. Several structural improvements to the original building were added to accommodate an ever-growing student body. When a new high school was constructed in 1974, the Depression-era building was converted to a middle school. It functioned as Christiansburg Middle School for the next 20 years and, today, has been converted to a school services building. (*Montgomery News Messenger* Photographic Archive.)

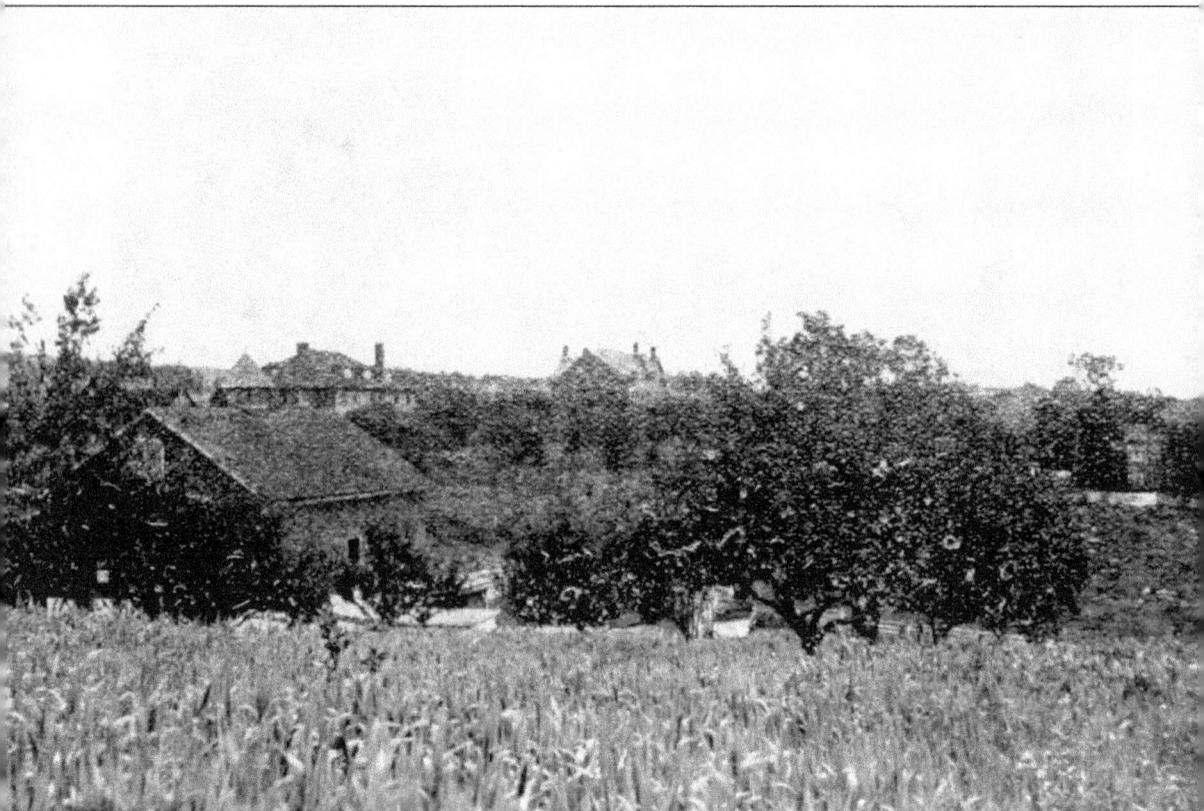

The African-American high school campus was located a few miles north of the town center. By the school's 50th anniversary in 1916, the campus had grown to include a shop, several teachers' cottages, a barn complex, and two handsome brick buildings. Before the end of the next decade, two more brick buildings were constructed. By the time Christiansburg Institute was closed in 1966, its campus had grown to almost 200 acres, lying north of Crab Creek along the west side of Route 460. The property that once made up the historic campus is today the site of the 1970s-era Christiansburg High School as well as several neighborhoods and shopping centers and the four-acre campus of the restored institute. (Christiansburg Institute Museum and Archive.)

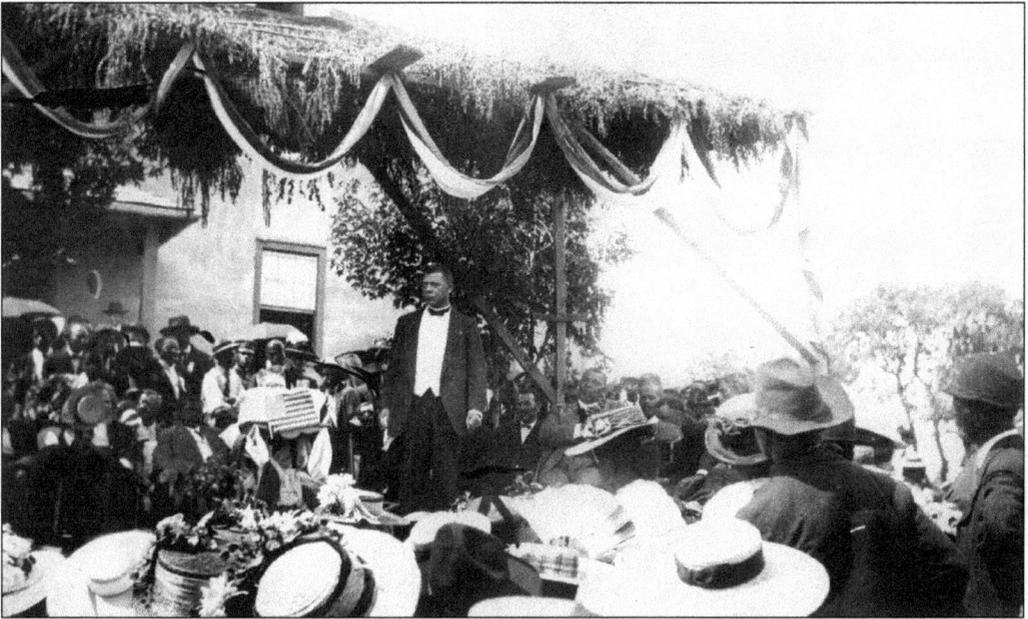

In 1896, Booker T. Washington, founder and leader of the Tuskegee Institute, agreed to serve as supervisor of the Christiansburg school. In 1909, Washington arrived on campus to speak before a large crowd of black and white citizens. The *Montgomery Messenger* covered the event, reporting that upwards of 5,000 people were in attendance. At the time, Washington was an influential educational leader who promoted a curriculum that would deliver life skills and promote economic independence. (Christiansburg Institute Museum and Archive.)

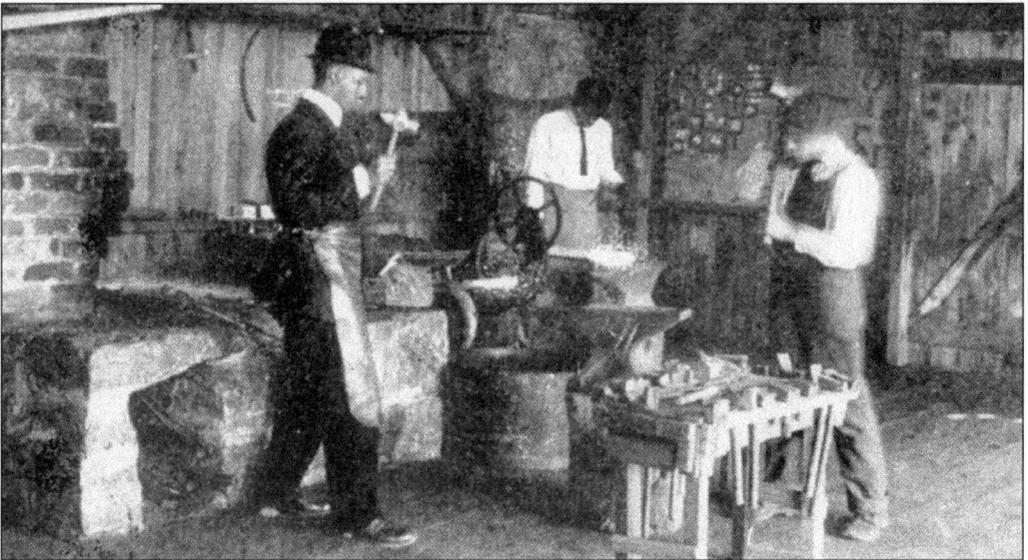

With the famed educator as its supervisor, Christiansburg Institute added agricultural and industrial courses to its classical and teacher-training programs. To better accommodate the new curriculum, the school acquired a farm. In 1902, the school's first trades building was constructed to provide work space for carpentry, blacksmithing, and printing. The student at right is a striker for the more advanced student—or teacher—at left. The student in the center is working at a separate forging station. (Christiansburg Institute Museum and Archive.)

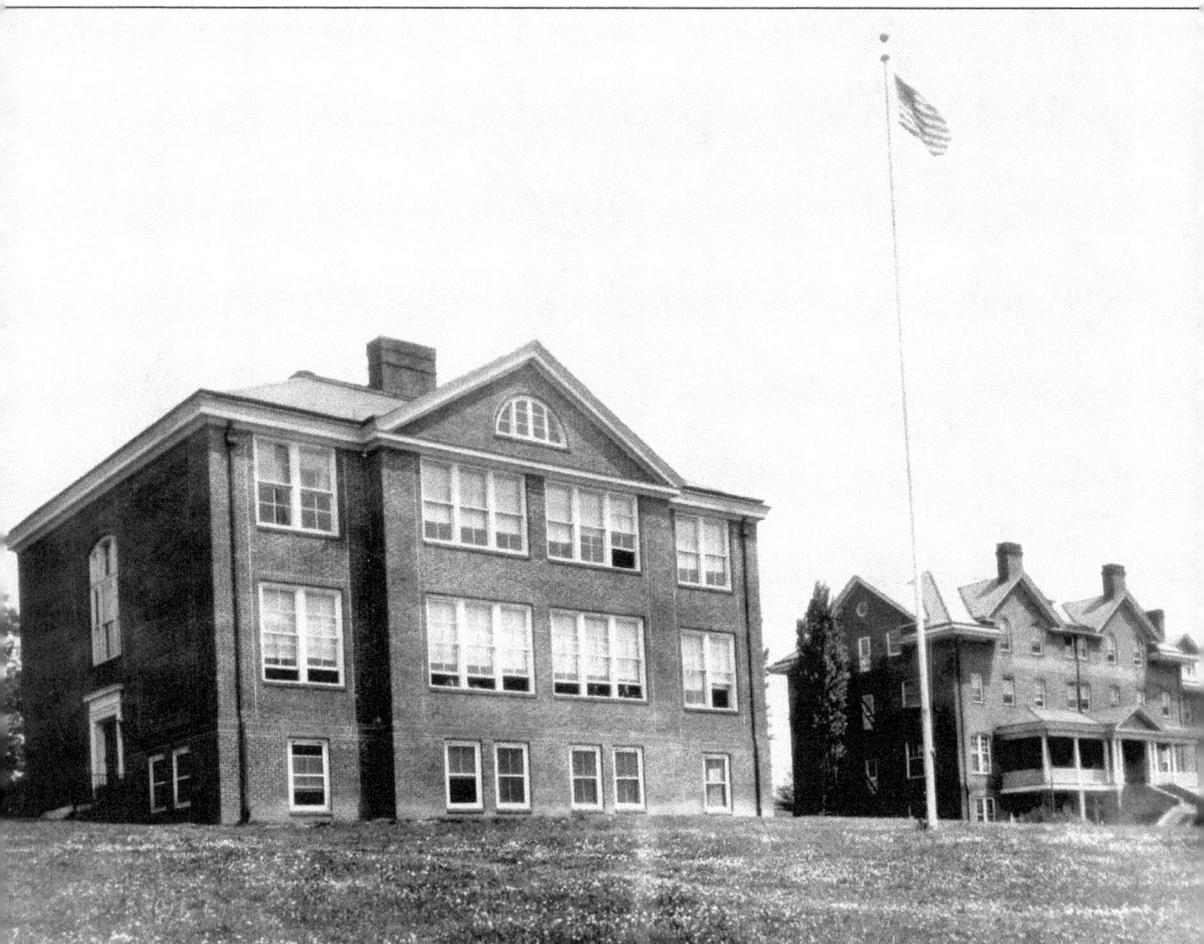

In 1927, the Friends' Freedmen's Association financed the construction of a new classroom building at left and named it in honor of Edgar A. Long, a beloved and dynamic school principal. Long had come to Christiansburg from Tuskegee in the last years of the 19th century with other newly hired teachers at the behest of Booker T. Washington. The Edgar A. Long building is currently the home of the revitalized Christiansburg Institute, which will include a community learning center, museum, and archive. Baily Morris Hall, the school's flagship building (at right), was torn down in the 1980s. (Collection of the Friends Historical Library, Swarthmore College; courtesy of Christiansburg Institute Museum and Archive.)

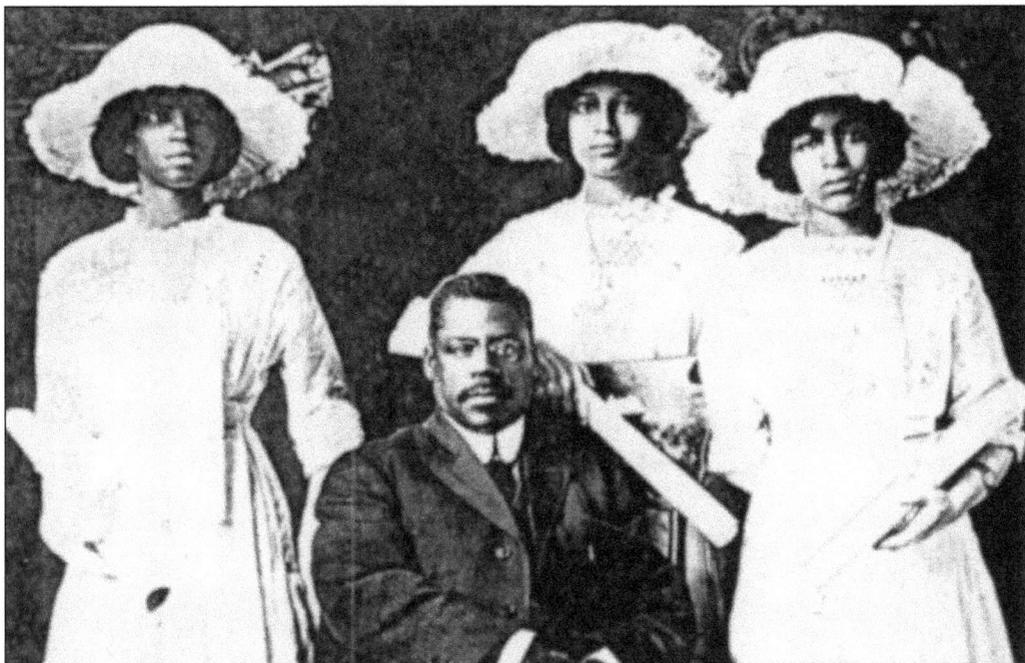

Principal Edgar A. Long sat for this formal portrait with members of Christiansburg Institute's graduating class in the early 20th century. After his arrival in the closing years of the previous century, Long served as the school's financial officer and printing instructor. In 1906, after the sudden and tragic death of his friend and fellow educator Principal Charles Marshall, Long was named principal, a position he held until his death in 1924. (Christiansburg Institute Museum and Archive.)

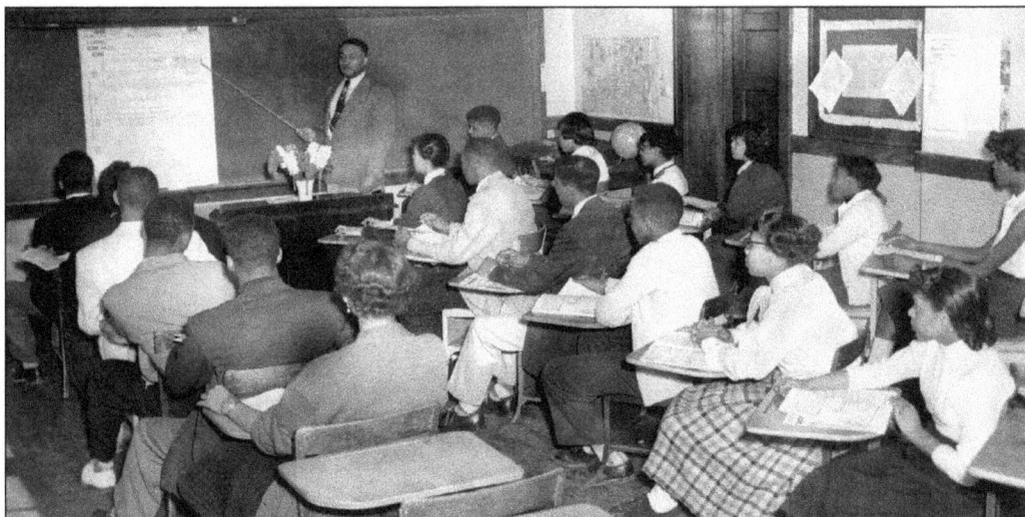

During the 1930s and 1940s, Christiansburg Institute underwent a transition from private academy to public school. Functioning as a regional high school in the absence of facilities for African-American students in Montgomery and Pulaski Counties, the school accommodated students from both counties and from the city of Radford. Here, a class of seniors receives instruction from Prof. Zimri Holmes in a government class held in the 1927 Edgar A. Long building. (Christiansburg Institute Museum and Archive.)

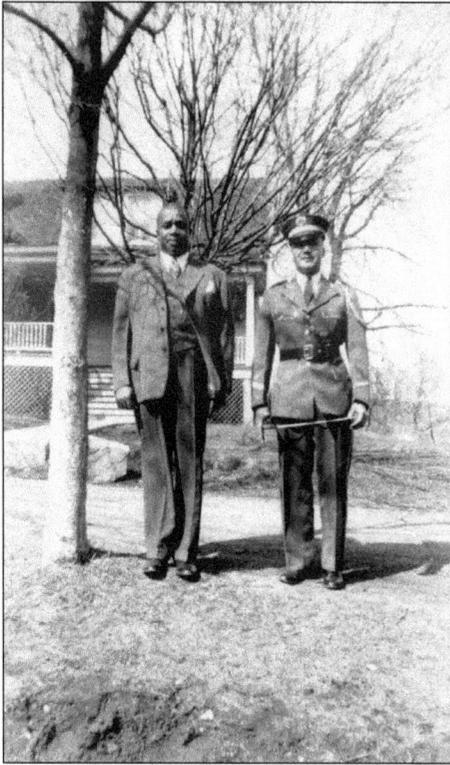

Christiansburg Institute's curriculum was augmented by a number of extracurricular activities, but it was its high school band that received the most acclaim wherever it performed. Posing on the grounds of the school is Principal Leslie Giles with Zedekiah Holmes, the school's renowned music instructor. While the bandleader holds his conductor's baton, Principal Giles stands at attention, appearing ready to join in the parade. (Christiansburg Institute Museum and Archive.)

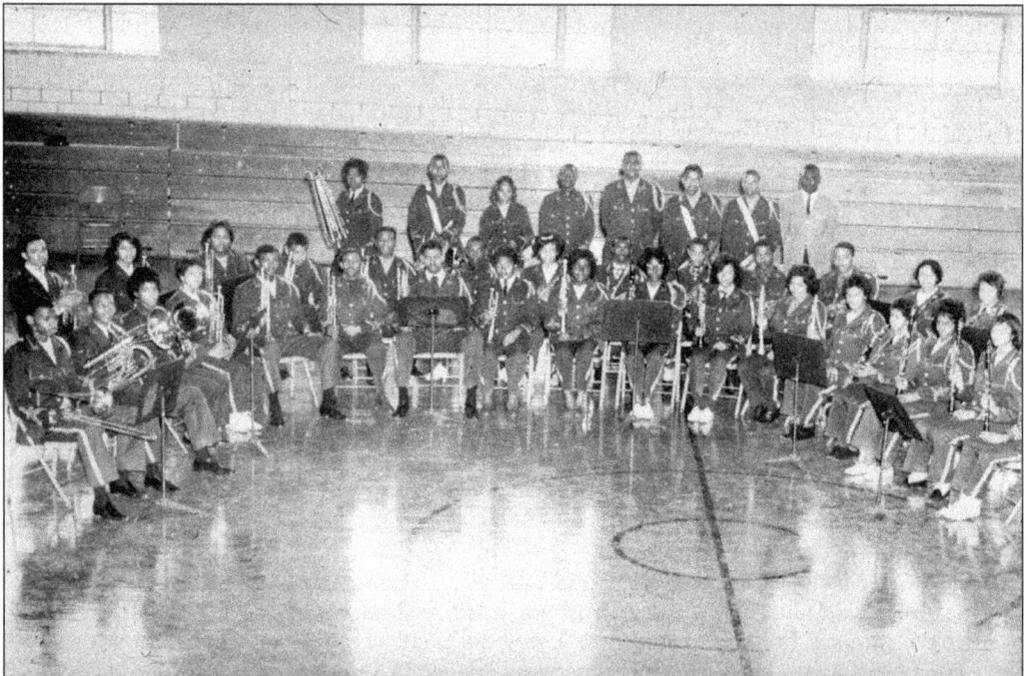

The Christiansburg Institute marching band poses on the floor of a new gymnasium, built in 1953 on Scattergood Drive. Alumni remark on the band's popularity and its performances in Christiansburg parades. (Christiansburg Institute Museum and Archive.)

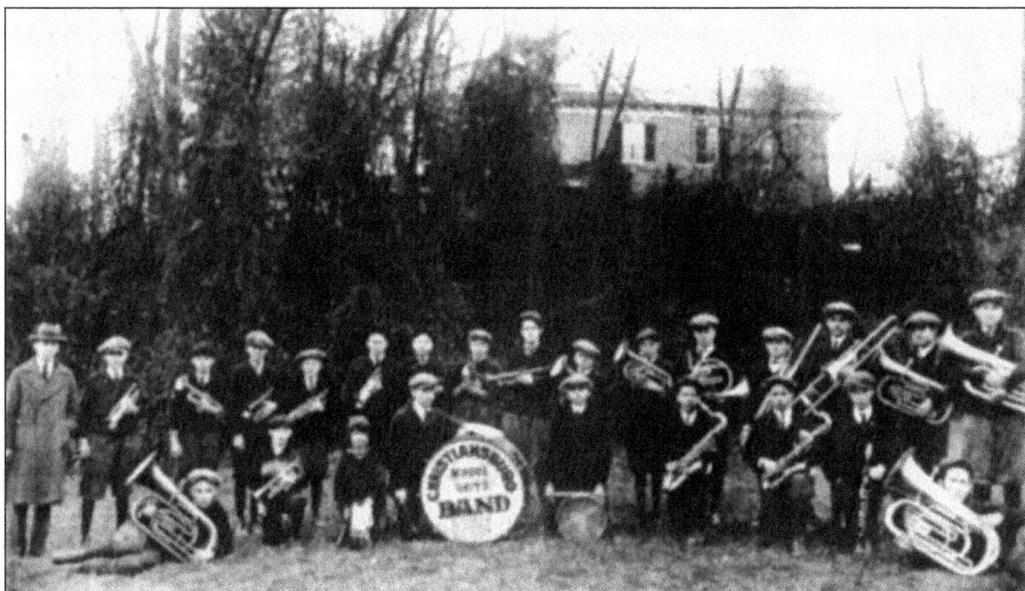

The Christiansburg School Boys Band posed for this 1922 photograph on the College Street lot below the Rangeley Estate. The musical group was almost entirely brass, save for the three percussionists in the middle of the seated row. Shown here from left to right are (seated) Arnold Smith, Lee Kenley, E. Heavener, Edgar Simpkins, Raper Shelton, Bill Gill, James Craft, James Haymaker, and Leon Johnson; (standing) band director King, J.T. Showalter, Mosby Mitchell, Clarence Sutphin, Ed Chrisman, Junior Roberts, Lance Knowles, Kenneth Ashworth, Bill Colhoun, Walter Hickok, Pat Kenley, Bob Hickok, Willard Bowen, and two Heavener boys. (Horne Family Collection.)

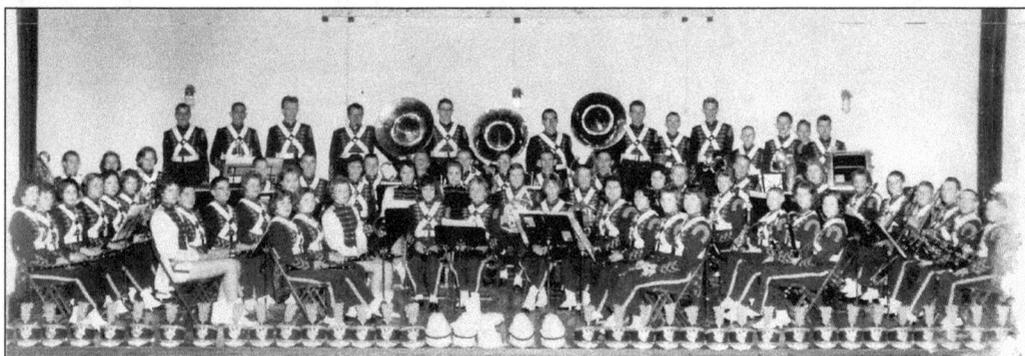

The impressive Christiansburg High School band numbered 54 students in 1961. The co-ed musical group, with their clean, crisp uniforms and excellent posture, sat for this formal portrait in the school's auditorium. Band hats, with ornate insignia and plumes, were placed neatly along the floor in the front row. (*Montgomery News Messenger* Photographic Archive.)

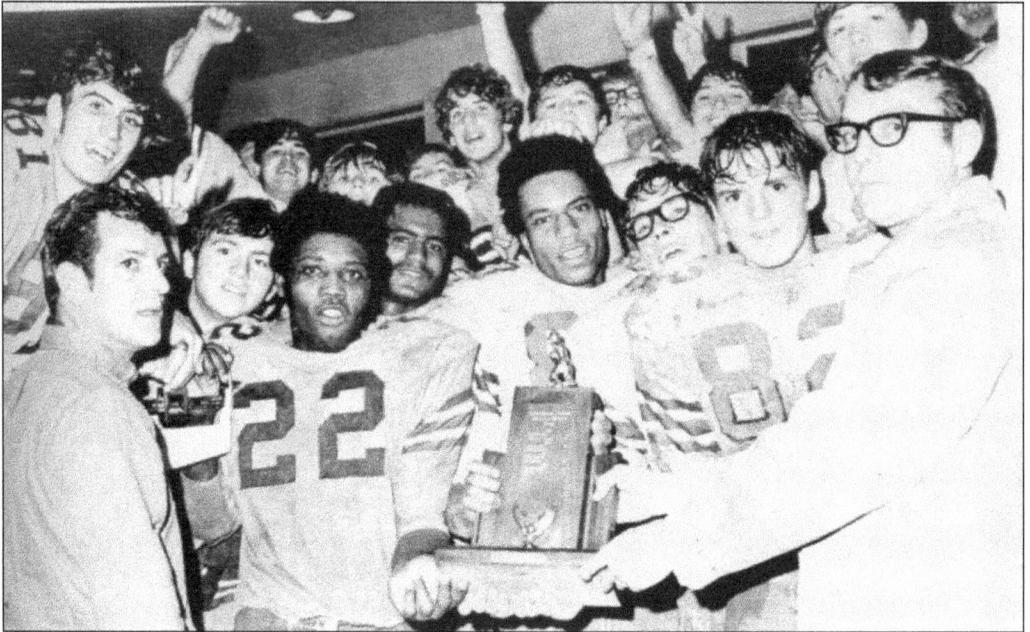

The 1971 Christiansburg football team, led by five senior co-captains, was crowned champion at the local homecoming game. The dedicated squad also celebrated a sought-after victory over neighboring Blacksburg High. Here, the team posed with coaches and the homecoming trophy. (Photograph from a 1971 Christiansburg High School yearbook; courtesy of Shelda Wills; Collection of Montgomery County Public Schools.)

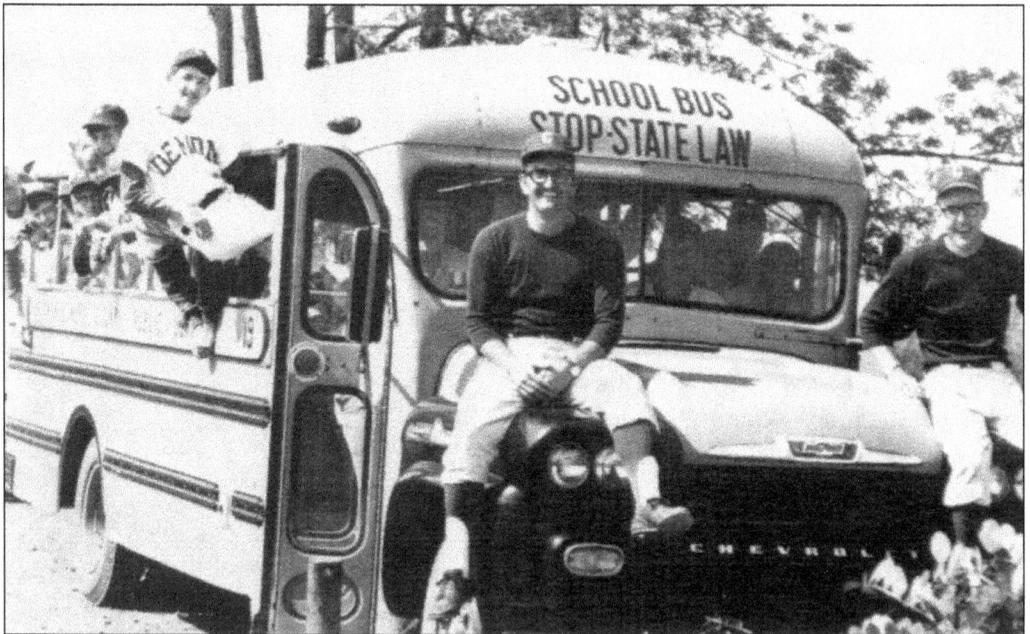

Very few athletic events say "Americana" like baseball. This 1971 Demon team hangs out of the school bus windows to celebrate another victory, while coaches Wally Flinchum and Arthur Poff find a seat on the Chevrolet's hood. (Photograph from a 1971 Christiansburg High School yearbook; courtesy of Shelda Wills; Collection of Montgomery County Public Schools.)

The 1971 Christiansburg High School Girls Athletic Association (GAA) was established to encourage female students to participate in sports and to reinforce a sense of school pride. The GAA traveled regularly on a "pep bus" to cheer at football and basketball games and hosted a year-end picnic and annual Sweetheart Dance. Posing here (left to right), each with a piece of athletic equipment, are Mae Gardner, Lulu Wirt, Peggy Phillips, Betty Jo Lester, Sandy Atkinson, and Vicky Hutchinson. (Photograph from a 1971 Christiansburg High School yearbook; courtesy of Shelda Wills; Collection of Montgomery County Public Schools.)

One of the most celebrated events of the academic year was the annual homecoming, a weekend marked with pep rallies, parades, a highly charged football game, and, of course, the crowning of a queen and king. These students demonstrate their school spirit by working on one of the many floats for the parade. (Photograph from a 1964 Christiansburg High School yearbook; courtesy of Shelda Wills; Collection of Montgomery County Public Schools.)

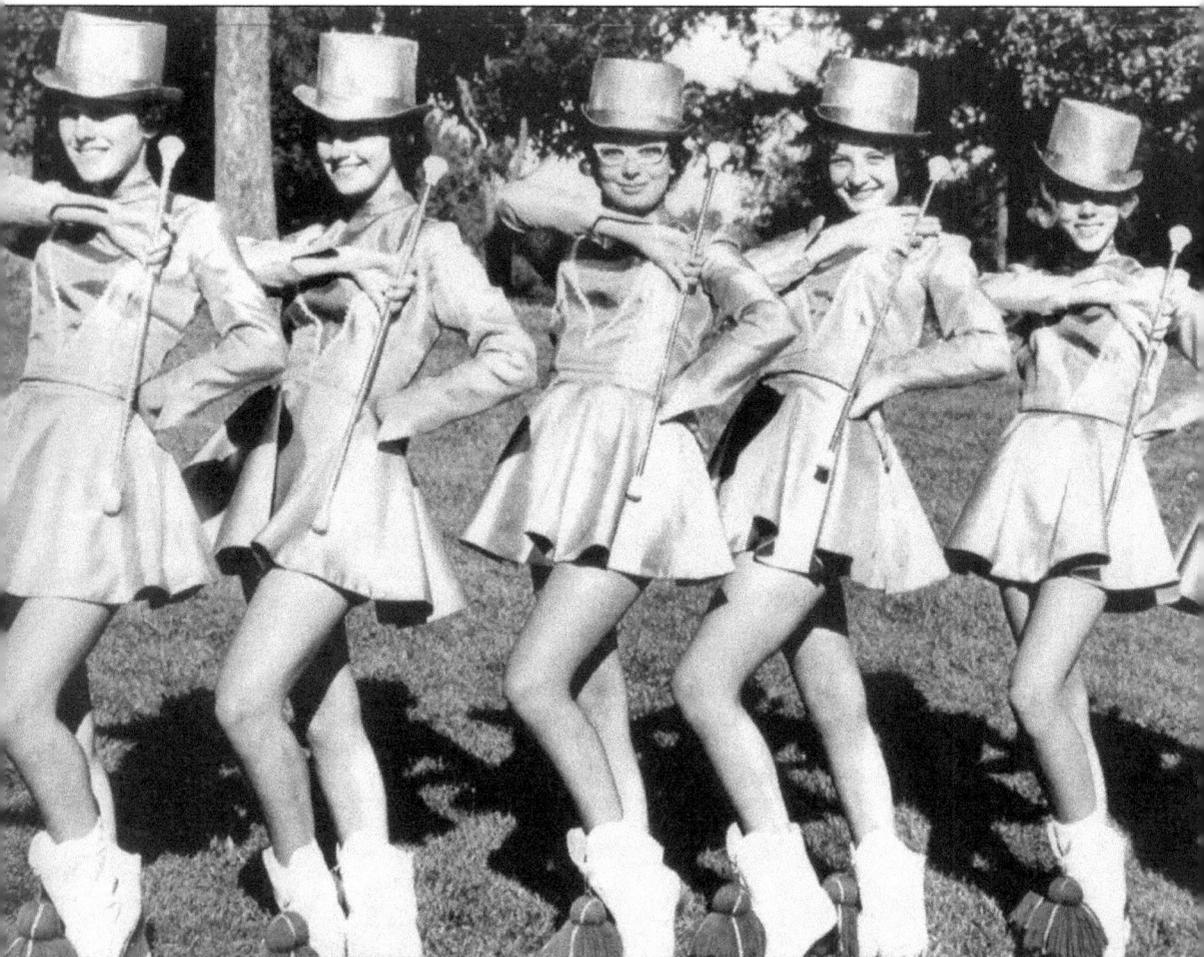

At Christiansburg High School (CHS), students were able to choose from a variety of extracurricular activities, including theater, band, athletics, student body politics, and other civic-minded organizations. This 1964 photograph depicts the uniformed CHS Majorettes: (left to right) Charlene Maxwell, Sandra Edwards, Pat Grandy, Marjorie Jordan, and Julia Earles. (Photograph from a 1964 Christiansburg High School yearbook; courtesy of Shelda Wills; Collection of Montgomery County Public Schools.)

Nine

BUILDING CIVIC LIFE

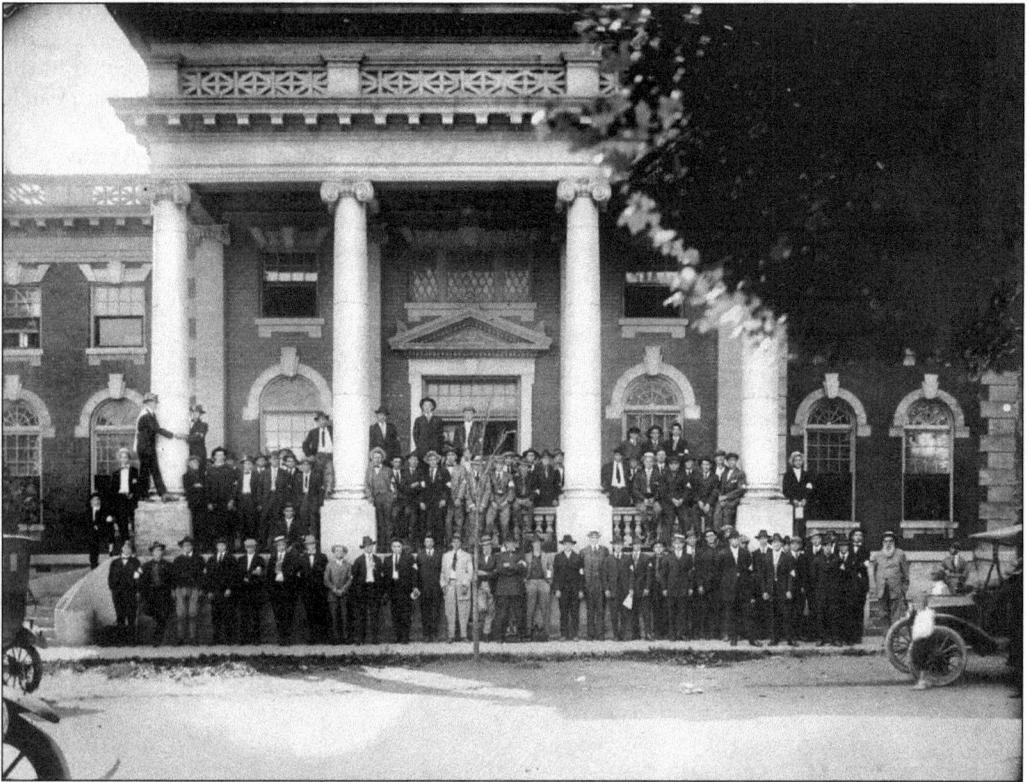

Taken May 24, 1918, this photograph portrays a group of World War I draftees gathered on the steps of Montgomery County's 1909 courthouse. Gentlemen off to service are distinguished by white armbands, while regular citizens join the group in plain dress. This crowd assembled to see the new soldiers off to training camp. The spoked tires of Henry Ford's horseless carriages are visible at the far right and left of a photograph restored by Earl Palmer. (Special Collections, McConnell Library, Radford University.)

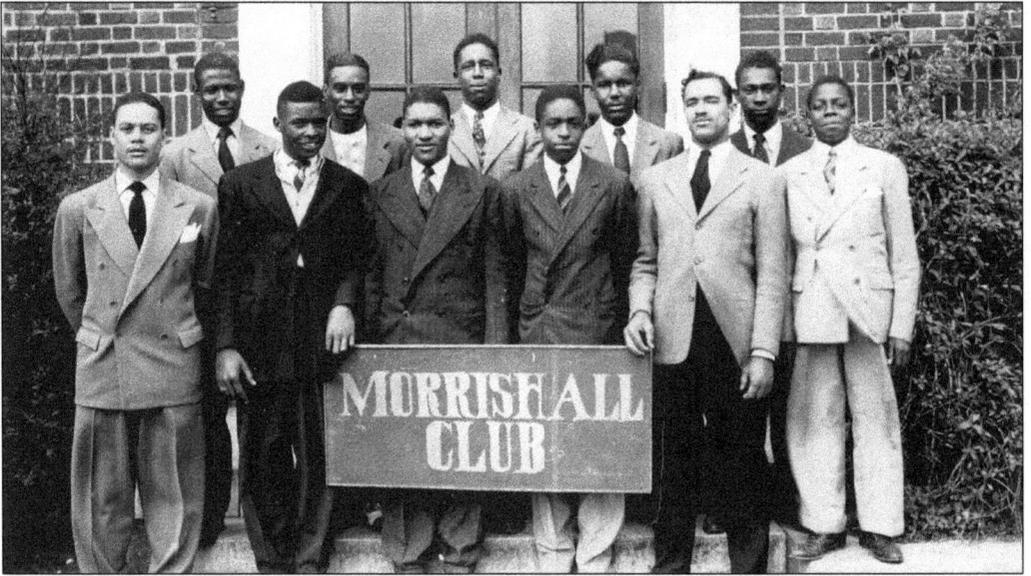

A group of high school students pictured here posed on the grounds of the Christiansburg Institute with a sign identifying their on-campus club. Many of the young men who joined the Morris Hall Club were boarders who lived in Morris Hall, a boys' dormitory constructed in the first decades of the 20th century. On-campus clubs, like this one and the Anna Woolman Circle for girls, were organizations in service to the community. Such service clubs reinforced values of leadership, compassion, and commitment. (Christiansburg Institute Museum and Archive.)

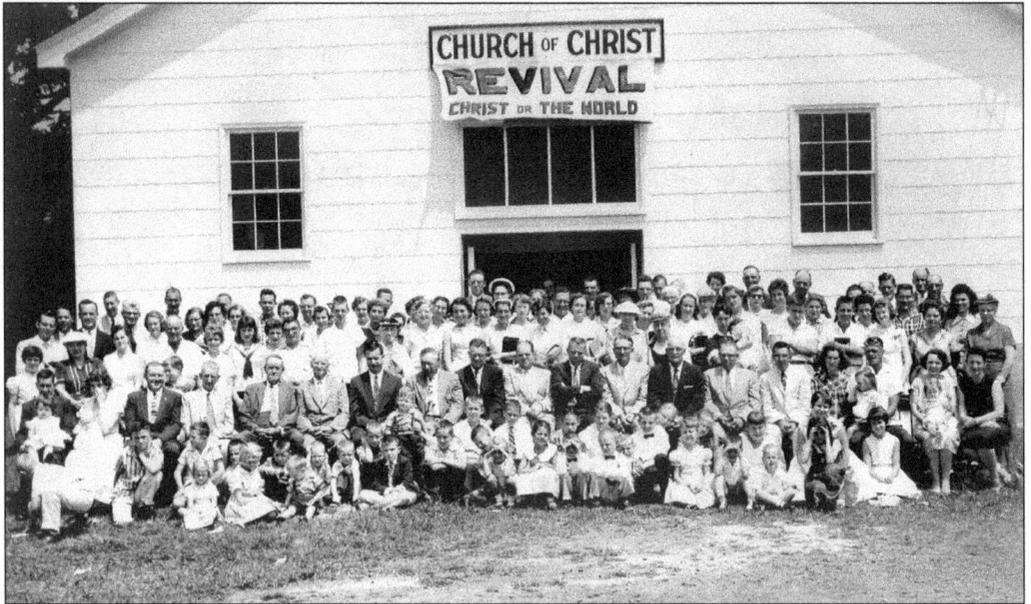

This revival took place on the site of the Union Church, originally constructed as a log meetinghouse in 1851. Located on the Blacksburg Turnpike that became present-day Route 460, the church over time became the Allegheny Church of Christ. This mid-20th-century gathering included several generations of families, from the church elders seated at the rear to the youngest in the front rows, attempting to sit still for the photograph. (*Montgomery News Messenger* Photographic Archive.)

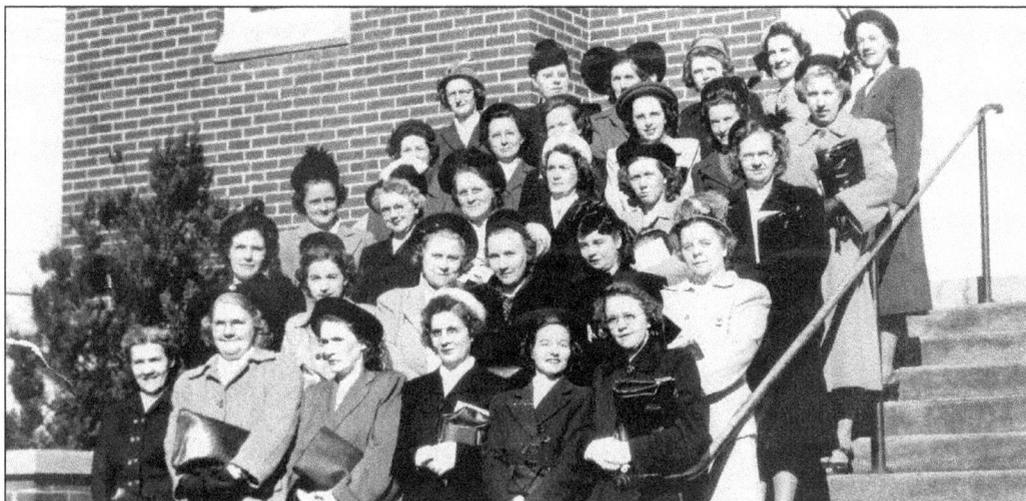

The history of Baptists in the region dates to the end of the 18th century, when a group of Primitive Baptists constructed their first church on Meadow Creek. By 1872, the Baptist congregation had constructed a church on a northerly hillside overlooking Cambria. The new structure became home to a thriving congregation who worshipped in these pews for another decade. Without the right to vote, women joined church congregations and influenced community behavior through church participation. Churches continued to attract women parishioners well after their enfranchisement in the 1920s, as this mid-20th-century photograph attests. (Mr. and Mrs. Richard Roberts Collection.)

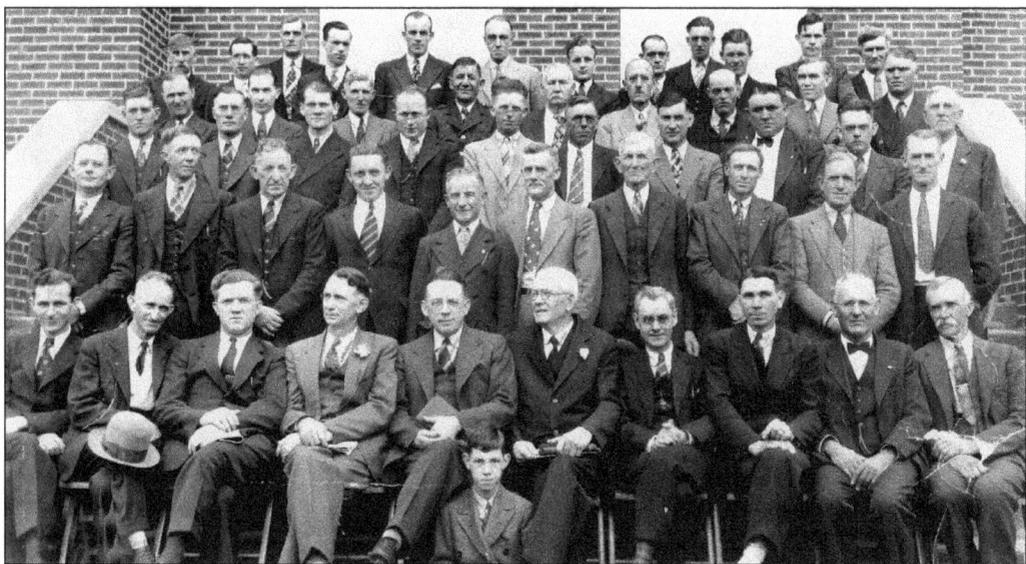

The local Baptist church board decided to relocate their church in 1885, when a more generous lot closer to the depot center became available. They designed a white frame building with a noteworthy steeple that stood out against an increasingly industrial landscape. The 1885 steeple is identifiable in an early view of Cambria (page 48). The parsonage was located in a modest four-room structure to the rear of the church building. A fire destroyed the building in November 1927. When the Baptist leadership recommended a new brick structure in 1928, the church was also renamed Cambria Baptist. This photograph of a men's study group was taken on the steps of the 1928 church and dates to 1938. (Mr. and Mrs. Richard Roberts Collection.)

The demure Christiansburg skyline has been defined by dramatic church spires since the earliest recordings of its landscape. Both sketch artist Lewis Miller and traveling painter Edward Beyer created views of Christiansburg that included its characteristic church spires (see page 10). Today, spiritual life remains an integral component of community and family life in Christiansburg. (*Montgomery News Messenger* Photographic Archive.)

Regional Methodist history dates to 1785, when the first Methodist institution west of the Alleghenies was established near Union, West Virginia. In Christiansburg, early 19th-century Methodist churchgoers met in a one-room, frame building near the old burying ground on present-day Pepper Street, before moving in 1855 to a two-story building nearby. A dramatic incline in church attendance had prompted the St. Paul Methodist congregation to move to East Main Street next to the county courthouse. There, they built the elaborate and richly detailed church on Courthouse Square that defined the Christiansburg skyline for so many years. This image shows the church with its Sunday school addition to the left. (D.D. Lester Family Collection, Montgomery Museum and Lewis Miller Regional Art Center.)

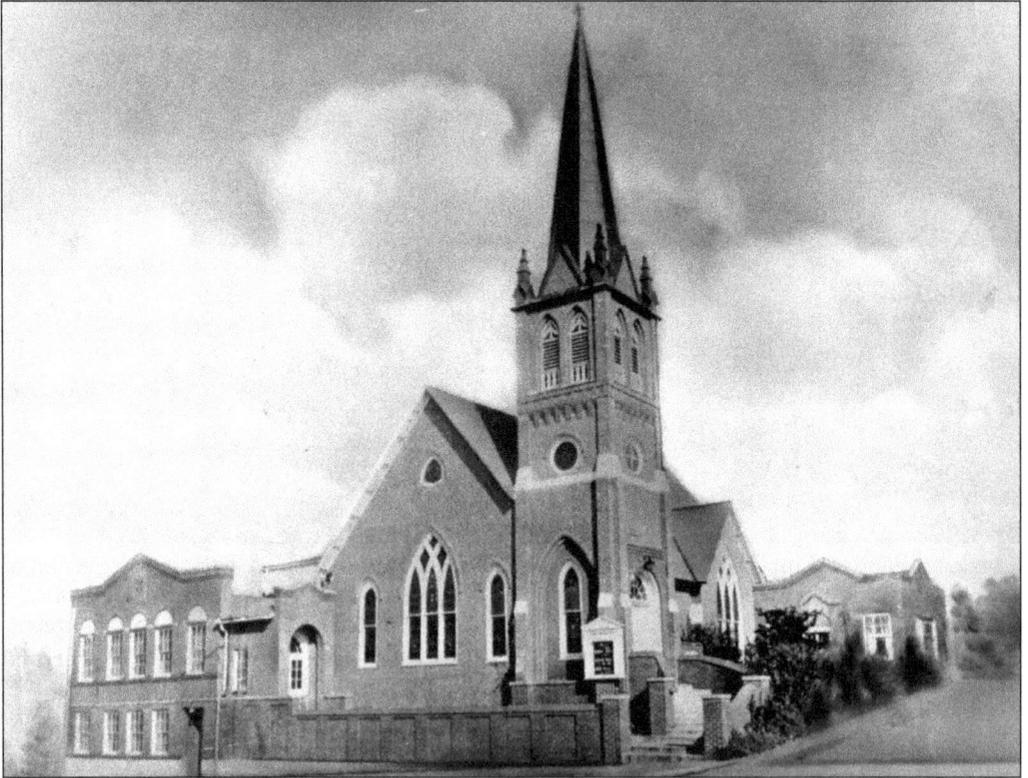

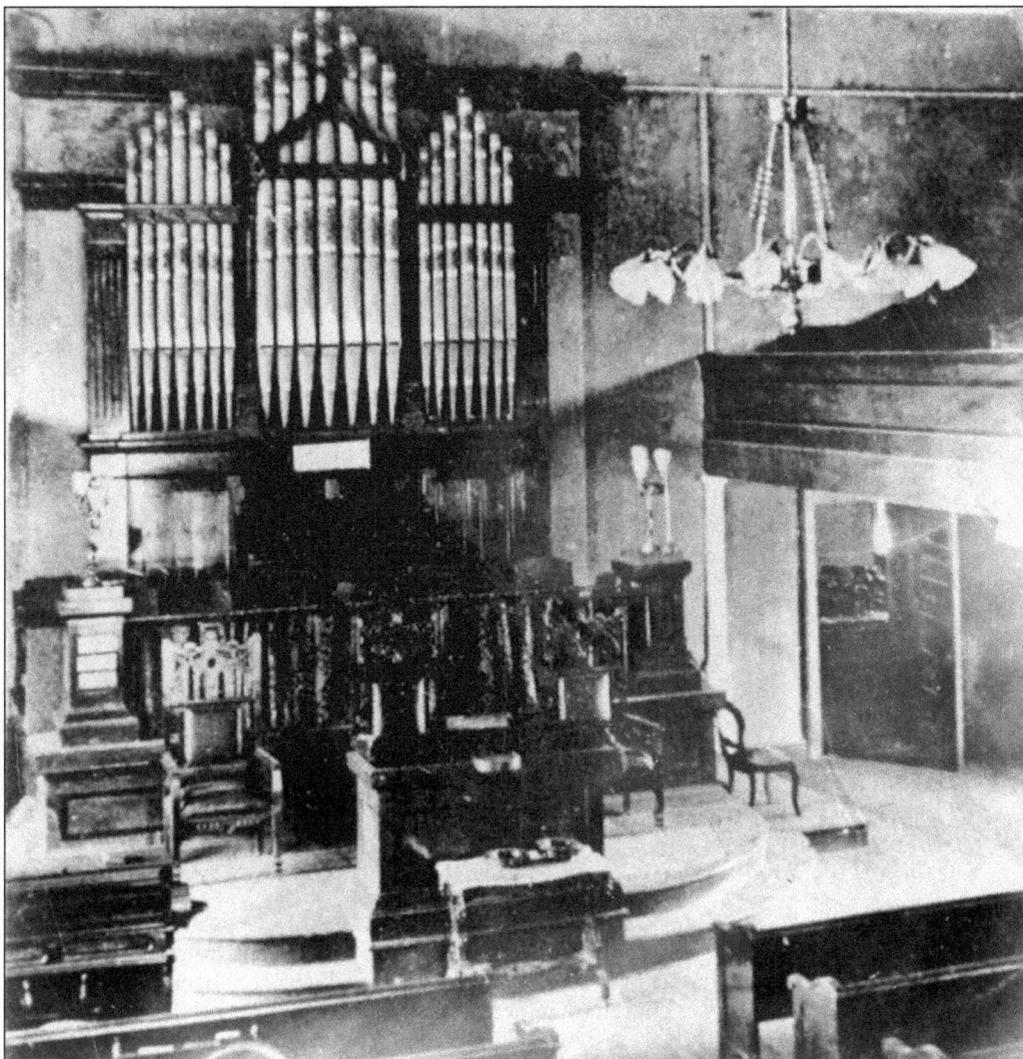

History credits Scotch-Irish and English settlers, relocated from Pennsylvania to southwest Virginia, with the early influence toward establishing Presbyterian churches in the region. In 1827, the first local Presbyterian church was built at the corner of (then) South Cross Street and Long Alley on the same lot that later accommodated the Montgomery Female Academy and the local Masonic Hall. In 1853, a new building was erected at 107 West Main Street, followed by a later one, built in 1908. The interior of the 1908 Greek Revival church included a pipe organ at the pulpit's rear. Today, the church is listed on the National Register of Historic Places. (Southwest Virginia Images Collection, Digital Library and Archives, Virginia Polytechnic Institute and State University.)

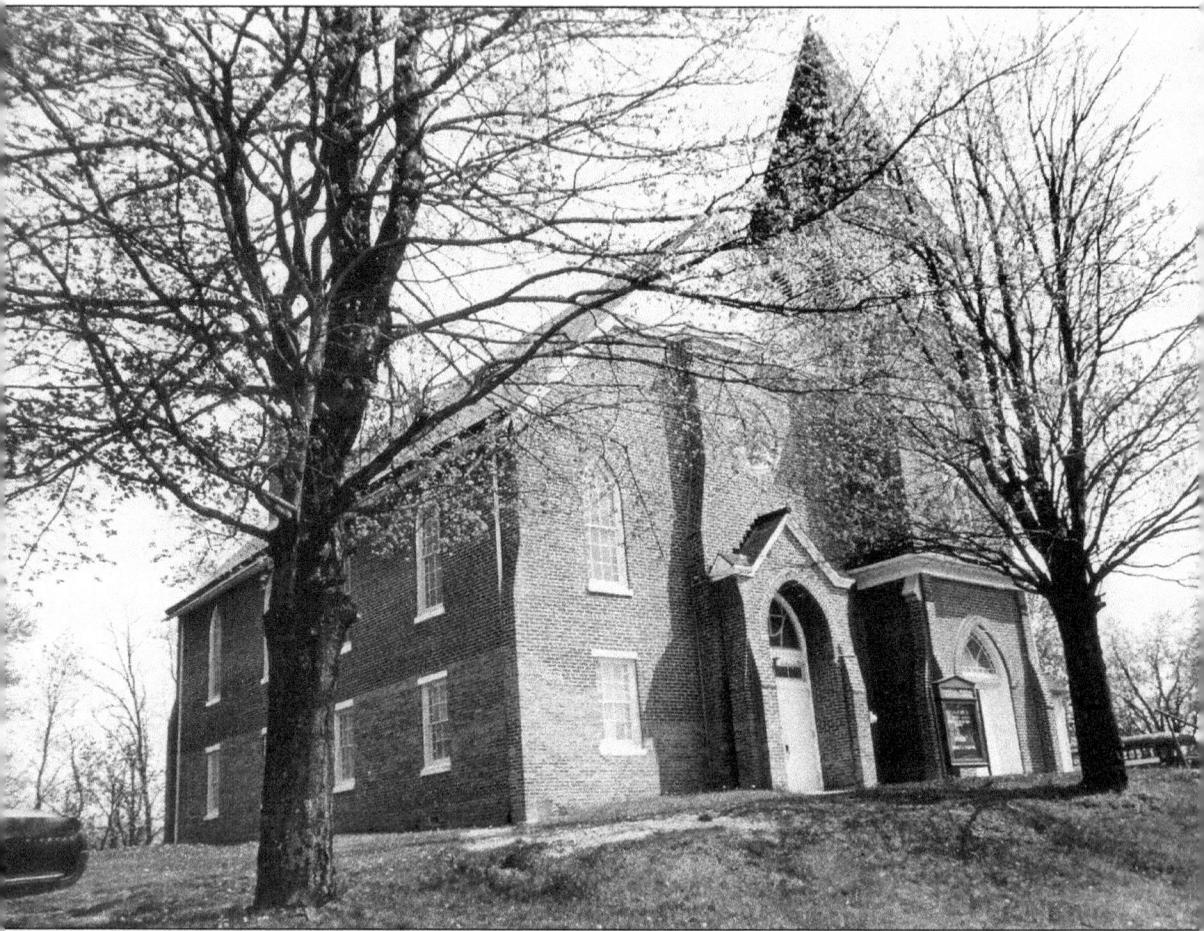

Union captain Charles Schaeffer came to Christiansburg on assignment from the Freedmen's Bureau to organize a school for the black community. A devout Baptist, Schaeffer established a number of churches as well. This church, renamed Schaeffer Memorial after the captain's death, was constructed in the late 19th century on High Street above Cambria. (*Montgomery News Messenger* Photographic Archive.)

Here, the Schaeffer Memorial Baptist Church is pictured beside the Christiansburg Institute classroom building on Zion Hill above Cambria. The school building, constructed in 1885, provided five classrooms for students at all levels. In the 20th century, after the institute's secondary department moved to a larger campus, this school on the hill, appropriately known as the Hill School, accommodated the elementary program of the Christiansburg Institute. Both buildings were named to the National Register of Historic Places in 1979. (*Montgomery News Messenger* Photographic Archive.)

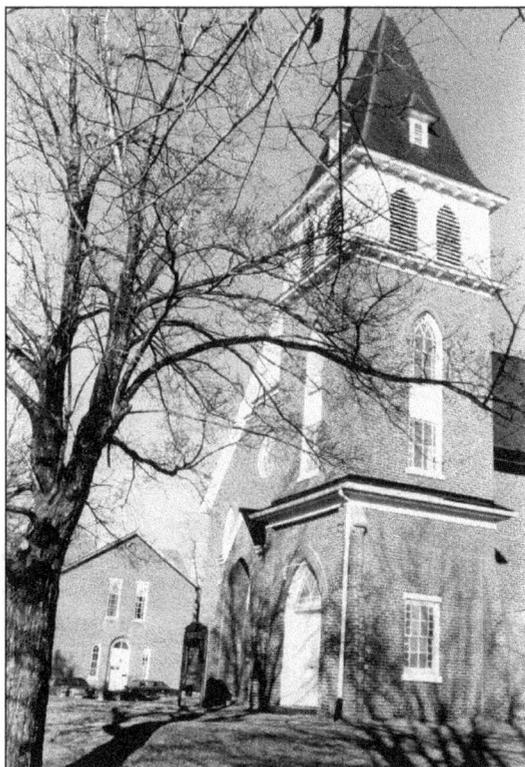

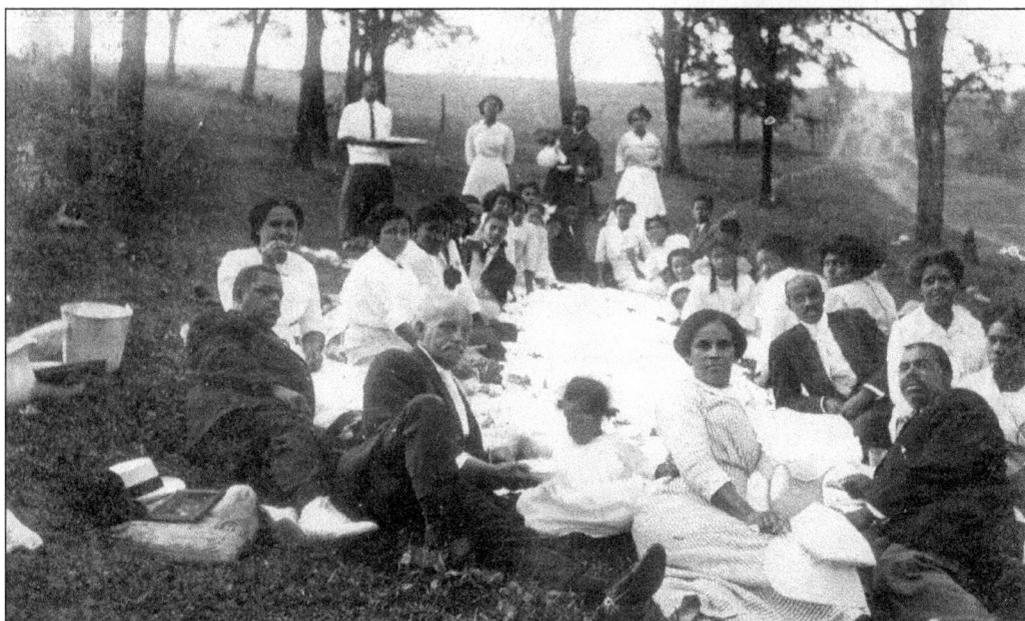

Church congregations provided opportunities for worship and fellowship, with services often concluding with a dinner on the grounds. This early 20th-century photograph was taken in the Christiansburg Institute cemetery. The gathering may have marked a memorial service or funeral or it may have been an afternoon of fellowship. The school's principal, Edgar Long, is seated at the far left. (Christiansburg Institute Museum and Archive.)

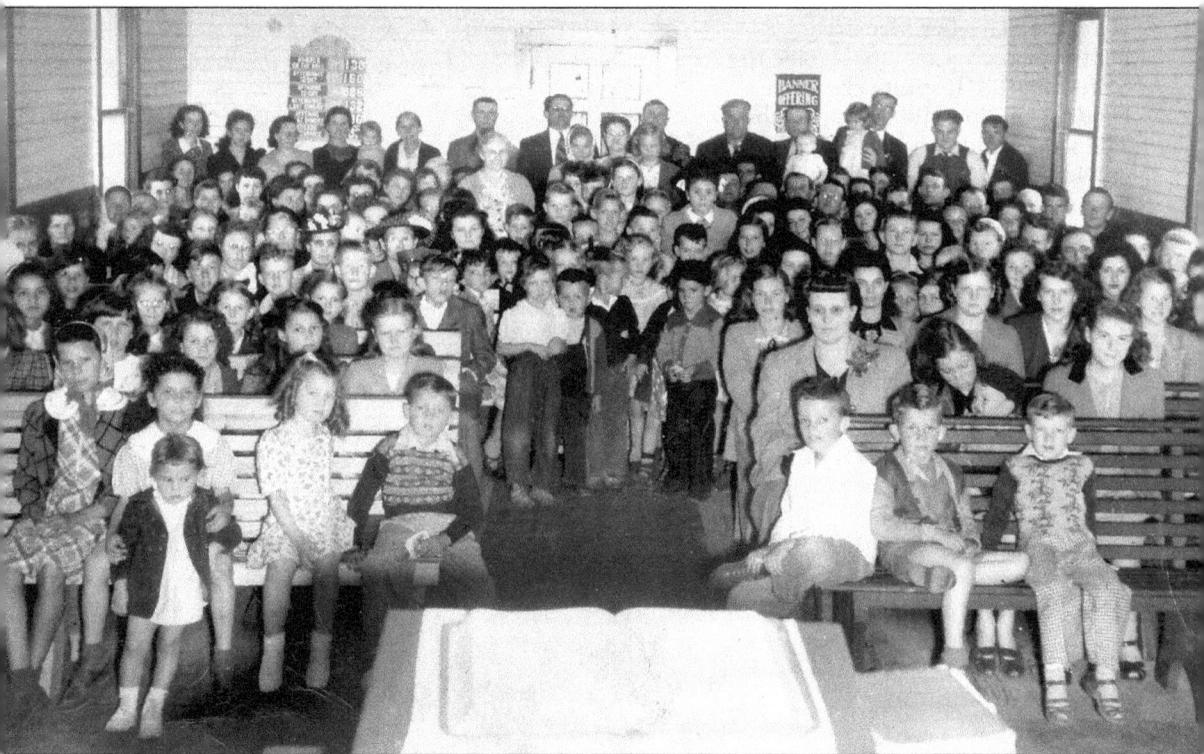

This mid-20th-century portrait, taken just before or after service at the Christiansburg Church of God, depicts a full congregation. Well-behaved girls and boys dressed in their Sunday best are seated in the front pews. The simple interior of the frame building is representative of many rural churches, where prayer and communion are the sole focus and the need for ostentatious surroundings is discouraged. (*Montgomery News Messenger* Photographic Archive.)

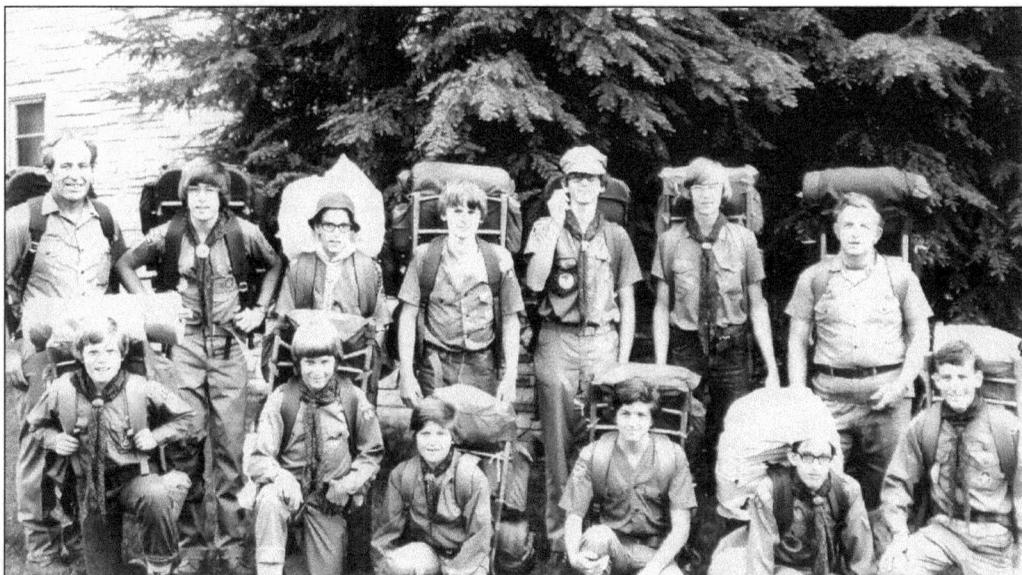

First established in February 1910, the Boy Scouts of America prepared young men, through a wide range of experience, to make value-based, ethical decisions as they participated in community events, developmental challenges, and governance. Outdoor activities promoted independence and environmental stewardship while sharpening the intellect and wit. Pictured here, a local chapter is off for an overnight trip into the woods of Montgomery County. (*Montgomery News Messenger* Photographic Archive.)

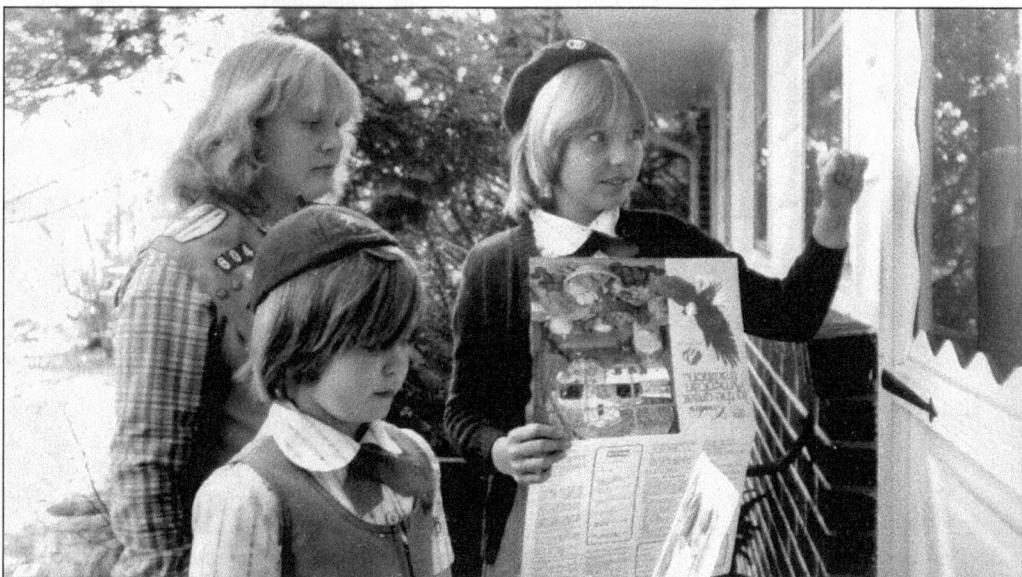

In 1912, Savannah resident Juliette Gordon Low gathered a group of 18 young women to discuss the prospect of a new course of experiential learning. Low's aim was to create opportunities for young women as alternatives to the traditional domestic roles cemented in the Victorian era. Her organization, Girls Scouts of the USA, was a success. It provided girls of all ages and backgrounds with a more active community experience. Pictured here are three local scouts at a neighbor's door, hoping to receive an expression of support for their current project. (*Montgomery News Messenger* Photographic Archive.)

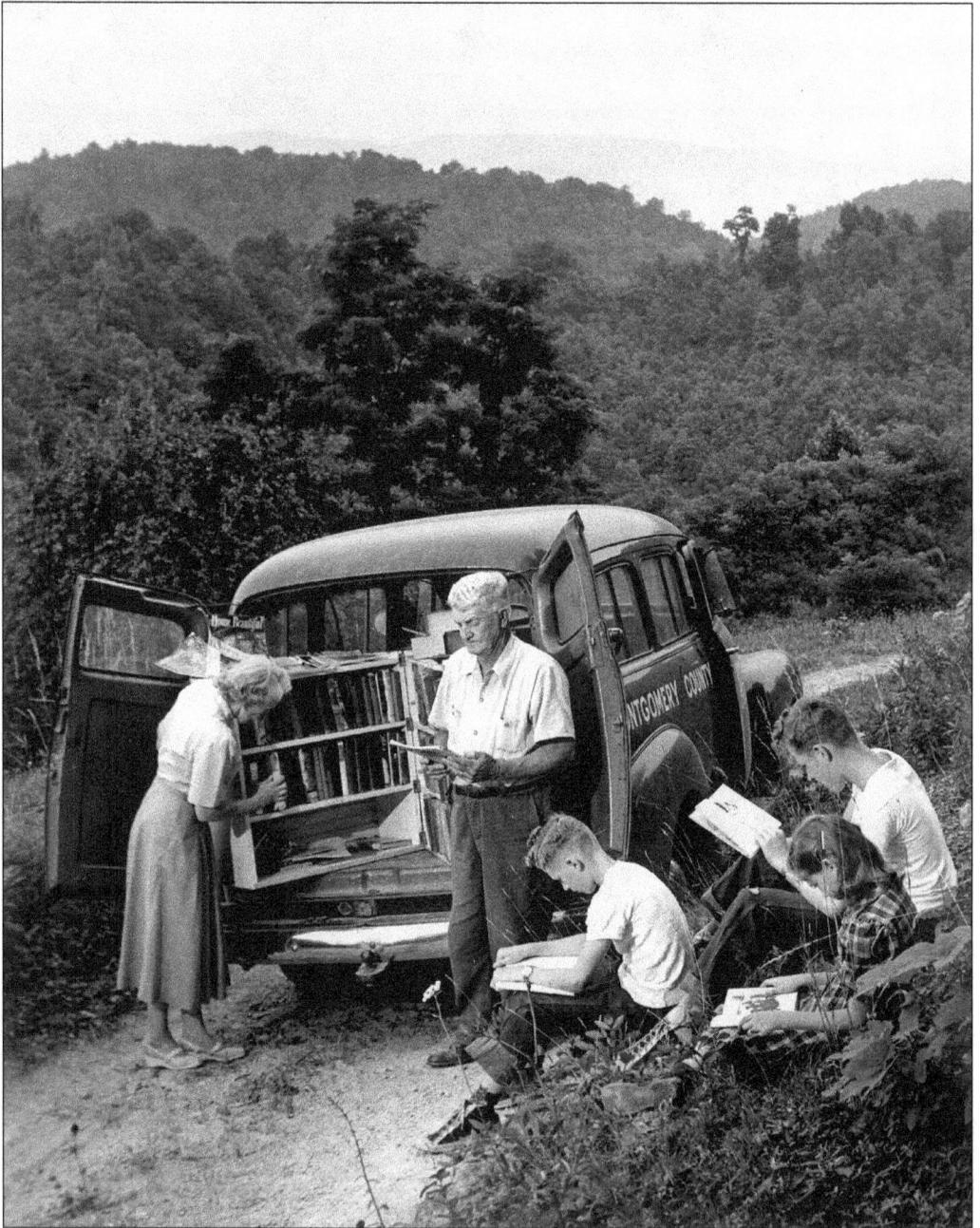

The Montgomery County Bookmobile traveled the rural roads and countryside around Christiansburg to deliver exciting stories to local residents of all ages. Here, three anxious children sit along the roadside, sampling selections from the mobile library as their father—or grandfather—makes his own choices. The librarian assists them and will come again on her next round. Churches, civic organizations, and libraries contribute to the quality of life of Christiansburg citizens. (Photograph by Earl Palmer; Earl Palmer Collection, Digital Library and Archives, Virginia Polytechnic Institute and State University.)

Ten

BRINGING FAMILIES TOGETHER

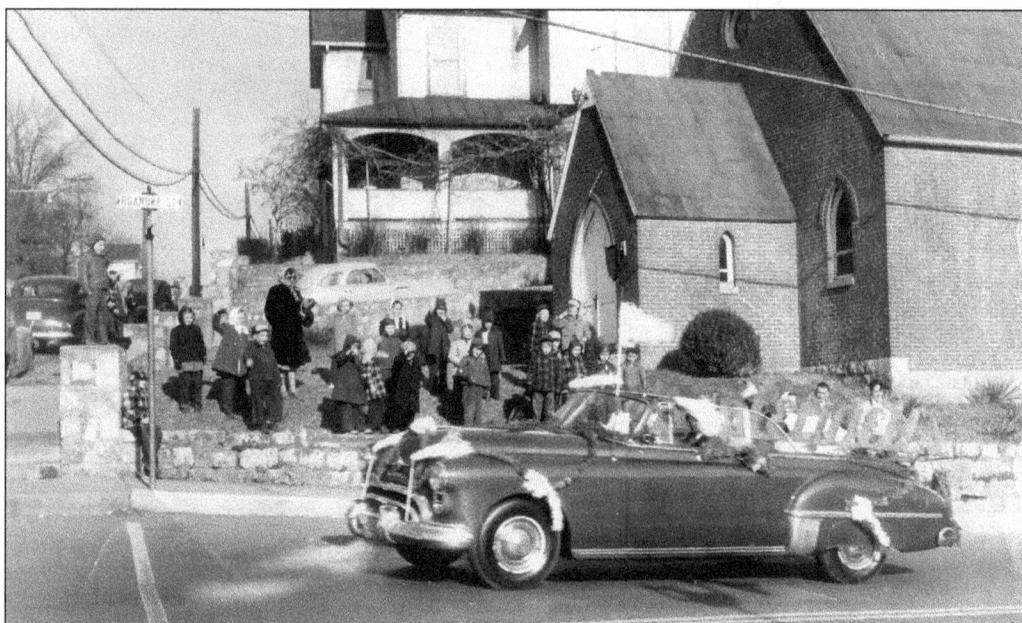

Christiansburg families celebrate good times with time-honored traditions. Here, a parade departs from in front of the St. Thomas Episcopal parish. Established in 1858, the present-day church was completed at the corner of Roanoke and East Main Streets in 1903. The church still stands on its original spot on Main Street overlooking the town center. A crowd of well-wishers stands alongside a stone retaining wall that today surrounds a landscaped and terraced garden, which, in warmer weather, is filled with colorful flowers. (*Montgomery News Messenger* Photographic Archive.)

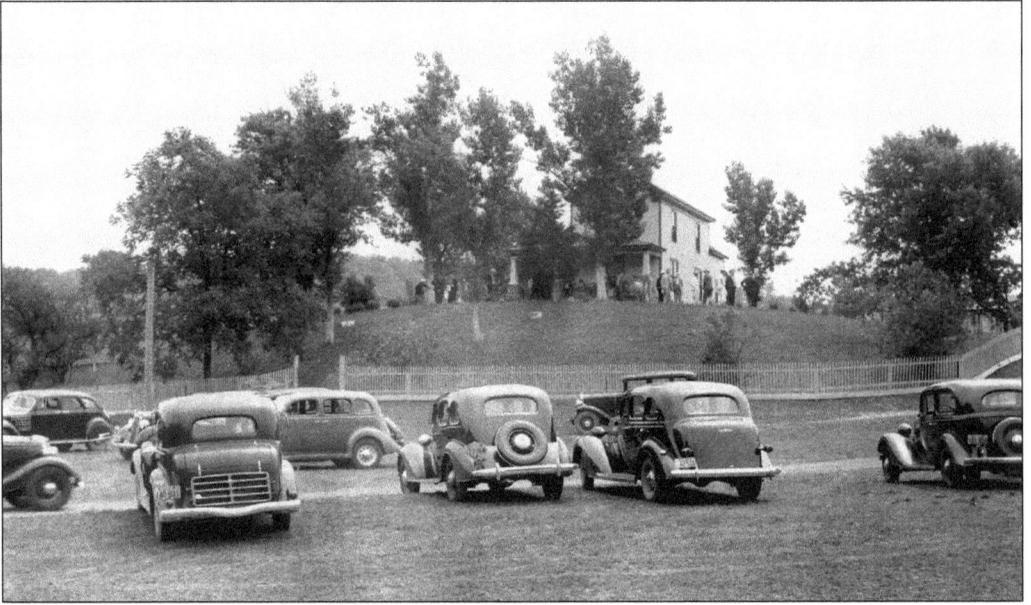

The roomy house on the hill, with its wide front porch and extensive grounds, was a perfect setting for social events. This depiction may celebrate a baptism, birthday, wedding reception, or funeral, marking familiar passages of family life. Close examination of the photograph reveals husbands, fathers, and sons talking in groups to the right of the residence, while the ladies have congregated beneath the shade of the covered porch. This social scene, c. 1930, was captured by Pulaski photographer David Cloyd Kent. (Mr. and Mrs. Richard Roberts Collection.)

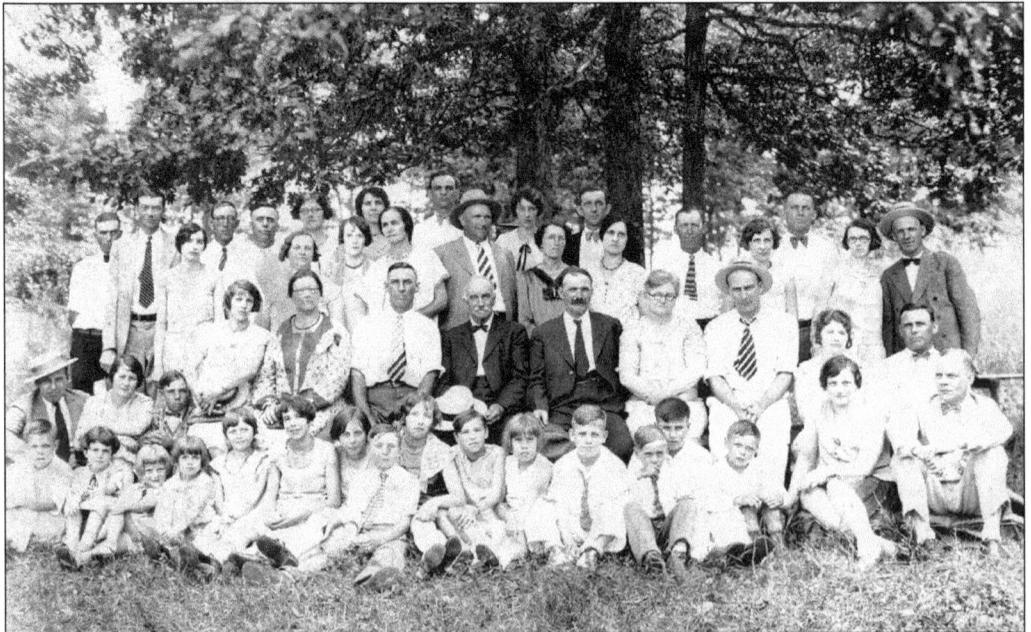

Although a great population shift occurred with the advent of industrialization at the turn of the century, in the early 1910s and 1920s, one could still find multi-generational settlements of family members within a fairly short geographic radius. This particular family photograph was taken in 1927, on the lawn of John Basham's log home in Cambria. (Robert B. Basham Collection.)

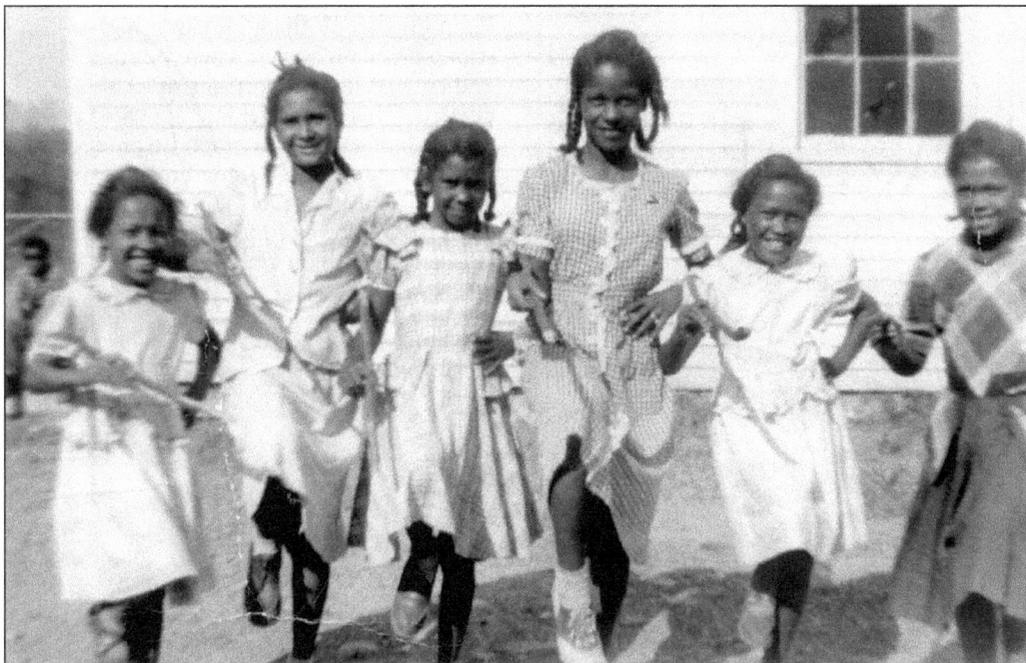

In Christiansburg, as in other small and close-knit communities, groups of young boys and girls needed little beyond their imaginations to celebrate their childhood experiences with self-created games and activities. This lively band of children is from the community of Elliston, at the eastern edge of Montgomery County, a few miles outside of Christiansburg proper. With smiling faces, this animated group appears to be marching in an imaginary parade led by an able leader with a "baton" at far left. (Christiansburg Institute Museum and Archive.)

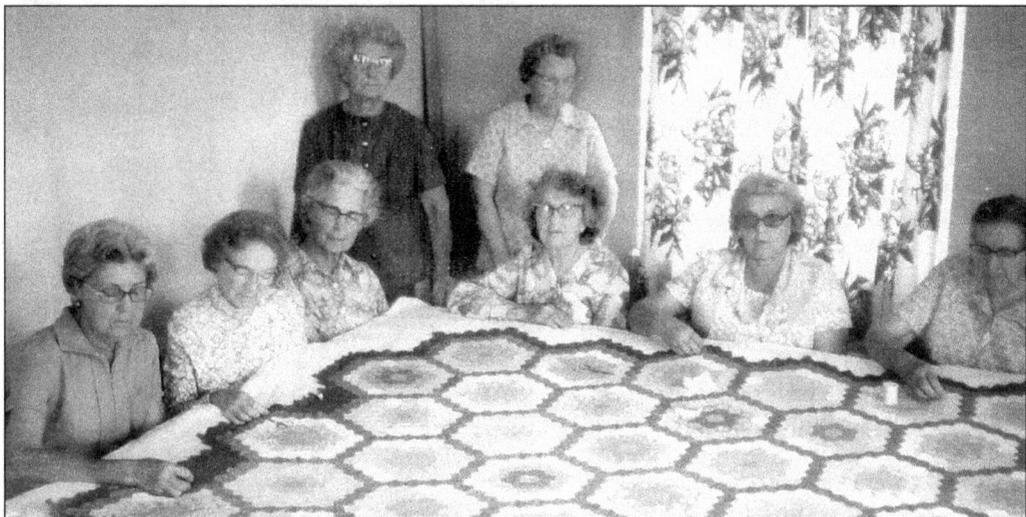

Quilt making, out of necessity, was an ingenious way of fashioning a warm bed cover out of small pieces of fabric cut from cast-off clothing. Colorful scraps were sewn together by an individual maker to create the quilt's top. Once complete, groups of women came together to hand-stitch the patterned top to layers of fill, sharing the work along with news and amusements. Even after such quilting bees were no longer a necessity, women still collaborated to finish quilts and share stories. (*Montgomery News Messenger* Photographic Archive.)

117

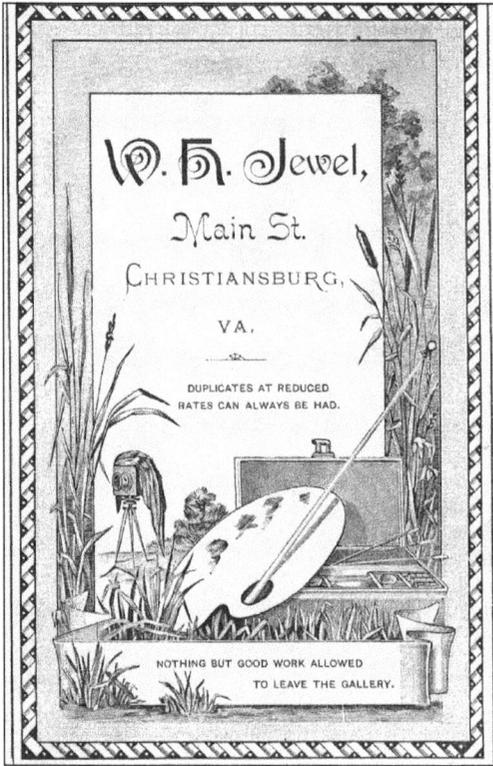

Photographer William H. Jewell had a studio on Main Street, where he staged and created unique portraits of local citizens. This advertisement appeared on the back of each photograph he produced. His elaborately styled signature appears above his business motto, "Nothing but good work allowed to leave the gallery." (Robert B. Basham Collection.)

According to a historical account posted in Christiansburg's county administration building, Earl Palmer was born to traveling circus performers in Bell County, Kentucky, in 1905. He attended Union College in Barboursville and then earned a teaching degree at Eastern Kentucky. Perhaps his spirited upbringing was one of the key influences in Palmer's diverse set of skills. Not only was he an accomplished and prolific photographer of local and Appalachian history, he served as mayor of Cambria for eight years. He is pictured here holding two of his train photographs while books, maps, prints, and antiques line the shelves behind him. Other local photographers credited with high-quality work and commendable attempts to record local history are Christiansburg photographers Frank Shelton and Douglas Lester. The collections of both men, now deceased, have been given over to the Montgomery Museum and Lewis Miller Regional Art Center. (*Montgomery News Messenger* Photographic Archive.)

William Jewel's Elite Studio included a romantic backdrop. In this formal portrait, a woman poses in a long dress cinched at the waist. A floral-trimmed straw hat in hand completed the portrait. (Photograph by W.H. Jewel; Robert B. Basham Collection.)

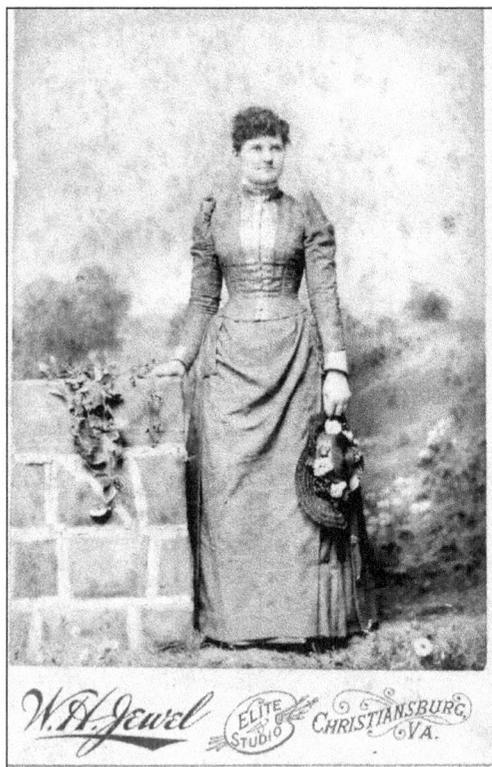

This young man looks somber posing for the well-known Christiansburg photographer. His serious facial expression is similar to painted portraits of the period. Until the invention of the Kodak Brownie camera in the mid-20th century, photographers required subjects to sit absolutely still long enough to ensure a clear image. Exposures may have taken a minute or more. Some photographers provided discreet head braces to help sitters keep still. (Photograph by W.H. Jewel; Robert B. Basham Collection.)

W.H. Jewel was still making pictures in the 1920s when he shot this portrait of Hazel Moore in his Christiansburg studio. She is seated on a fainting couch, a full-length backless sofa popular around the turn of the century. (Photograph by W.H. Jewel; Robert B. Basham Collection.)

A group of young men and women poses around a crank-operated record player soon after the turn of the century. These Christiansburg Institute students most likely lived in one of the school's two dormitories, which operated from the first decades of the 20th century until the 1930s, when the school began its transition to a public institution. When it was still a private academy, a 1920s school catalog listed students attending from Christiansburg, other areas of Virginia, and places from across the nation. (Christiansburg Institute Museum and Archive.)

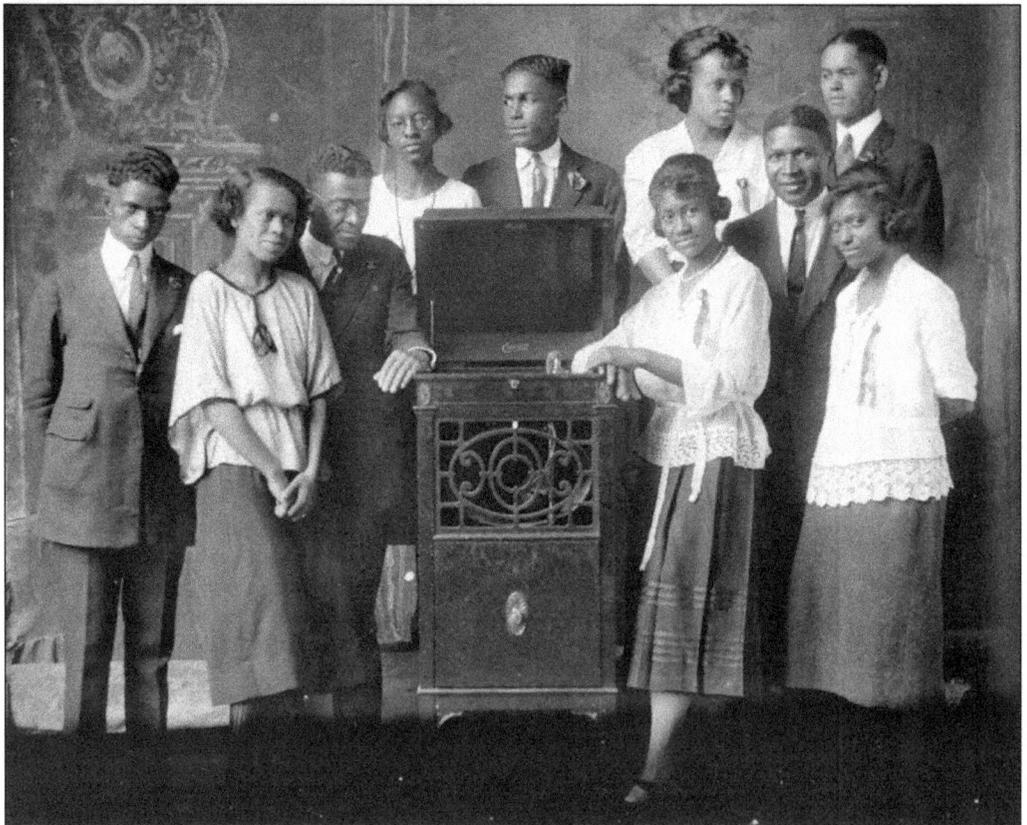

A dapper couple is out for a leisurely boat ride in style. For recreation, they have taken along a hand-operated record player that will entertain them all afternoon, as long as they remember to turn the crank. She wears a flapper-style dress and hat, while he sports a parted-down-the-middle hairstyle typical of the times. (Robert B. Basham Collection.)

Two young women pose on the running board of an early Ford automobile during the first decade of the 20th century. These early motorcars rode high off the ground on large, spoked wheels. The wide running board allowed ladies such as these to step up easily into the high-riding vehicle. (Robert B. Basham Collection.)

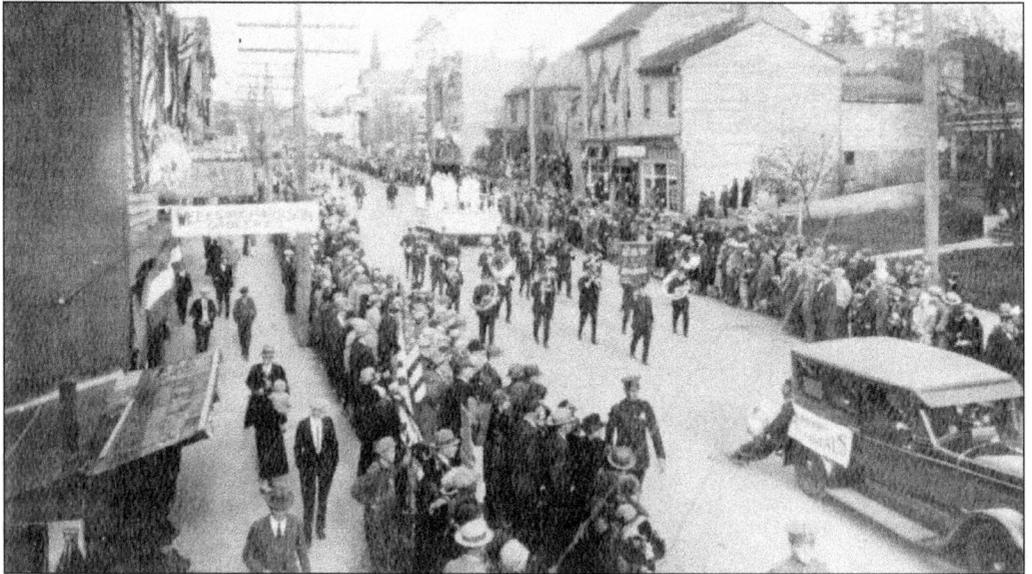

This photograph depicts a parade through downtown Christiansburg that commemorated the completion of the Lee Highway in 1926. The festivities ran along West Main Street away from the courthouse square to where the Lee Highway came into town. A brass band preceded a homemade float and several riders on horseback, parading past citizens who lined the sidewalks waving American flags. From the photographer's vantage point at the corner of Hickok Street, the 1909 courthouse dome and old Methodist church steeple are recognizable in the background. (Horne Family Collection.)

In the mid-20th century, Americans took to the road like never before. Having recovered from World War II, the nation was on the upswing. A sense of optimism, a diligent work ethic, and strong family values permeated community life. Parents and children made time for leisure trips to visit relatives or explore faraway places. This vintage Esso tank advertised gasoline for just under 35¢ a gallon. (*Montgomery News Messenger* Photographic Archive.)

The popularity of the automobile inspired new approaches to community life. As the interstate highway system replaced the traditional roadbed, drive-in movie theaters competed with their indoor counterparts. A new breed of restaurant, like Christiansburg's Dude's Drive-In, offered curb service to customers who enjoyed dinner in their cars. The Starlite and Dude's Drive-In signs appear as local roadside sculptures along the eastern edge of town near where business Route 460 meets Interstate 81. (Photograph by Anna Fariello; courtesy of the author.)

123

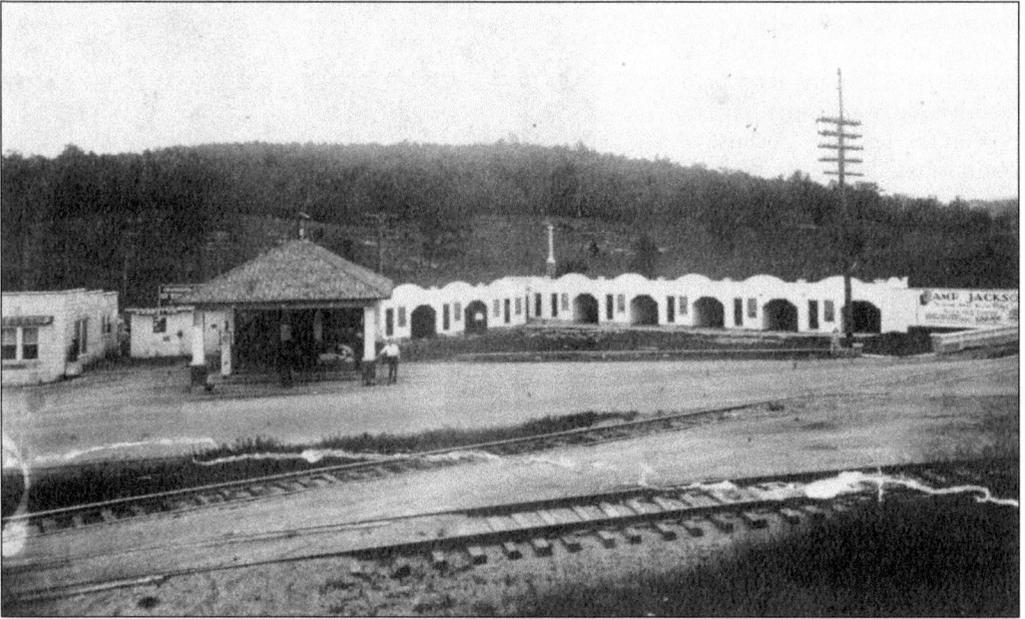

The last paved link of the Lee Highway was laid in November 1926. The increase in car travel through Christiansburg along this major southern thoroughfare prompted the construction of several individually owned motels, restaurants, and filling stations. Camp Jackson, pictured in the 1940s, combined them all. Located on Roanoke Street near the rail crossing, visitors could gas up, eat up, and rest up before moving on. Each of the diminutive cabins was equipped with a hot water bath. (Horne Family Collection.)

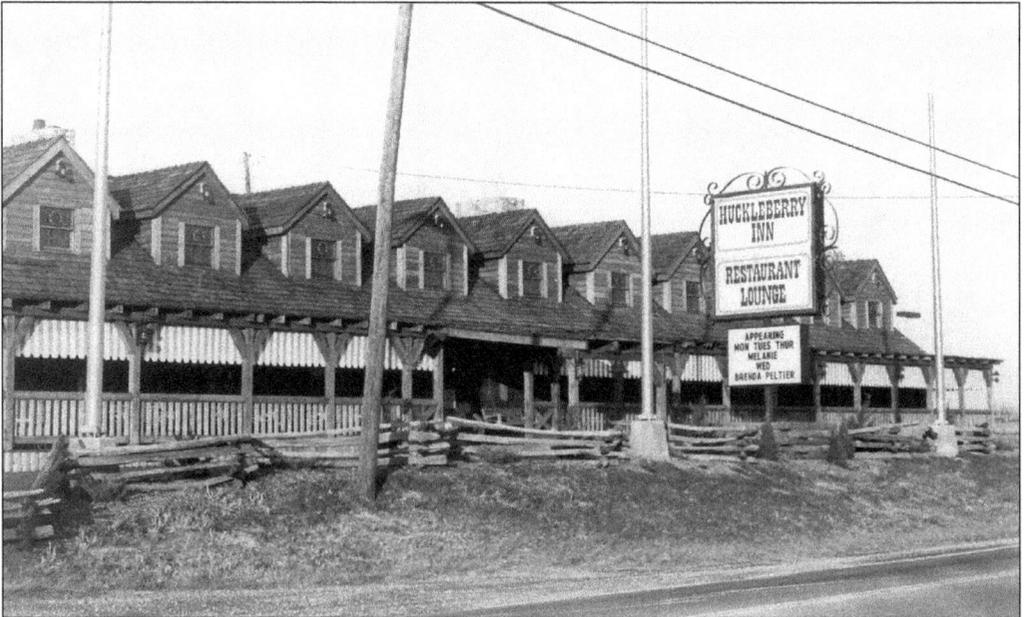

The Huckleberry Inn was a modern adaptation of early motel development and design. Still located today on Route 460 at the junction of Interstate 81, the local restaurant accommodates locals and travelers alike with weekly entertainment. (*Montgomery News Messenger* Photographic Archive.)

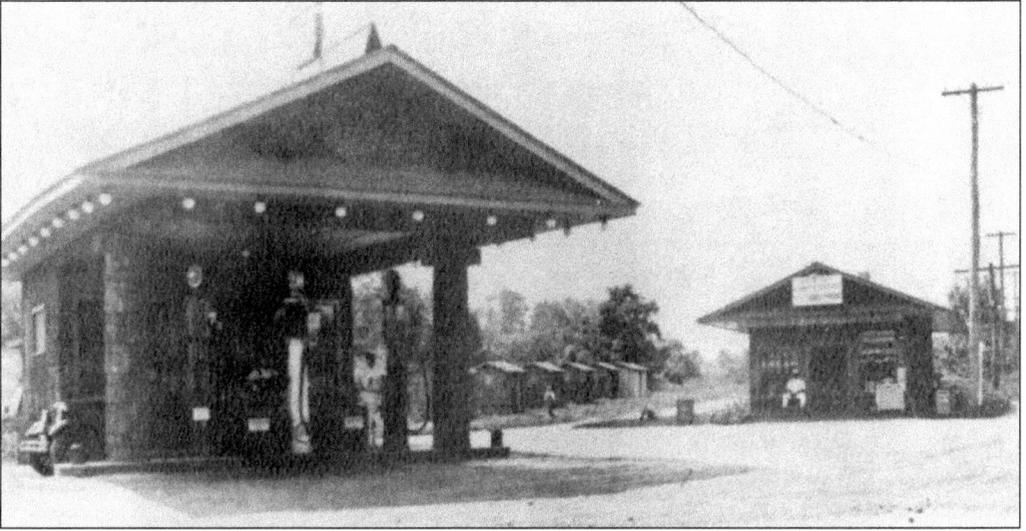

This similar establishment was located off Radford Road near the New Altamont Hospital. Convenient for hospital visitors and folks passing through, Camp Comfort was made up of a row of cabins situated to the left of present-day College Street as it winds around the general store at right. Camp Comfort's market offered two travel essentials, ice cream and homemade sandwiches. (Horne Family Collection.)

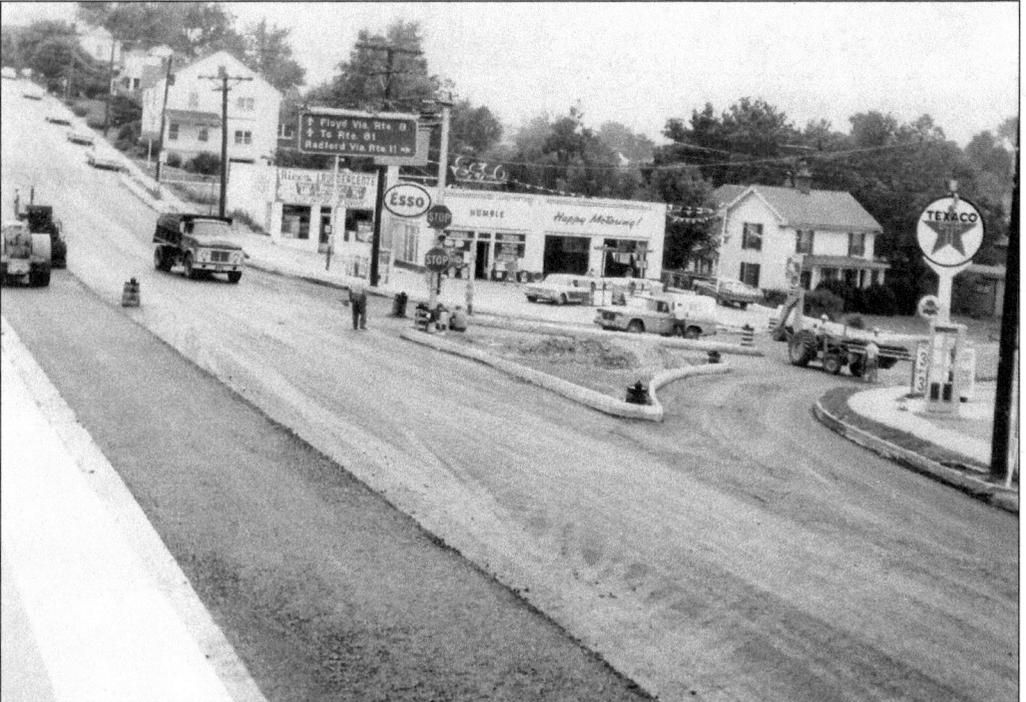

Vintage Esso and Texaco station signs convey an image of "happy motoring" in an era when Americans took to the road for business and pleasure. These gas stations were conveniently located at the intersection of Main Street and the Lee Highway (State Routes 8 and 11). Two motorized rollers at left add pavement to the busy roadway, proving that road construction is not new to the New River Valley. (*Montgomery News Messenger* Photographic Archive.)

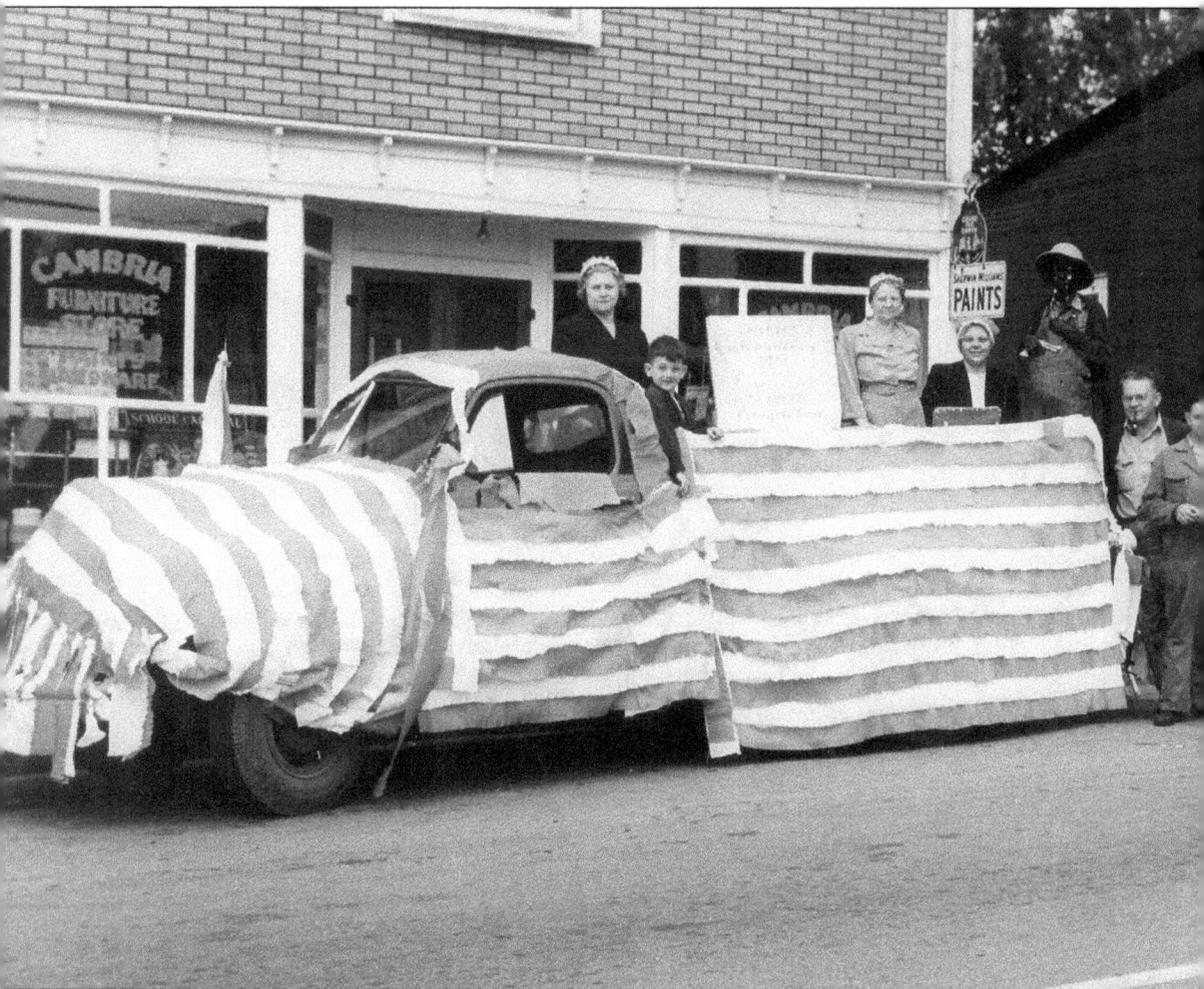

A sign displayed in the back of this decorated pickup truck reads, "Cambria Home Demonstration Club." The ladies seated in the festive wagon performed in-home demonstrations of new equipment and instructed new buyers through their first-time use. "Compliments of Cambria Furniture Store," this service echoed proprietor Howard "Speedy" Roberts' personality: friendly, generous, and affable. (Mr. and Mrs. Richard Roberts Collection.)

Students dressed in white circle a traditional maypole to celebrate the coming spring. At the far right is one of Christiansburg Institute's four brick buildings, which composed the central core of its landscaped campus. Commemorative events and pageantry, as depicted here, were common in the 1950s. Today, spring festivals take the form of more athletic events, such as the annual spring field day held at many area schools. (Christiansburg Institute Museum and Archive.)

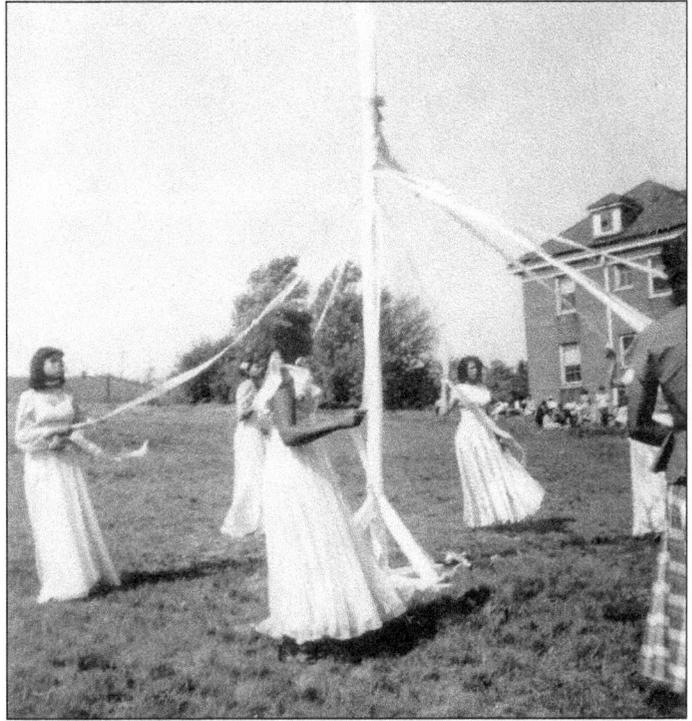

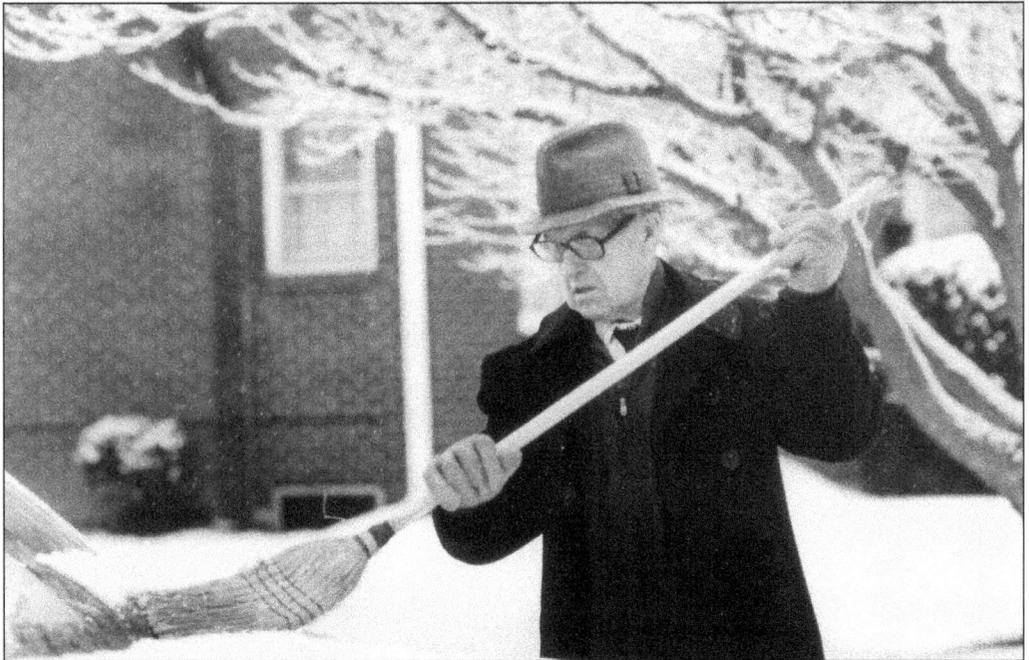

Community life, dating back to early agrarian roots, is punctuated by the changing of the seasons. Alan Miller sweeps snow off of his car while the sun shines through the bare, snow-covered limbs of a tree in his yard. Photographs like this one offer quick, candid snapshots of small-town American life as it moves through its cycle of seasons. (*Montgomery News Messenger* Photographic Archive.)

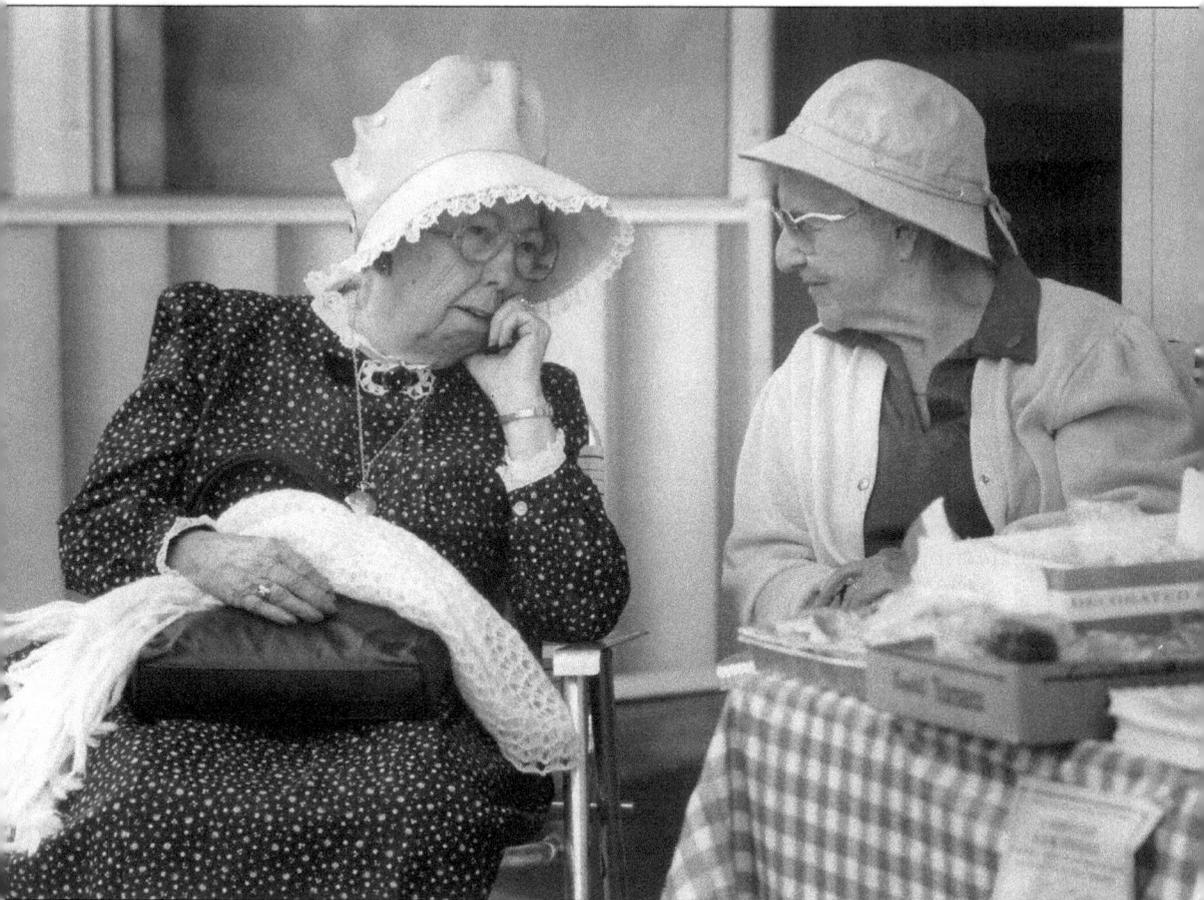

The town of Christiansburg began to commemorate its early history with celebrations like the Wilderness Trail Festival, an annual event for 32 years. The festival is held every September and features old-time music, local arts and crafts on display, and authentic foodstuffs made fresh. Its name pays tribute to pioneer migration along the Great Wagon and Wilderness Roads. Pictured here are Edna Looney (left), wearing an old-fashioned sunbonnet, and Edrie Slusher, who share memories of days gone by while they mind the bake-sale table. (*Montgomery News Messenger* Photographic Archive.)